THE
DRAWINGS
OF
L. S. LOWRY

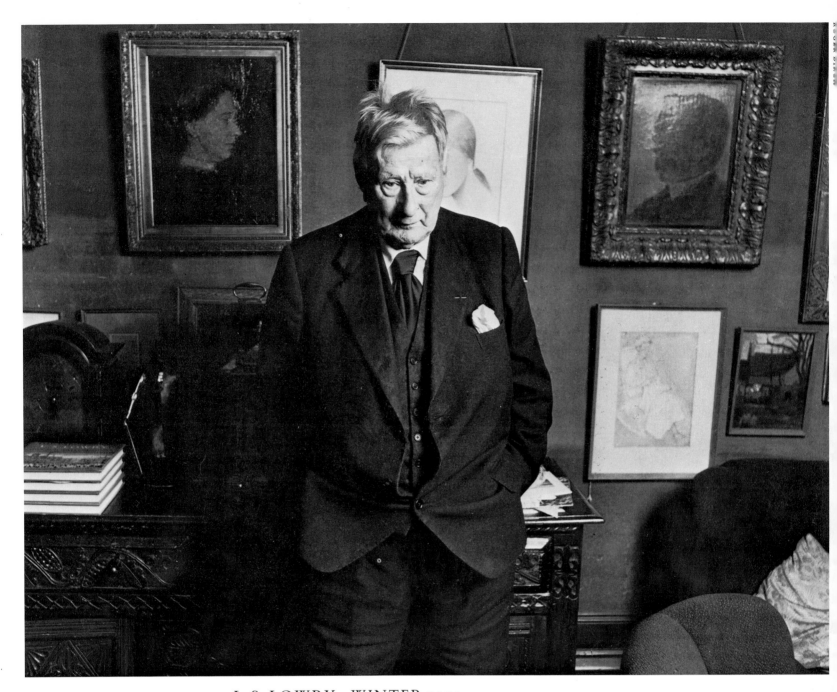

L. S. LOWRY · WINTER 1975

THE DRAWINGS OF L. S. LOWRY

PUBLIC AND PRIVATE

With an Introduction and notes by *MERVYN LEVY*

1976
JUPITER BOOKS

FOR PANNYC

First published in 1976
JUPITER BOOKS (LONDON) LIMITED
167 Hermitage Road, London N4 1LZ.

SBN 904041 69 7

Printed and bound by: AMILCARE PIZZI ARTI GRAFICHE S.p.A.
CINISELLO B. (MILANO - ITALIA) - 1980
Composed in Monophoto Bembo 270 by Ramsay Typesetting (Crawley) Limited;
display type by the Mouldtype Foundry Limited, Preston.

CONTENTS

ACKNOWLEDGEMENTS 6

BIOGRAPHICAL CHRONOLOGY
 OF THE ARTIST 7

INTRODUCTION 13

SELECT BIBLIOGRAPHY 31

THE COLOUR PLATES 33

THE MONOCHROME PLATES *following the Colour Plates*

ACKNOWLEDGEMENTS

The author and publishers wish to express their thanks to the late L. S. Lowry R.A., for his warm and whole-hearted assistance in so many respects; and to the following galleries and individuals who have given permission to reproduce drawings from their collections, or have in other ways afforded invaluable help in the preparation of this book: The Tate Gallery, London; The Director and Trustees of the City Art Gallery, Salford; The Lefevre Gallery, London; The Revd. G. S. Bennett; Mr Edgar Astaire; Mrs Ellen Solomon and family; Mr Keith Mead; Mr Bruce Sharman; Mr Monty Bloom; Mr Norman Satinoff; Mrs Marie Levy; Mr Ceri Levy; Mr John Maxwell; Mrs Loré Leni-Cowan; Mr Anthony Frewin.

BIOGRAPHICAL CHRONOLOGY
OF THE ARTIST

1887
Laurence Stephen Lowry born in Manchester, 1 November. Only child of R. S. Lowry, an estate agent, and Elizabeth Hobson. The family lived in Rusholme, a suburb of Manchester.

1895–1904
Educated at Victoria Park School, Manchester. On leaving school, he attended the private painting classes of William Fitz in Moss Side, Manchester.

1904
Joined the firm of Thos. Aldred & Son, Chartered Accountants, 88 Mosley Street, Manchester, where he worked as a clerk.

1907
Joined the General Accident, Fire & Life Assurance Corporation, 20 Cross Street, Manchester, as a claims clerk.

1909
Moved with his parents from Rusholme to 5 Westfield, Station Road, Pendlebury, in Salford.

1910
Began work as a rent collector and clerk for the Pall Mall Property Company, Manchester.

1915-20
Began to develop his interest in the industrial scene. During this period he also attended drawing and painting classes at the Salford School of Art, and continued to do so, infrequently, until 1925. His art school associations thus continue over a period of some twenty years.

1926-30
During this period he exhibited in open exhibitions in Manchester and at the Paris Salon. *An Accident* was bought by the City Art Gallery, Manchester. This was the first of his paintings to be acquired by a public art gallery. Commissioned to illustrate *A Cotswold Book* by Harold Timperley (Jonathan Cape, London, 1931).

1932
His father died. First exhibited in the Manchester Academy of Fine Arts. First exhibited at the Royal Academy.

1934
Elected a member of the Royal Society of British Artists.

1936
Six of his paintings were shown in a mixed exhibition at the Arlington Gallery, London.

1938
Chance discovery by A. J. McNeill Reid, who saw some of his paintings while visiting the framers, James Bourlet & Sons Ltd.

1939
First one-man exhibition, at the Lefevre Gallery. Subsequently he exhibited there on some thirteen occasions. *Dwellings, Ordsall Lane, Salford* purchased by the Tate Gallery. In October his mother died.

1941
An exhibition of the artist's work was presented at the City Museum and Art Gallery, Salford.

1943
One-man exhibition at the Bluecoat Chambers, Liverpool.

1945
Made Honorary Master of Arts, University of Manchester.

1948
Elected a member of the London Group. Moves from Pendlebury to The Elms, Stalybridge Road, Mottram-in-Longdendale, Cheshire. October: one-man exhibition at the Mid-day Studios, Manchester, where he exhibited regularly with the Manchester Group from 1946 to 1951.

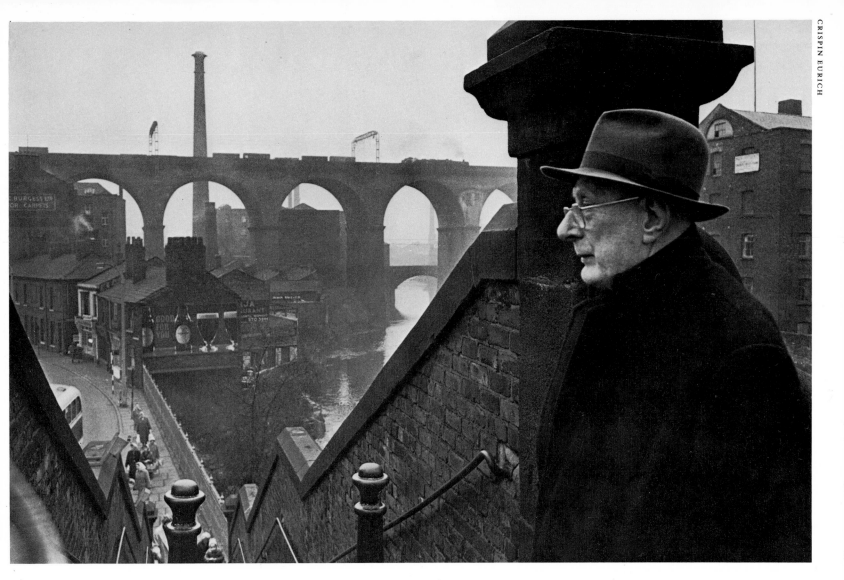

1951
July–August: retrospective exhibition at the City Art Gallery, Salford.

1952
First exhibition at the Crane Gallery, Manchester. This gallery, under the direction of Mr Andras Kalman, was the first commercial gallery outside London to show Lowry's work. Further exhibitions were held there in 1955 and 1958. Now the Crane Kalman Gallery, London, it has shown his work on a number of occasions. Lowry is represented in the collection of the Museum of Modern Art, New York. Retired on full pension from the Pall Mall Property Company, for whom he had worked since 1910. At the time of his retirement, he was chief cashier to the company.

1955
Made an Associate of the Royal Academy. An exhibition of his work held at the Wakefield City Art Gallery.

1959
June–July: retrospective exhibition at the City Art Gallery, Manchester. Exhibited, Robert Osborne Gallery, New York.

1960

April–May: exhibition of drawings and paintings at the Altrincham Art Gallery.

1961

Made Honorary Doctor of Law, University of Manchester.

1962

Elected Royal Academician. September–October: retrospective exhibition at the Graves Art Gallery, Sheffield.

1964

In November, an exhibition in his honour was held at the Monks Hall Museum, Eccles. Twenty-five contemporary artists, including Henry Moore, Barbara Hepworth, Ben Nicholson, Duncan Grant and John Piper, took part. The Hallé Orchestra gave a special concert in Manchester to celebrate the occasion of his seventy-seventh birthday.

1965

June: received the Freedom of the City of Salford.

1966–7

Travelling retrospective exhibition organized by the Arts Council of Great Britain visited the Sunderland Art Gallery; the Whitworth Art Gallery, Manchester; the City Art Gallery, Bristol; and the Tate Gallery, London. On 10 July 1967 the G.P.O. issued a Lowry stamp reproducing a mill scene.

1971

Exhibition organized by the Northern Ireland Arts Council in Belfast.

1975

Made an Honorary Doctor of Letters by the Universities of Salford and Liverpool.

1976

On 23 February, in his eighty-ninth year, L. S. Lowry died in Wood Hospital, Glossop, Derbyshire.

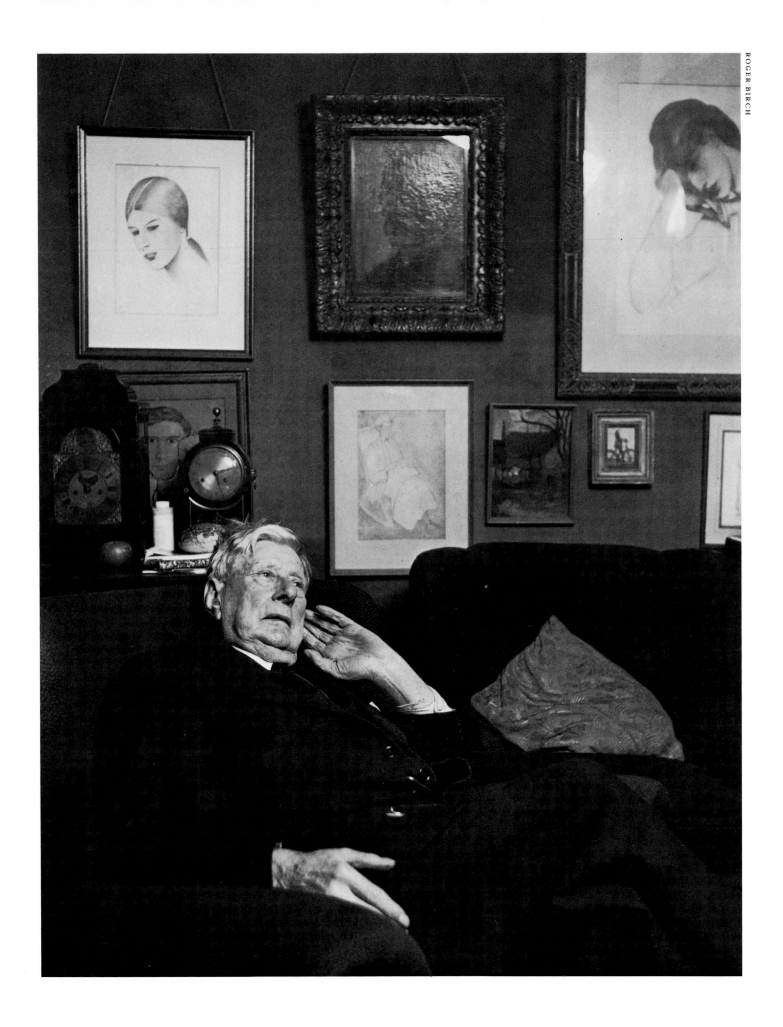

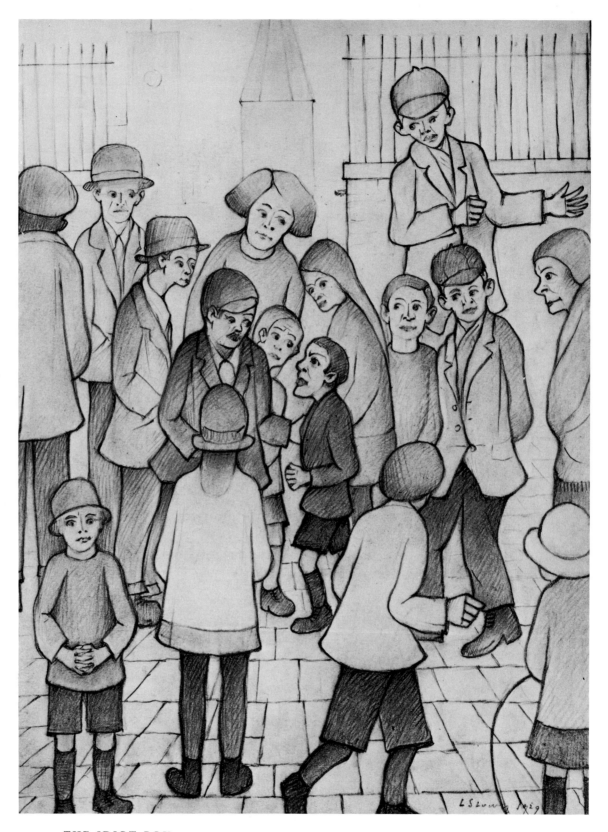

THE IDIOT BOY

1929. Pencil 37.5 × 27.4 cm. Collection: Mrs Lore Leni-Cowan.

INTRODUCTION

'CAN YOU TELL ME, SIR, WHY DOES A PAINTING COST MORE THAN A drawing? After all, a drawing is every bit as important, and sometimes a damned sight more effective. Besides, it is more difficult to do; for one thing, you haven't got *colour* to get you out of a mess.'

These remarks of L. S. Lowry are central to an understanding of his drawings and to an appreciation of his attitude to, and respect for, the craft and the passion of drawing. Drawing is both the most perilous and the most rewarding of the visual techniques, and I am talking now not of coloured chalks, white highlights on the tips of noses drawn in conté on coloured 'Ingres', I am talking simply about the run-of-the-mill pencil and a sheet of white paper. It was with these simplest of materials that Lowry created his finest drawings. His line drawings of the 1920s show how cleanly and economically he could use the medium. They have the purity of engineering drawings, lacking all pretension, all slickness or sleight of hand. They are totally representative of a mind which always thought before it drew, for Lowry was that rare artist, one who never committed himself to any statement - slight or complex - unless he had something of consequence to state. Drawing was an art which Lowry never trivialized. He drew constantly on scraps of paper, on envelopes, on bits of card, but even his slightest notations are perfectly precise. He was as economical and to the point as Jacques-Louis David. Compare Lowry's brilliantly succinct working drawing for the painting *A Woman with a Beard* with David's sketch of Marie Antoinette on her way to the guillotine. In many ways these two drawings are quite similar; both capture the essence of their subject in a ruthless, entirely unsentimental fashion. Even the

[13]

J.-L. David's pencil drawing of Marie Antoinette on her way to the guillotine, October 16, 1793. This sketch from the life, drawn as she passed the artist, is a pure Lowry subject.

technical style is comparable. The brisk, relentless, stabbing style rips the soul out of the subject.

In concept and style Lowry's line drawings of the twenties are closer to the classical than to the emotive streams of European art: closer to the architectural masters of the trecento than to the rhetorical emotivity of the High Renaissance – closer to Lorenzetti than to Tintoretto. Yet in his *feeling* for the art of drawing Lowry can be likened to the late Italian masters such as Michelangelo and Leonardo. It is, after all, pure Renaissance thinking to see in drawing an art form as total and significant as painting. The debasement of the craft of drawing was to come later, in the slippery and facile techniques of the French court artists (on occasion even Fragonard and Boucher are guilty); and later still, after a temporary strengthening of the crumbling edifice by David and Ingres, there begins a long slide into drawing as a mere mechanical skill. Masters of great integrity there are, of course, always. Whistler never trivialized his drawing, but for many artists of the late nineteenth and the early twentieth century drawing was merely a form of relaxation from what they considered the more rigorous demands of painting; so that when we reach a relatively poor painter like Augustus John, or an outrageously bad one like Philip de Lazlo, equipped only with varying degrees of technical skill, drawing soon plummets to the level of a cheap confidence trick. Great painters never draw in this way.

Certainly Lowry often made 'fun' drawings, as did Picasso, but he was always quick to rate them as such. 'Oh, it's nothing,' he would say; 'just an autograph scribble.' (See, for example, the two very amusing drawings entitled *Man Drowning* and *Another Man Drowning*, Plates 272 and 273.) It was not his fault, any more than it was Picasso's, that in his later years dealers would scramble for any scribble they could rummage from his studio or buy from a friend to whom he had given some scrap, then mount and frame it expensively and offer it to a gullible public for a ridiculously large sum of money. Lowry was the first to see through this kind of dishonesty. He hated the chicanery of the dealers.

Lowry did not always work in pencil; like any artist of breadth and vision he needed to experiment. In later years especially, he liked to use felt-tip pens (usually black). Earlier he had experimented with coloured crayons such as any child might have used. From these in particular he extracted a shimmering beauty. Some of the crayon drawings, like showerings of coloured sparks, are among the most exquisite he ever produced; but they are clearly drawings – executed with tiny strokes and stipples, the actual mark made by the point of the crayon always remaining in evidence. But let us return to a consideration of Lowry's use of the pencil, for it was with this simple instrument that his whole career began.

Lowry was an art student for some twenty years, on and off. From 1905 until 1915 he studied at the Manchester College of Art, and from 1915 until 1925 he attended classes at the Salford School of Art. What has not been documented before is the remarkable fact that from 1904, when he was sixteen, until his retirement in 1952 at the

age of sixty-five, L. S. Lowry was in full employment – first as a rent collector and clerk, and later as a book-keeper and chief cashier for a Manchester business house. This information, which has only recently come to light, makes it clear that Lowry was never a full-time student, but attended evening classes after a day's work at the office.* His drawings from the antique and from life were usually made by artificial light therefore. Lowry's art teacher at the Manchester College of Art was Adolphe Valette, himself an artist of very great ability, who taught Lowry not only the impressionistic method which he was so often to use in his paintings, but also the skills of drawing. Often working in a soft pencil, Lowry would mass his areas of velvety dark by the use of a finger-smudging technique which evolved, he once told me, from the use of the 'stump' – popular with art students in his early days at the Manchester College of Art, when drawing from the antique and from the life – a pencil-shaped roll of blotting paper which was used to rub one's pencil-work into a smooth effect. Lowry soon discovered that he could supplement this technique by using his finger or the ball of his thumb. In this way he could create with light, deft smudges areas of silvery grey, patches of cloud, the trail of smoke, the swell of the sea, or even, magically and mysteriously, the quality of the industrial atmosphere itself.

This finger-and-thumb technique which Lowry developed in those early days at the Manchester College of Art he continued to apply extensively through all phases and periods of his work. He was such a brilliant master of the smudging technique that he could create in this way not only volume or atmosphere, but even 'colour'. According to Odilon Redon, 'Black is the most essential of all colours. Nothing can debauch it.' In his lithography Redon used black as an adjunct of symbolism, and this area of his work is perhaps the most successful and certainly the purest. Whistler in his print-making used black as a means of purification. Between them Redon and Whistler produced fewer than ten lithographs in colour. Lowry extended the use of black into the realm of drawing and used the materials of drawing, and especially the pencil, to create 'atmosphere', whether the physical atmosphere of the industrial scene, the atmosphere of psychological tensions in which his people are often locked, or the atmosphere of mystery which pervades the hazy and misty country scenes occasionally set with strange old houses and drowned in shadows. Everywhere in Lowry's work there is clear evidence that black was used both as tone and as a synonym for colour. In his hands black – solid, or broken into silvery greys – suggests the colour of objects, materials, clothes; the pallor or robustness of complexions; the weathered, grime-encrusted character of stone; the fleeting haze of smoke; or even, magically, space itself. An early page from a sketch-book of 1920 (Plate 37 et seq.) shows two schoolgirls in conversation. The background, a mass of scribbled black, provides the space in which they exist. It is as telling and as infinite as the 'white'

*I owe this information to Mr Allen Andrews whose forthcoming biography of Lowry will add greatly to our knowledge of the artist.

space which holds the figure of a man in a smudged grey suit, also from the same book. Who would say after looking at these two drawings that black – or grey – cannot convey as much as the colours of a painting? Painted colour can perhaps add a dimension of sensuous pleasure for the eye, but it cannot tell us anything more about the existence of objects in space.

This 1920 sketch-book merits close consideration – as indeed do the sketch-books of all the masters. (How can one really get to grips with Constable or Turner without studying their sketch-books?) It is true that in recent years the practice of carrying a sketch-book has become unfashionable among artists and, unhappily, among art students, who have been allowed to pursue their own arrogantly ignorant and un-informed paths. When one thinks of the years of desperately hard work which an artist like Lowry had to serve, working only in his spare time, the illusion of 'instant art' which has so degraded the whole of the art scene in recent years can be seen as the shoddy little con trick it is. One can hardly be surprised that, beyond a handful of masters who were prepared to lay the initial foundations of academic discipline (Henry Moore is the shining example) the present climate of achievement in the visual arts stands at its lowest ebb. There can be no evolution, no apotheosis, of talent, without the kind of notation which all really great artists have made in their sketch-books.

Lowry's 'type faces', to borrow a printer's term, can be seen already taking their distinctive shape in this early sketch-book. Lowry 'types' are as unmistakable as those of Thomas Rowlandson, and the forging of this hallmark was made at sketch-book level. Lowry's symbols for the human figure were patiently distilled from many such sketch-book notes. Action and repose were closely observed and then beaten into an image which gave even the clothing of his personages as much personality, and meaning, as the figures it covered. Caps, shawls, bowlers, suits, all played their role in creating the total image of man.

Lowry himself was of lower-middle-class origin (his father worked for a firm of estate agents), but he was a keen observer of the working class at a time when there really *was* a working class. His wanderings around Manchester as a young rent collector in the twenties brought him into contact with people at the poorest level of society. He was able to observe that the clothing which poor people wore was strictly utilitarian. Fashion had not yet filtered down to the lower reaches of society. Trousers simply covered the legs, and hats the head. Coats and mufflers gave warmth. The bowler may have been a mite more respected than the cap, but it was still primarily a covering for the head. The cult image of the twenties was the tragi-comic figure of Charlie Chaplin as the Tramp, in his baggy trousers and cracked shoes. Lowry was a great admirer of Chaplin, and many of his characters are, of course, fully Chaplinesque in essence. Clothes were often second-hand and in consequence either too large or too small for the wearer. In his drawings Lowry frequently emphasizes this point with great humour. Seldom did he show any interest in the evolution

of fashion in dress. With a few exceptions he stuck resolutely in the 1920s and his natural feeling for the grotesque.

The comedy of man's appearance led Lowry to view him with a coldly satirical, often cruel eye, and in his later drawings man is often the object of ridicule. The studies of the sixties – the tramps, the football hooligans, and other unsavoury characters – tell this side of the story very well. Lowry, as he admitted to me on many occasions, positively delighted in the sight of these local 'seedies'. 'Oh, just look at him, sir!' he would say as some tragic cripple hobbled by us as we walked through Manchester or Salford together. In later years he developed a passion for drawing derelicts, tramps, and Manchester down-and-outs of both sexes, and would, I think, have been really happy sketching in a 'skid row', a mental hospital, or a geriatric ward. He saw how ludicrous man was, and his ability to depict this in the sharpest terms can be traced back to the sketch-book of 1920. There he was primarily concerned with posture or stance; with the clothing that was always either too big or too small; and with the way in which head coverings and footwear accentuated the predicament of human destiny as revealed in the visual image. If this seems a strange observation at first sight, one need only consider Lowry's use of the hat to suggest poverty, comedy, stubbornness, brutishness, idiocy, or what you will, which shows at all stages of his work, from the earliest to the last drawings. He invests the hat with a greater ability to 'speak' than the face. Indeed, the facial expression is a minimal consideration in Lowry's art. Expressions are always rendered in a low key, as though the artist were deliberately avoiding saying too much through the face. Being himself a reticent, guarded, and retiring man, Lowry was well aware that the face, and the eyes in particular, can too easily reveal what is better kept hidden. We can learn nothing from the blank, totally uncommitted faces of his characters. The story of their lives is told instead in the way they stand, walk, run, loll, droop, drift, hobble, skip, and stroll. In Lowry's rare portraits – for example those of the mysterious 'Ann' – we are met with an almost catatonic emptiness, as though the soul of the sitter had been permanently withdrawn from all human contact.

In the 1920 sketch-book we can study too the way in which Lowry began to weave his subtle figure patterns, overlapping bodies, legs, arms, faces, caps, hats, and movement, to produce the most thrilling figure compositions since Brueghel. Whereas Brueghel documented the peasant life of his time, Lowry has documented the life of the modern industrial landscape. The line drawings of the twenties contain some of the best examples of his genius for relating figures in mass. Great crowds are rendered with all the delicacy of petit-point. *Bank Failure* (Plate 61), drawn in 1922, is a perfect illustration of this. In the early line drawings the artist usually represented his people with a remote coolness, concentrating rather on pattern-making than upon social comment and satire. The latter aspect of his work was to develop and become more prominent only as he grew older and saw more frequently the black comedy of the human predicament. One could, of course, argue that such serene masterpieces

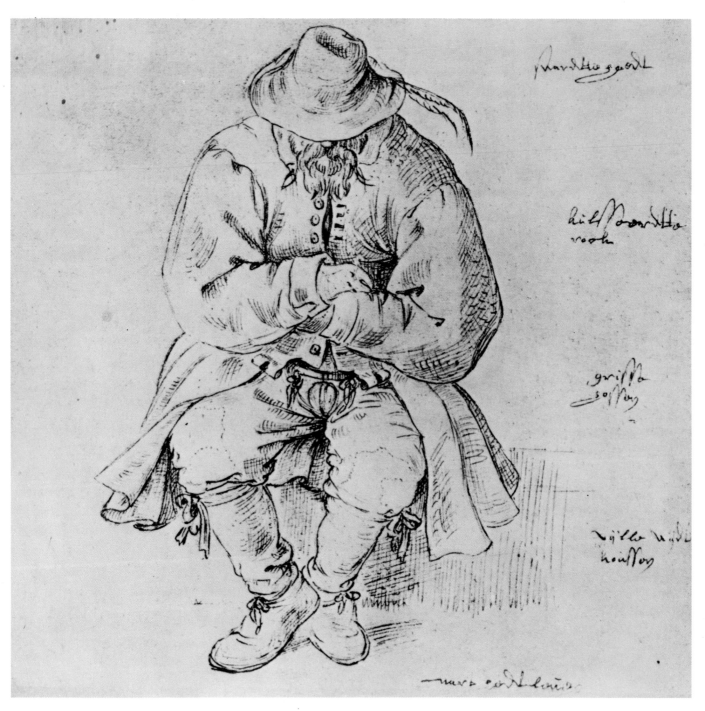

A Manchester man! Pieter Brueghel's *Seated Peasant Asleep*, c. 1565. Lowry has often been compared to the earlier artist and this drawing would undoubtedly have appealed to him.

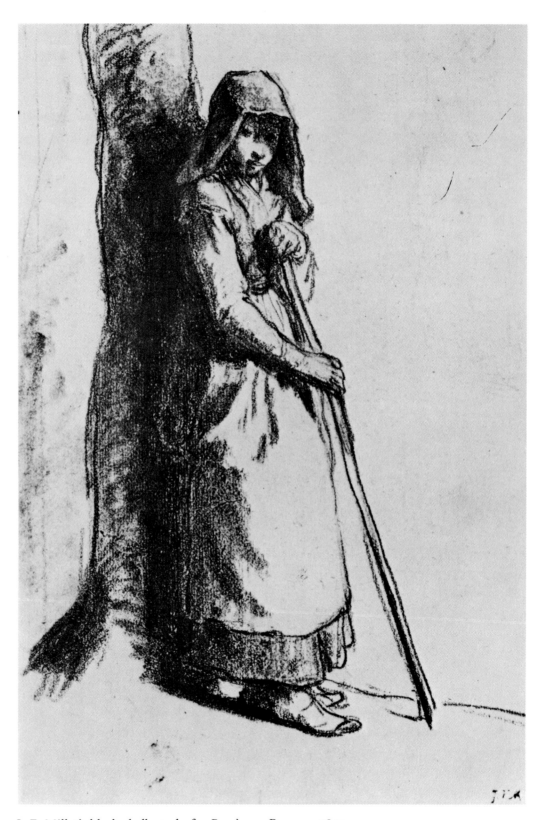

J.-F. Millet's black chalk study for *Bergère au Repos, c.* 1849.

as *Daisy Nook* and other densely populated oils of the 'high' period – the forties especially – have their origin in the splendid, almost mathematical line drawings of some twenty years earlier. Yet by the late fifties this vein of the serene had been worked out; the gold extracted, the seams emptied. Henceforth man would be dealt with less gently, and serenity would now be found mainly in the bleak late seascapes.

The purely academic drawings of his art classes trained Lowry to see literal appearances. In the life room an artist learns the basic grammar of drawing, the vocabulary of anatomy. Eventually, on the basis of long years of solid academic study, it is not so much what the artist puts in as what he leaves out that counts. The most brilliantly free sketch, which looks so effortless and easy, is based upon a foundation of excruciatingly detailed academic study. And although Lowry never possessed the technical virtuosity of a draughtsman like Augustus John or John Singer Sargent, he was a sufficiently dedicated student of drawing from the antique and from life to store carefully for future reference all the vital information which other masters may have expressed with more dexterity, but certainly with no more knowledge. Lowry's drawings from the antique and from life repay close study. In his life drawings we can often see the germination point of his linear drawings of the twenties, and also of the satirical drawings which were to come much later on and in which editing is all-important.

It is always illuminating to compare masters of quite different temperaments and achievements, so let me just refer here to the drawings of Picasso. It is upon exactly the same bedrock of academic observation and achievement that the most dazzlingly descriptive and apparently effortless contours of Picasso depend. They emerge from his student years in Barcelona to reach a climax of brilliant achievement in the Vollard suite of etchings of the 1930s. This was the period of Picasso's most exquisite draughtsmanship. Lowry was never a draughtsman in this sense, but there is no question that his considerable and utterly different descriptive powers sprang from his long years of slogging it out with pencil and paper in the antique and life rooms of the Manchester College of Art. There are a number of drawings from this period in the present volume. The ruggedness of Lowry's drawing in some of these early studies recalls, I think, something of the earthy toughness of the Barbizon School – especially J.-F. Millet – and perhaps even the peasants of Van Gogh. The admirably clumsy (though never hamfisted) chopping of figures and faces into rude areas of light and shade enabled him to convey form in the simplest manner, by setting light against dark.

Lowry scarcely ever used middle or half-tones. In later years his figures, whether in his drawings or his paintings, are frequently no more than silhouettes. The nuances of posture, attitude, or movement are suggested in the most simple and telling terms. Lowry's figures are either almost solidly black or, in his drawings, smudged with an overall coating of grey. Either way they are really dark silhouettes against a light background, or occasionally light silhouettes emerging out of a dark background.

All of this derives from the acute simplifications of his early drawings, and indeed from the style, manner, and conception of his attitude to drawing in general. In his paintings too he uses flat areas of colour – blue, brown, black, red, ochre – with lines drawn with the brush, as in his drawings, to denote the hang of a garment, the hem of a coat, the line of the arm, or the folds of a dress.

The simplification of form in his early drawings led inevitably to a way of depicting the human figure which by its very simplicity was to prove more telling than any literal interpretation. The artist conveys his meaning by moulding the silhouette shapes of his figures as though he were bending pipe cleaners. (This process has led certain insensitive critics to talk of Lowry's 'matchstick men' – a term which he himself loathed.) The silhouette is moulded and bent with enormous skill. The merest bend of a limb or tilt of a head is always in itself a powerful and potent part of Lowry's visual speech pattern. He never needed to show detail in his later work: his symbols with their clean-cut, one-tone shape were always articulate enough.

Of his stylized figures Lowry himself wrote: 'They are symbols of my mood, they are myself. Natural figures would have broken the spell of my vision, so I made them half unreal; had I drawn them as they are it would not have looked like a vision.' The misinterpretation of this sophisticated simplification has led the shallow-minded (critics among them) to see Lowry as some kind of half-baked northern primitive. He is, of course, nothing of the kind. His very simplicity is the measure of his complexity. One can see how vital were the formative years of his art school training. One cannot simplify a subject without understanding its totality. Art is about editing, and about the stylistic inventions which only come via the processes of editing. This evolutionary editing Lowry was already carrying out in the many line drawings of the human figure which he made during the years 1914–18. The contours are searching in the extreme, and sometimes as subtle and descriptive as those of any master. But they place him too closely in the great academic tradition, and had he progressed along these lines he would certainly have ended as a second-rate academic painter rather than as a first-rate individualist who in the end realized that the niceties of the impersonally formal had to be renounced for the sake of the far more telling qualities of the personally informal.

The academic manner finally gave way to an originality of vision which places Lowry alongside Stanley Spencer. Spencer may have possessed a greater technical dexterity than Lowry, but together they are superbly representative of the English eccentric vision. Both artists waived academic refinements – Spencer to create a unique view of man's spiritual striving, and Lowry, by way of complete contrast, to establish his vision of man as a comical ant scuttling about the world. Together they offer complementary views of modern man: the soul and the body. Lowry was not concerned with the soul; Spencer was. It is interesting to compare the way in which Spencer distorted his drawing (and he could draw with great academic skill) with Lowry's eventual silhouetting of the human figure. Spencer stuck mainly to the

'round' and unlike Lowry made frequent use of the half-tone, but both used distortion to heighten and intensify the significance of the message they wished to communicate. They are, perhaps, the two most important eccentric Expressionists produced by England in the first half of the twentieth century.

Expressionism is, of course, primarily a European movement, with origins in modern German art. But the schools of painting originating in Europe in the early part of the present century – Impressionism no less than Expressionism – tended to produce groups of artists all working in more or less the same way. When we come to the English version of Expressionism, however, we find that our own brand of eccentric individualism strongly asserts itself, so that whereas the early paintings of the French Impressionists look very much alike and it may be difficult to tell whether a Cubist painting of 1908 was painted by Picasso or Braque, it is quite easy to distinguish between Spencer and Lowry. The English have always had this genius for producing eccentrics, whether in literature, politics, or art, and Spencer and Lowry descend naturally from Blake, Fuseli, Dadd, and John Martin.

The technique of simplification was also followed by Lowry in his treatment of landscape. At the time of his best line drawings from the life, he was also drawing the countryside around Lytham and the Fylde in Lancashire, where he had often spent childhood holidays with his parents. Here too one can study the opposition of unbroken darks set against light. In some of these drawings, sometimes made in pencil and white chalk on tinted paper, whole areas are smudged with a finger into a single grey mass. This technique can be studied in the Peel Park sketches of around 1919. Areas of flat tone are either achieved by flat pencil scribbling or put in with the tip of a finger or the ball of the thumb. 'Your thumb is one of the best tools you've got, you know,' Lowry once told me; 'you can do a lot more with it than you can with any brush!' Lowry sometimes carried this technique into his painting, smudging and smearing his oil colours with the ball of his thumb. 'If you want a bold, strong effect,' he said, 'attack your colours with your thumb. If you want delicate effects use the tip of your little finger.' The need to make actual physical contact through the hand with the shaping of a drawing or painting was in his case almost a sculptural identification with the subject. He moved into the very soul of his images by this close process of *loving* (for only such can I call the pure sensuous joy that he got from this aspect of his creativity). In later years I often saw him suddenly throw down his pencil or brush to 'jump in', so to speak, using his fingers and thumb as a sculptor might.

In the series of twelve drawings that he made as illustrations for H. W. Timperley's *A Cotswold Book* (Cape, London, 1931), Lowry followed the same technique of drawings he used rather more half-tones than usual, and the overall effect is one of a velvety richness comparable in its opacity with oil paint. No painting could offer a richer appearance than some of the Cotswold drawings or one of his key masterpieces, the marvellous *View from the Window of the Royal Technical College, Salford* (Plate 68). The reader has only to look at the illustrations that follow to find many

drawings that possess a distinct physical body, a textural character as full and ripe as the body of an oil painting.

Although, as I said at the beginning, drawing was always an end in itself for Lowry, the present volume contains several examples of drawings from which the artist was later to make paintings. Even so, these works exist in their own right, and the subsequent paintings represent not the development of an inconclusive stage of thought or vision but rather a stage of experience which reveals something else – an awareness or an aspect of the subject which could only be revealed in oil colour. Pencil therefore represented one totality, and painting another. Here is the proof that the truth with which the artist is concerned has more than one face and can exist on a number of levels. The subjects that an artist draws or paints have no permanent aspect. They are continually changing. Furthermore, a subject reveals a different reality to the pencil than it does to the brush. Lowry may have made a drawing of St. Simon's Church (Plate 98) and have followed this later with a painting of the same subject (Plate 96, *The Paintings of L. S. Lowry*; see Select Bibliography), but only a bad artist would have tried to make the painting a more complete extension of the 'working drawing'. We are faced here with pictures of equal strength, and in no sense can one say that the drawing is a working note for the painting. In fact, by enlarging the areas of building to left and right of the oil painting the artist has diminished the elegance and grace which mark the drawing, so that the painting has a clumsiness which is quite absent from the pencil study. But this is not to say that one view is more truthful than the other. They merely stress the variability of aesthetic truth.

One of the most important qualities which the work of a great artist possesses – and Lowry was a great artist – is the power to send you along tracks of thought and experience which reveal themselves with surprising suddenness. Art, like life, is an experience of continuous revelation. A drawing or a painting by a master possesses an endless range of possibilities. Form, rhythm, nuances of light and shade, human interest, satire, tenderness, metaphysics – where does one stop? Clearly anywhere and nowhere, and no artist can make one think more in this wide-ranging fashion than Lowry. His drawings in particular seem to crystallize with their crisp lines and broad areas of light and shade the very essence of life, offering a sense of continuous move-ment and change. We do not just *look* at his drawings or his paintings as mere spec-tators: we actually live them out as a real experience.

After being struck by the elegance which I discovered in the pencil drawing of St. Simon's Church, I looked back to the artist's drawing of the band stand in Peel Park, Salford (Plate 66), made in 1924. Here too was an elegance, a grace, a fragility, a delicacy of touch and conception, a deftness of style, which seemed uncharacteristic of Lowry and more typical of Whistler. Whistler was, of course, always an elegant painter, whereas Lowry, as I have suggested, does possess some of the peasant flavour of Millet, Van Gogh, or Brueghel. Nevertheless, if one compares Lowry's *Band Stand* with, for example, Whistler's lithograph *The Steps Luxemburg*, made in 1893, the

similarities are obvious and somewhat startling. The execution of the trees, and the stylistic character, are very similar. Lowry is like Whistler in many instances where the figure and its setting are rendered with a touch that suggests more the brush of a butterfly's wing than the scratch of a pencil. In most other respects the two artists were very different, of course, but in spirit, and at selected moments, they are remarkably alike. Both were capable of a nervous, breath-takingly sensitive response to phenomena; to nature and to people. Both found they could best express these feelings – these often profoundly tender responses – better in black and white than in colour. (Lowry's early landscape drawings, especially the Cotswold series, are typical of this form of communication.) Whistler was perhaps more concerned with people, though in his lithographs he can distil with the most fragile and delicate touches the *sensation* of buildings, alleys, lanes, trees, and water. Add to this the mystery of atmosphere with which Whistler can invest a river or sky, or Lowry a patch of industrial haze, and the comparison is rewarding. Often it is not possible to see the totality of an artist's achievement, except through similarities with the work of another, in the main, quite different kind of artist. It is like the sudden revelation of the meaning of mirror writing.

Earlier I pointed out that aesthetic truth has many faces. Lowry, it seems to me, reached a conclusion, an end, a finished interpretation or view of a subject, *only* in his painting. And for all the magnificence of his achievement in a painting like *Daisy Nook* or *The Cripples*, the very fact that he has reached an answer is in itself a limitation. There are, of course, no answers, whether we are thinking about art, philosophy, or the meaning of art itself. Painting does tend to have a sense of the definitive, whereas drawing is a more fleeting and transient experience. Lowry's drawings, as distinct from his paintings, always suggest that he could have taken another step – modifying, extending, developing, editing, changing his view continually. He was never trapped by the final statement and always in his drawing shifted the emphasis of what he saw and what he wanted to say. Indeed, one can say that Lowry's drawings are activated by the very nature of their inconclusiveness. This applies even to the early life drawings. Only in the obviously static subjects, such as those from the antique, do we feel a sense of things having come to a full stop; of the truth frozen, locked within a continuum of experience which interests the artist only in so far as it offers the opportunity of exercising technique. Lowry continued to draw until the end of his life; partly because it was easier for an old man to use pencil and paper rather than the more complicated paraphernalia of painting – but also because drawing was for him a form of breathing. Indeed, some of his late drawings, in their flashing sketchiness, are as light and fleeting as breathing itself.

If we compare the beach scenes of 1945 (Plates 131 and 132) we see that the relationship of the figures is as arbitrary and infinite in potential as the organization of any group of objects. You must surely have played around with tableware on occasion – pushing the knives, forks, spoons, salt, pepper, ashtrays, and whatever

around, trying to relate them in the best possible way to the background of the table-top itself, to find an ideal solution. There is, of course, no more possibility of a final solution of this problem than Lowry would have found had he done fifty thousand drawings of this same beach scene. We see how, with the merest stab or bend, thrust, or removal of a section of line, the artist can convey exactly that delicate nuance of meaning which tells the whole story of the personalities involved. Age, and youth, movement and repose are all captured with the utmost economy.

One of the most interesting factors to emerge from these 1945 beach scenes is the autobiographical note. Lowry himself often appears discreetly in his own work, and frequently in his drawings. He is, he once confirmed to me, the tall man with the walking-stick (he was in fact over six feet tall). Here you can look for his tall, gangling, hatted figure, either standing still or moving through the picture. Invariably he is apart from the crowd – watching, observing, but never really taking part in the activities. In the foreground of Plate 131 he strolls masterfully across the bottom of the sheet, his head turned to observe the activity to his left, his hat pulled well down onto his head, his stick moving powerfully forward. Here his participation is positive. In other drawings, such as the curious *Visit to Burton-upon-Trent* (Plate 206), he stands reflectively considering, pondering, a tall, somewhat clumsy personage. He once told me that he made this drawing after a visit to Burton on which he had found himself strolling through a narrow passageway that led, as he said, 'Nowhere!'

Lowry was a deeply reflective man, and although he viewed the human situation with great humour, he always leaned towards black comedy. Children in particular come in for pretty sharp, sometimes even cruel, treatment in his work. They are frequently portrayed as idiotic, daft, or demonic (as in the drawings he made of children squabbling and fighting). They drag impossible dogs through the streets, push their tiny, raging brothers or sisters in absurd carts, or tear by on home-made vehicles. They stand at level-crossings waving Union Jacks as the trains trundle across. Despite his portrayal of them, in real life Lowry was very fond of children and would cheerfully make drawings for their amusement.

A constant theme in Lowry's work is the insignificance of man in his setting, which he stresses by placing him against majestic buildings which dwarf his absurd smallness. The scuttling of his people, their stoppings and startings, are always brilliantly crystallized in Lowry's drawings – the momentary illusion of a position in space and time, before they disappear leaving only the buildings standing erect and proud. Buildings are not crippled by nature; man is. The very existence of churches and chapels, factories and great houses, is symbolic of man's striving towards a permanence and stability which is beyond his attainment. Except in architecture and the arts, man must inevitably fail. He is flawed, ugly, silly, daft, and only very seldom beautiful or graceful.

To consider Lowry's drawings in a slightly different light, it seems to me that they are as profound in their implications as the novels of Dickens or Balzac. Indeed,

I think one can see him as a pictorial novelist. He is not a poet, except in the occasional lyricism of some of his more tender landscapes, or perhaps those exquisite, melting boat scenes that stem from the Lytham St. Annes period. As a novelist-painter Lowry has a great deal to say about man, as an individual and in relation to his fellows and to his environment. We are left to wonder after looking at his drawings whether in fact heredity, or environment, or society, plays a greater part in determining the eventual shape – and I mean the physical shape and character – of man. Heredity does of course play its part. Physical traits, health, fitness, and a variety of genetic elements determine to some extent man's appearance and general character. Lowry would have observed these in passing. Look again at *The Idiot Boy* (facing the beginning of the Introduction), or at some of the crippled or deformed characters who appear in his work. But Lowry also gives a very good idea of the extent to which environment plays its part in the general shaping of man's appearance and character. Many of Lowry's people are bowed and twisted by the rigours of mill life. Poverty can create its own kind of deformity, and one must always remember that Lowry's main view of the human situation stems from the twenties and the Depression period.

Students of Lowry will soon realize that in the main his people and their clothing, habits, and settings are firmly rooted in the lean years somewhere between 1925 and 1935. All his later work is based upon this view, this vision, of working-class man – and working-class man of the poor and desperate years. Lowry possessed no social conscience about the plight of man in this setting. The mistake has often been made of thinking that he was *concerned* about his fellow men at this time, but I am afraid this view is quite unjustified. As Lowry often told me, he very seldom felt sorrow or pity for the people he drew, but saw them only as interesting, ridiculous, or, occasionally, attractive objects. There is, however, an acute period feel about his drawings of people shuffling around the working-class areas of Manchester and Salford. I asked him once why even his late drawings and paintings so often look as though they had been done in the twenties. 'Because,' he said, 'I was happiest then, and because I like the look of ill-fitting clothes, big bowlers, and clumsy bodies. They are comical.'

Lowry's father died in 1932, leaving him alone with his mother, who died in 1939 when he was in his fifty-second year and still unknown. (It was not until that year that the artist had his first exhibition at the Lefevre Gallery.) There is, I believe, a deep psychological reason for Lowry's obsession with the working-class ethos of the Depression years. It was not only the appearance of life at that time that haunted his imagination in later years, but the fact that his mother had died before he achieved recognition. By identifying himself as closely as possible with the actual backdrop of life in the twenties and thirties, he was able to preserve as a kind of homage to his parents, and his mother in particular, that long, secure period in his life which was, paradoxically, a time of general poverty. In later years he sorrowed greatly that his mother, especially, had not lived to enjoy with him the very considerable success which followed his first exhibition. 'What is the good of it all?' he often asked when

I congratulated him on some honour or success in later years. 'What's the good of it all, sir – my mother never lived to see it.' And so he became the 'author' of a great social 'novel' in which he set out the mores of his family years, preserving for ever like flies in amber a working class content with their lot, comical, tragic, but not yet debauched by the dissent and self-indulgence of modern trade unionism. It may surprise some readers to learn that certainly in his mature years Lowry was a fierce Conservative, ever more worried about the breakdown of social values and the disappearance of any discernible moral code. 'Where will it all end, sir?' he would ask. 'With a dictatorship, I shouldn't wonder!' (Time may yet prove him right.) He preserves the status quo of the twenties and thirties intact; for he was not interested in social reform and never believed with Tennyson that 'The old order changeth, yielding place to new, / And God fulfils himself in many ways, / Lest one good custom should corrupt the world.'

Lowry, as Michael Shepherd pointed out (*Sunday Telegraph*, 3 May 1976), was a 'portrayer of man's individuality and sense of community'. In his drawings he showed the inevitability of man's destiny; his comicality, his weirdness, and above all his calm, unruffled acceptance of the endless panoramas of life passing from one generation to the next with unrelenting imperfection. (Lowry was too good an artist to look for perfection; all such nonsense can be left to bad artists like Annigoni.) 'You had better accept the universe' is the essence of the cool philosophy of Lowry's art. No idealism. Accept the cripples, the ugliness, the poverty – but most of all the vein of humour which is always there. The laughing cripple is the strongest link in the human chain. This Lowry knew; it is one of the key parables of his art.

Critics or biographers seldom discuss an artist's attitude to money. Naturally the prices commanded by his work are often referred to, but not how he personally feels about such sums: about sale room prices, about gallery commissions and all the economic complexities which enmesh the artist. In such matters most British artists are simpletons. They are only too happy to hand over their financial destinies to the dealers and more or less take what they are given. Unlike his French counterpart, the British artist seems to be born with the idea that an artist should be grateful for any financial crumb. Lowry's attitude to the economics of his art was always very mixed. When he remarked that he could never understand why a drawing did not command an equivalent price to that of a painting, he was already indicating that he was at least concerned about the scale of values placed upon works of art. In later years when pictures that he had sold years before for small sums of money turned up in the sale rooms and changed hands for thousands of pounds, he showed considerable hostility to an appreciation in value that gave *him* nothing. 'When I think that I sold that picture in 1942 for £50 and that it made £8,000 at Sotheby's last week, it makes me sick,' he would say. 'All I got out of it was about £20. The frame cost £5; the materials, the time it took to paint, the tax I paid, the cost of getting it around exhibitions, took about another £30; so what did I get out of it all, sir? *A damned useless £15.*' This

attitude is characteristically eccentric. While he was always conscious of his drawings and paintings in terms of money, Lowry made no allowances for the fact that the few pounds he had gladly accepted for a picture in the thirties was in fact all that anyone would have given for that particular picture at that time when he was still an unknown artist. Nevertheless, he would have wished years later, notwithstanding the growth of his reputation and the whole process of inflation, that that same picture should have changed hands at *exactly* the same price it had originally commanded. He just did not like anyone making any money out of his work. He did not like the idea that people bought him as an investment or as a hedge against inflation. He knew, of course, that galleries had to charge a considerable commission on sales to cover their overheads, but it was still something that he deeply resented. I can imagine what he would have had to say if he had known that within a few months of his death an early landscape drawing would fetch as much as £1,000 at a Sotheby's sale. (Since his drawings are now fetching proportionately more than his paintings, however, at least his judgement about the value of drawings would have been vindicated.) At the same time Lowry was an extremely generous man. On visits to his friends he would often sit down after a meal or cup of tea and make drawings for the family, the children especially. 'Fun' drawings, but drawings from his hand nonetheless. Drawings that always gave some valuable, even vital, clue to his thought processes. An example of this type of drawing is the strip cartoon (Plate 140) which was made for the children of the late Leo Solomon, principal of the Rochdale College of Art and one of Lowry's closest friends. Another is a fragment of drawing (Plate 279) made in my presence in about sixty seconds flat.

Although he has been dead only a few months, it is not too soon to consider Lowry's international standing. He has yet to find his niche in the mainstream of Western art, but I have no doubt that he will do so. Though at first sight his vision seems distinctly regional in flavour, the implications of his art are international. Had he been French, Italian, or indeed any nationality but British, he would already have been far better known internationally – in both Europe and America – than he is at present. The natural insularity of the British, their general reserve, and their inability to promote their artistic genius, has kept artists like Lowry relatively unknown abroad. True, some British artists have achieved recognition beyond their home shores, but in the main British art remains very much a product for home consumption. Today Henry Moore and Francis Bacon are well known abroad because of the international flavour of their genius. The impersonal, archetypal forms of Moore are universal at a glance, the psycho-analytical connotations of Bacon equally so. Easter Island and Freud are universal common denominators. But English eccentrics like Stanley Spencer or L. S. Lowry are virtually unknown abroad simply because it is assumed, quite incorrectly, that the English eccentric is fundamentally a local or regional product. Nothing could be less true, and I remain convinced that once some work has been done to promote the vision of Lowry abroad, he will quickly acquire the status of a master who, for instance, supports and confirms the directions of American

Social Realism by his own vision of the British Depression years. He is, in this respect, our native extension of the American 'Ashcan School', whose representatives were themselves so often concerned with subjects of comparative poverty and squalor. Thus Lowry fits neatly into the cosmopolitan scene. Time will prove him a major documenter of the mores of twentieth-century urban and industrial life.

Lowry left a huge body of work, and one can clearly trace his evolution over a period of some seventy years. These fall into three distinct areas, which can best be studied in his drawings.

The early years were concerned with the establishing of academic first principles: learning about anatomy and perspective, about form, about light and shade. It was upon these solid foundations that all the later edifices were constructed. Out of this soil the vision emerged and grew – took the shape and form that made it unmistakably that of L. S. Lowry and no one else. This period runs from the early art school years to the mid-twenties and the line drawings of that period. The antique and life classes were the basis of the apprentice years.

There followed, between the mid-twenties and the late fifties, the vintage years, in which was consolidated the academic training and out of which his vision was forged. From the late fifties until Lowry's death in 1976 there followed some twenty years of a glorious running-down of genius. In countless relaxed and informal drawings the artist brilliantly commented on many aspects of life and human behaviour, frequently using great humour to press home his ideas, observations, and messages.

Only in the last two or three years of his life does he finally withdraw from the world. In this last period his drawings express and reveal mainly personal issues (the late 'erotic' drawings, or those drawings bustling with figures which are primarily a disguise for the projection of some autobiographical note or idea). The furious figures flying along the Promenade in the extraordinary drawing of 1971 (Plate 275) are surely a parable of the passage of time. And time was passing then, for Lowry, passing quickly, carrying him headlong towards the rest he always craved in those last years of his life. 'I'm waiting for the big sleep,' he often said; 'the long sleep! I'm fed up with it all, sir! I've had enough!' And when I tried to discount all this gloomy talk he would look me in the eye and say, 'Well! – don't you think I've had enough? What more do you damn well want from me?'

But sometimes the vision was purely nostalgic, sentimental even. Not a common element in Lowry's philosophy of art – or of life. Yet, just now and then, gentle evocations of those long-ago summer holidays at Lytham would come flooding back; misty, gentle, tender. A little drawing of boats closes this volume, and a similar scene opens the Monochrome Plates. Between them lie some seventy-three years – a chasm of time that was filled with genius. *A la recherche du temps perdu* – time regained simply by joining two images.

All in all it was a thoroughly rounded life, absolutely complete. Lowry had

achieved everything an artist could have wished. His work was complete; his success was complete. Whatever the inadequacies, the unfulfilments, of his personal life, they do not matter. He was an artist, and as an artist he was complete. 'What more do you want from me?' What more, indeed?

MERVYN LEVY

London, 1976

SELECT BIBLIOGRAPHY

COLLIS, MAURICE. *The Discovery of L. S. Lowry.* Alex Reid & Lefevre Limited, London, 1951.

LEVY, MERVYN. *L. S. Lowry.* 'Painters of Today' series. Studio Books, London, 1961.
The Drawings of L. S. Lowry. Cory, Adams & Mackay, London, 1963, and Jupiter Books, London, 1973.
'Lowry and the Lonely Ones'. *Studio*, March 1963, London.
The Paintings of L. S. Lowry: Oils and Watercolours. Jupiter Books, London, 1975.
Selected Paintings of L. S. Lowry: Oils and Watercolours. Jupiter Books, London, 1976.
L. S. Lowry R.A. 1887–1976: Memorial Exhibition. Introduction and notes to the catalogue. Royal Academy of Arts, London, 1976.

MULLINS, EDWIN. *L. S. Lowry: Retrospective Exhibition.* Introduction to the catalogue. Tate Gallery, London, 1966.

THE COLOUR PLATES

There is frequent confusion about the precise dating of many Lowry drawings. Owing to the fact that a great number of these were neither signed nor dated at the time they were made, but only many years later as they passed to collectors, galleries (for exhibitions), or friends, the dates then added by the artist are often highly inaccurate.

The reader will observe therefore that here and there the date given by the author conflicts with that added at some later date by the artist. In all doubtful instances the dating of the drawings in this book, whether made by the writer or by such authorities as the City Art Gallery at Salford, is based upon stylistic considerations.

The same problem applies to certain titles which were also added long after the drawing was made, when it already possessed an adequate title or description. Still further confusion was caused by the churlish and reluctant signings and datings scribbled by the artist, literally on his doorstep, to get rid of the frequent and un-welcome possessors of unsigned drawings or sketches acquired somewhere or other.

I

GOING TO THE MILL

1917. Coloured crayons 45.7 × 54.6 cm. Private collection.

An early industrial scene, still hesitant in concept and execution, but·already portending the coming industrial 'explosion'. The vision of the industrial landscape is already beginning to exert its fascination on Lowry.

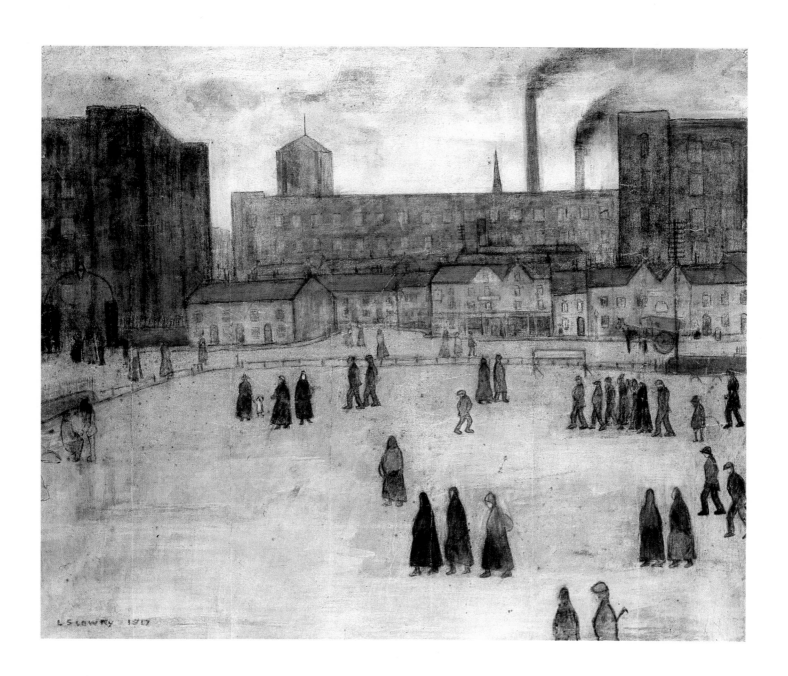

II

INDUSTRIAL SCENE

1926. Chalk on coloured paper 25.4 × 35.6 cm. Private collection.

Compare this study with the previous one. Here the industrial scene is moving towards its ultimate 'shape'. There is more movement. The vision sharpens.

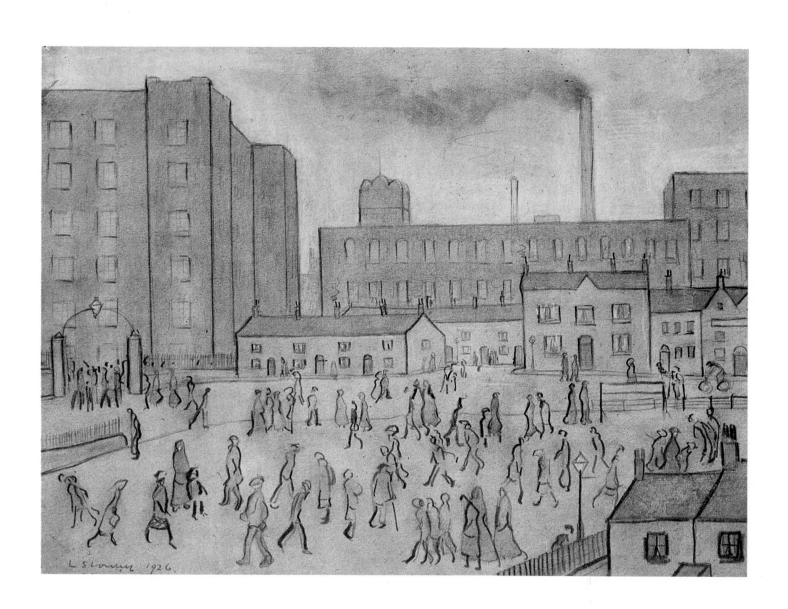

III

1947. Coloured crayons 26.7 × 36.8 cm. Private collection.

One of the artist's many 'composite' versions of a favourite subject: the yachts at Lytham St. Annes. He was always adept at treating similar subjects with considerable variation, particularly of style. In essence this is the same as all Lowry's other drawings and paintings of yachts; yet it is quite different in technical execution. A familiar subject is given a startlingly fresh aspect by the imaginative use of children's crayons.

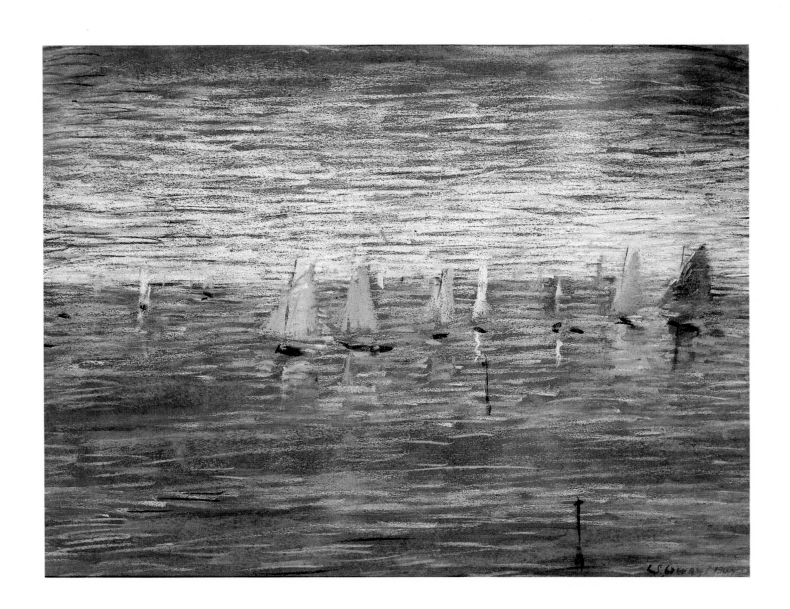

IV

WATH BROW CHURCH, CLEATOR MOOR

1948. *Coloured crayons 27.9 × 37.5 cm. Private collection.*

Lowry's brilliant use of crayon is well exemplified in this drawing. The formula for success is disarmingly simple. In the foreground the strokes are mainly horizontal, adding to the sense of breadth. In the drawing of the church and the sky, the crayon strokes are mainly vertical to intensify the feeling of height.

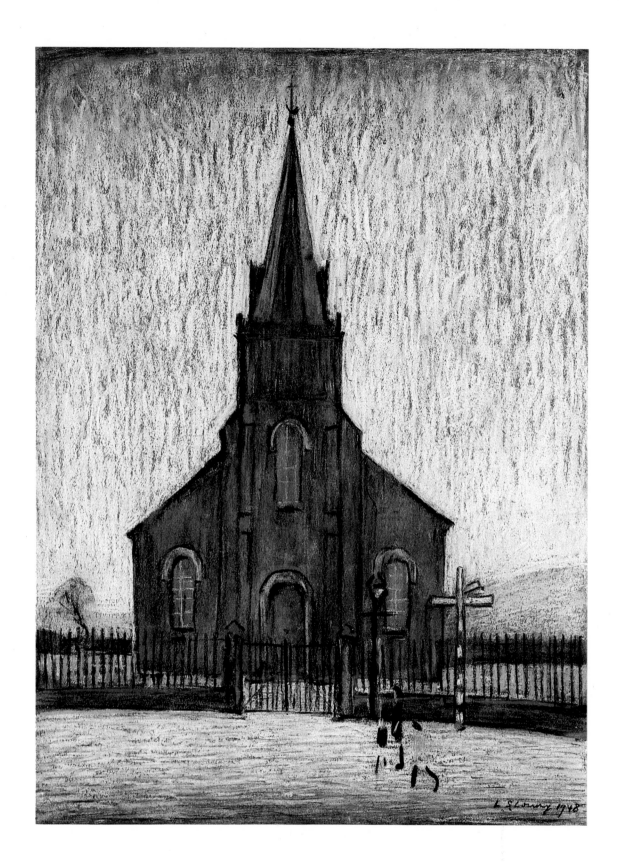

V

CHIP SHOP, CLEATOR MOOR

1950. *Coloured crayons 27.9 × 37.5 cm. Private collection.*

Lowry portrayed working-class society with deceptive simplicity and childlike-ness. Football matches and chip shops represented for him the crucial focusing points of a contemporary working-class 'culture' in moments of leisure and relaxation.

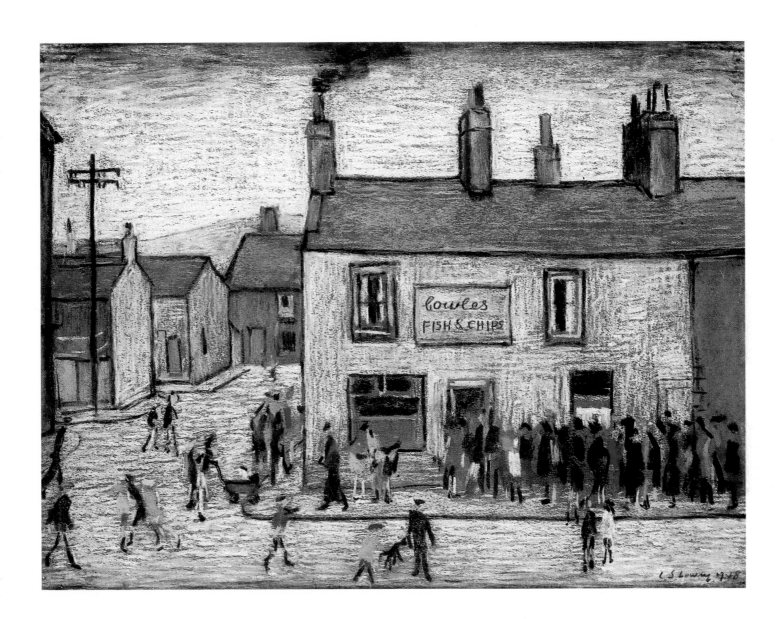

VI

MARKET SQUARE, CLEATOR MOOR

1950. *Coloured crayons 23.4 × 36.2 cm. Private collection.*

A simple subject, simply portrayed – open, spacious, and invested with a sense of deep calm. The slowly moving figures gangling across the foreground add to this feeling.

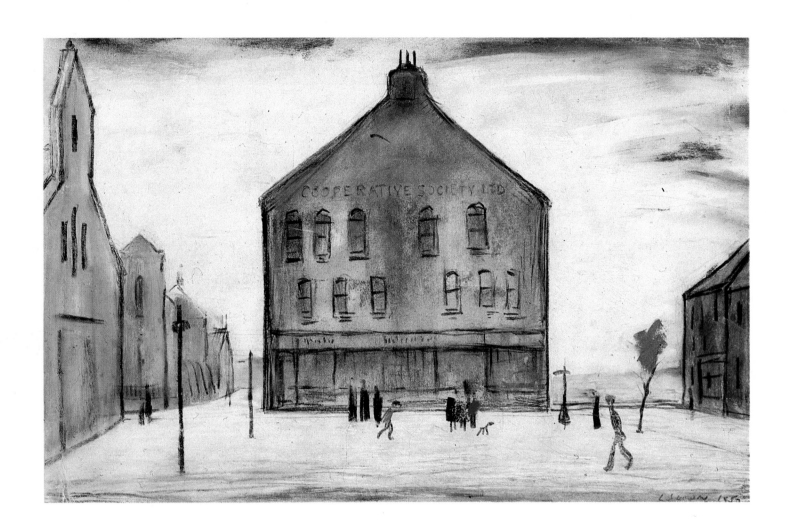

VII

THE SEA AT SEASCALE

1950. *Coloured crayons 26.7 × 36.8 cm. Private collection.*

One of the most marvellously 'infinite' of all Lowry's seascapes. The feeling of space is intensified by the handling of the medium: the water is rendered with minute, deft touches, the sky with a complementary breadth of style.

VIII

MILL SCENE WITH FIGURES

1951. *Coloured crayons 26.7 × 36.8 cm. Private collection.*

The freedom with which the artist used his crayons allowed him to portray a subject such as this, in colour, with all the spontaneity that one might expect from a freely rendered drawing in pencil or chalk. The colours flow easily from the tip of the crayon with none of the inhibiting problems of colour mixing and the attendant delay in expression which necessarily accompanies even the most freely painted pictures.

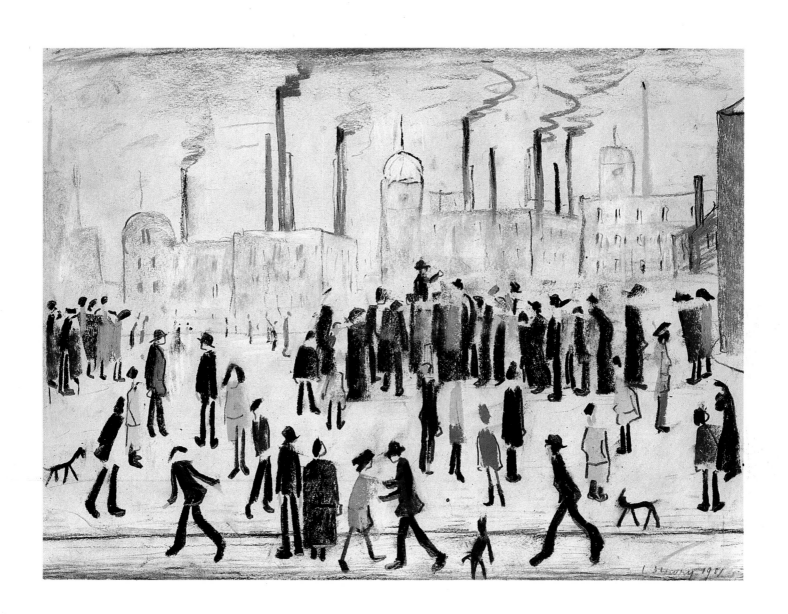

IX

INDUSTRIAL SCENE

1956. Coloured chalks 25.4 × 35.6 cm. Private collection.

A loosely drawn street scene. The mood is gently but pointedly satirical. The artist frequently concentrated his use of distortion upon the image of the dog. 'Man's best friend'? – these dogs are more like the hounds of hell. Invert the proposition and you have *man* in his true role. Lowry's symbolism was often complex and provocative.

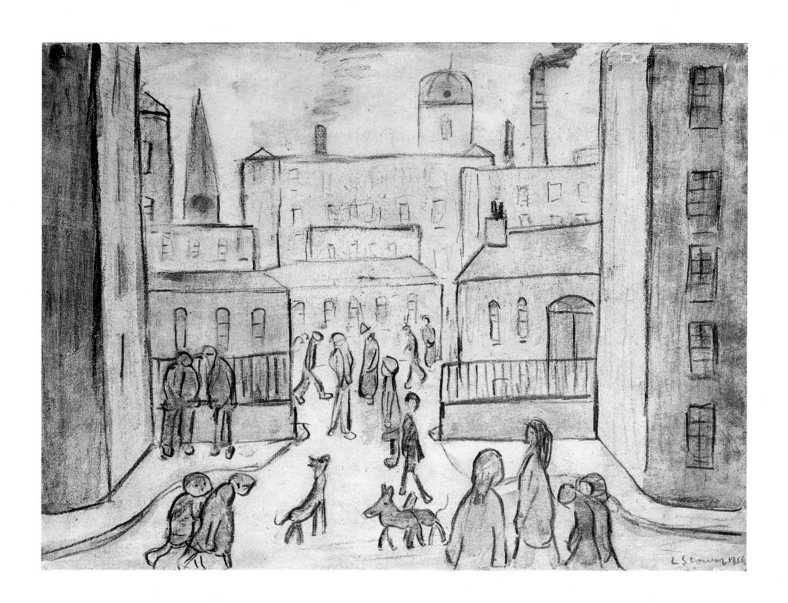

THE MONOCHROME PLATES

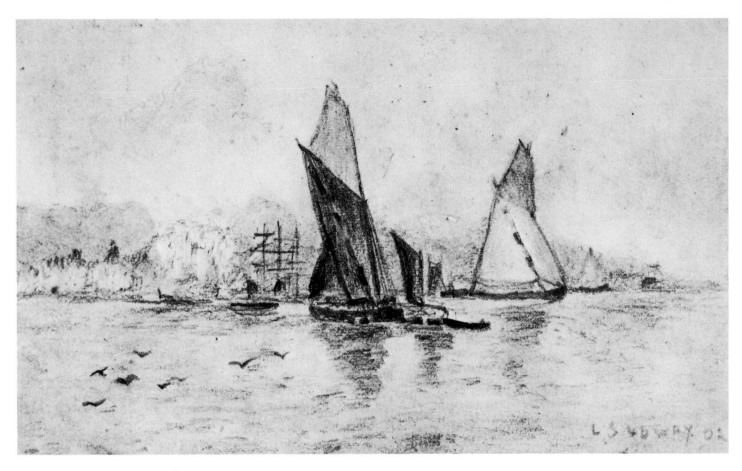

I

YACHTS

1902. *Pencil 6.8 × 11.3 cm. Collection: Mrs Ellen Solomon.*

The earliest surviving drawing by the artist. Done at Lytham St. Annes, where the Lowry family often spent their summer holidays.

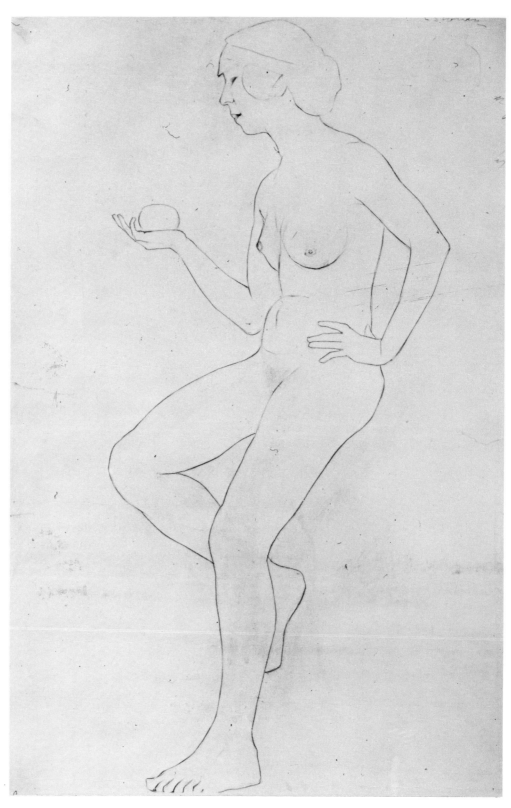

2

NUDE GIRL HOLDING APPLE

1906. Pencil 54 × 37 cm. Collection: City Art Gallery, Salford.

An early, tentative figure drawing using only the contours to suggest form. Compare this study with the next plate.

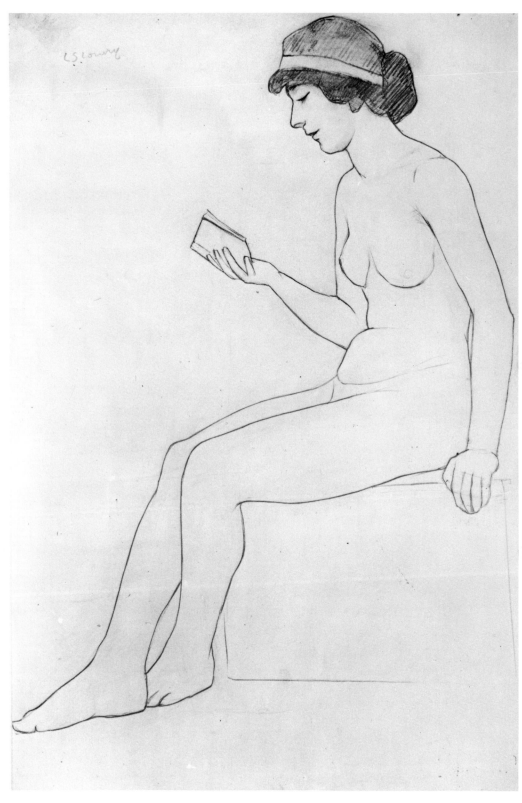

3

SEATED WOMAN WITH BOOK

c. 1906. *Pencil 54 × 36 cm. Collection: City Art Gallery, Salford.*

An early figure drawing made at the Manchester College of Art, which displays Lowry's ability to convey form solely through the contours of the figure. His understanding of anatomy is already considerable.

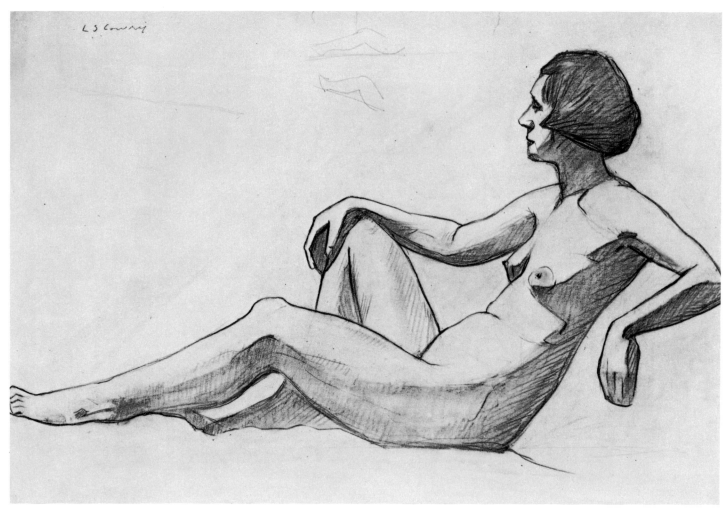

4

RECLINING NUDE

c. 1906. *Pencil* 35.5 × 53.5 *cm. Collection: City Art Gallery, Salford.*

An extension of the artist's contour style to incorporate broad masses of dark.

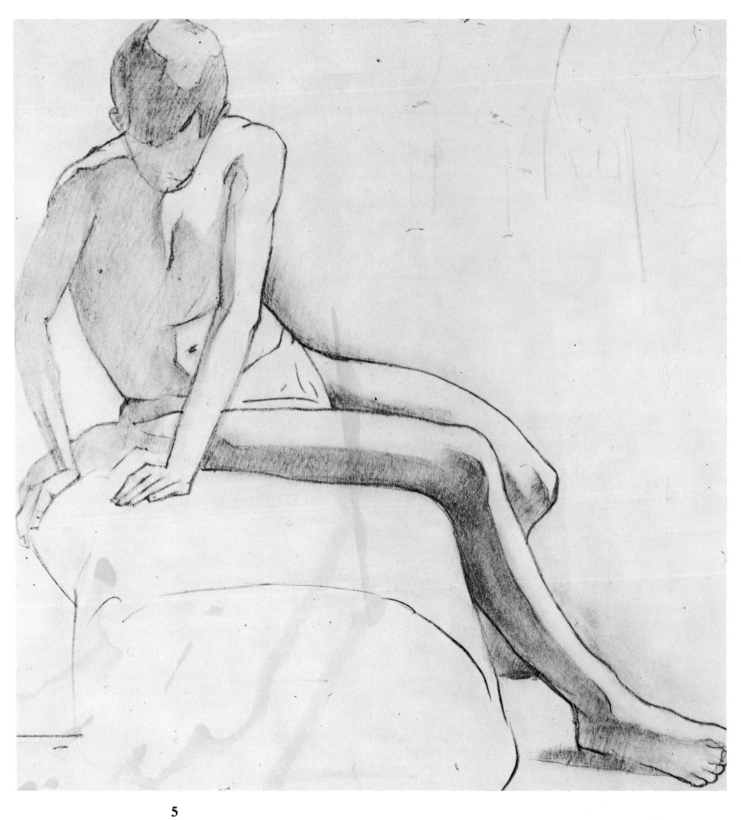

5

NUDE BOY

1906. *Pencil 37 × 35.5 cm. Collection: City Art Gallery, Salford.*

In this drawing the artist has intensified the areas of dark to create a more substantial sense of form.

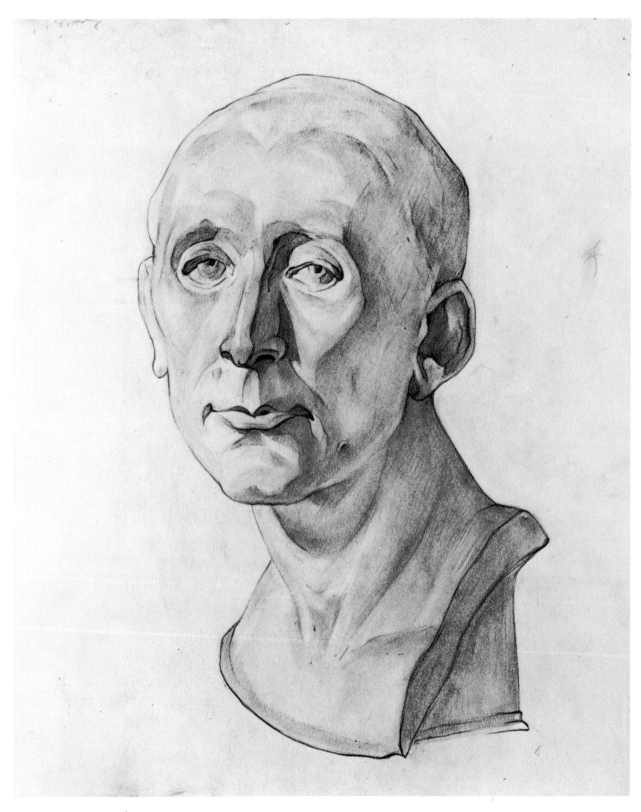

6

STUDY FROM THE ANTIQUE

c. 1907. Pencil 42 × 34 cm. Collection: City Art Gallery, Salford.

A drawing from the antique which explores the broad planes of the head.

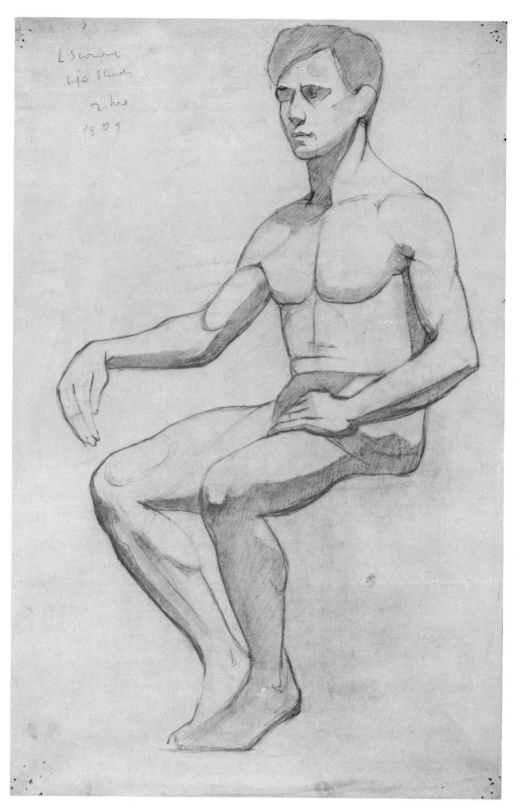

7

STUDY FROM THE LIFE

1907/9. Pencil 55.9 × 36.2 cm. Private collection.

A thoughtful exploration of the anatomical construction of the human form. It possesses the rough, earthy quality of a drawing by J.-F. Millet or Van Gogh.

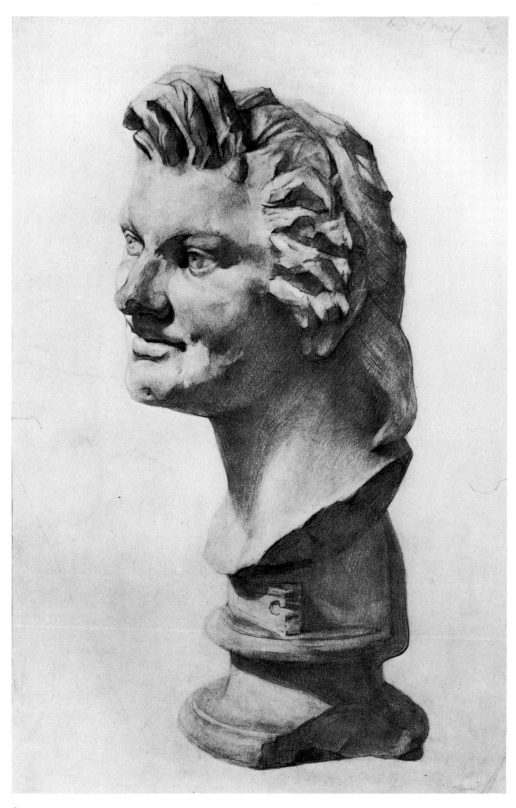

8

HEAD: FROM THE ANTIQUE

c. 1908. Pencil 42 × 34 cm. Collection: City Art Gallery, Salford.

A drawing which clearly demonstrates Lowry's ability to draw in a highly finished, academic manner. Here he has used the traditional 'stump' to help add smoothness and 'polish' to his pencil-work. Drawings of this highly detailed kind often took a long time to produce. As the artist has noted under his signature, this study took ten hours.

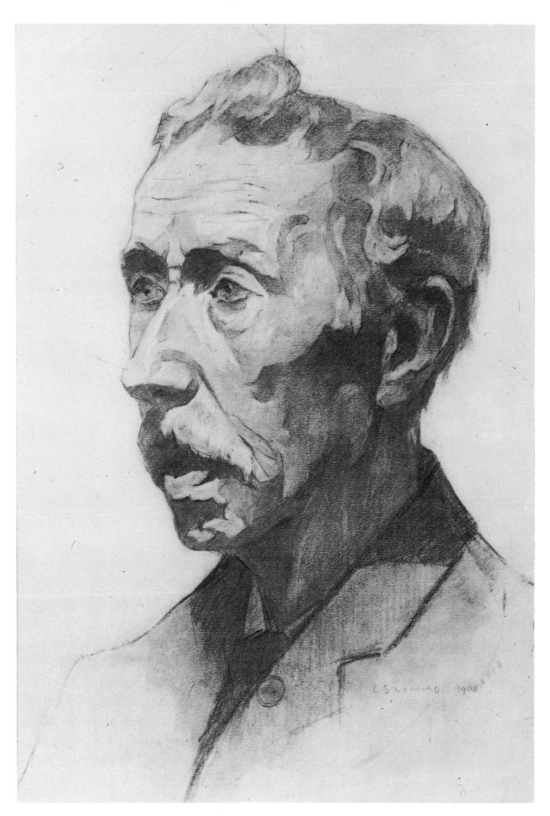

9

PORTRAIT OF A MAN

1908. *Pencil 41 × 28 cm. Collection: City Art Gallery, Salford.*

This was the artist's first portrait drawing from the life. The subject was a
model at the Manchester College of Art.

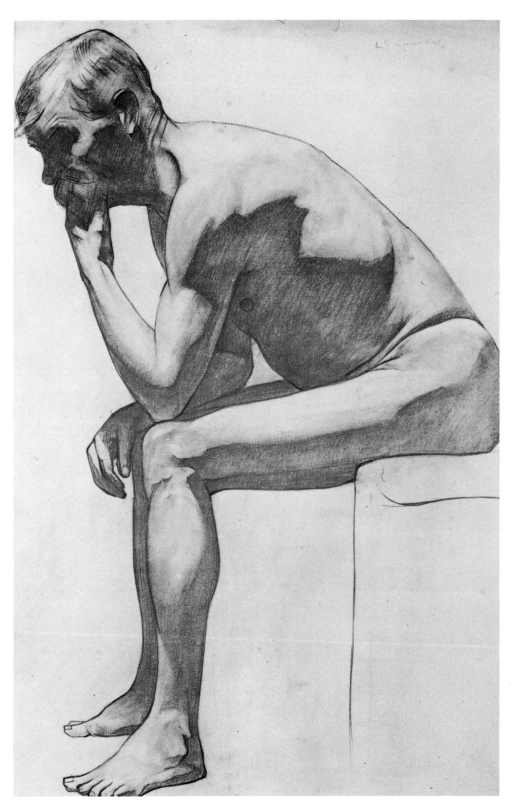

10

SEATED NUDE

c. 1908. Pencil 54.5 × 35.5 cm. Collection: City Art Gallery, Salford.

An example of the artist's ability to create a sense of volume, of weight, by breaking the figure into simple, powerful masses of light and dark.

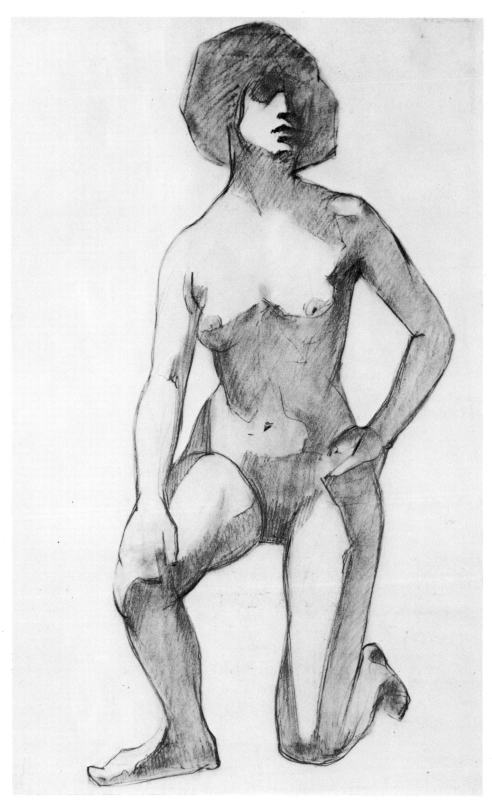

II

NUDE STUDY

1910. Pencil 53 × 35 cm. Private collection.

A typical evening life-class drawing, obviously done by electric light. It is broken into simple areas of light and dark, and shows how well Lowry could simplify the problems of figure drawing. He could reduce complexity to very simple statements.

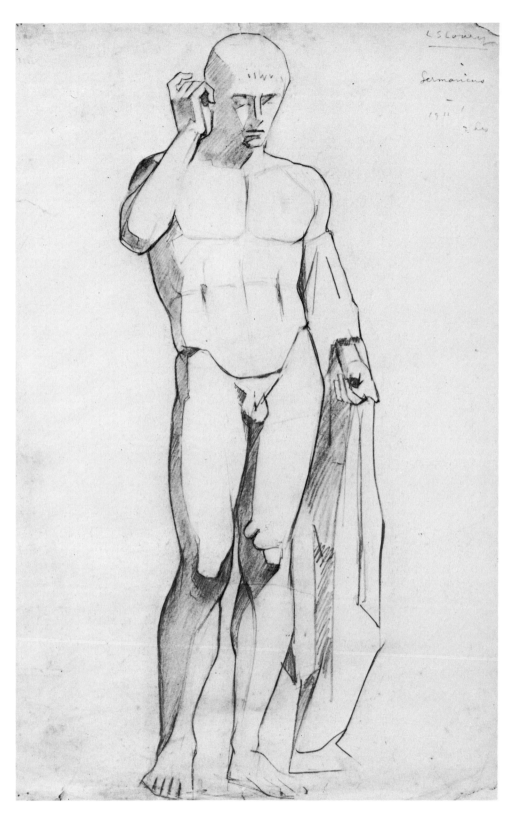

12

FROM THE ANTIQUE

1911. Pencil 55.9 × 36.2 cm. Private collection.

A searching but well-simplified study from the antique, in which the darks are kept to a minimum.

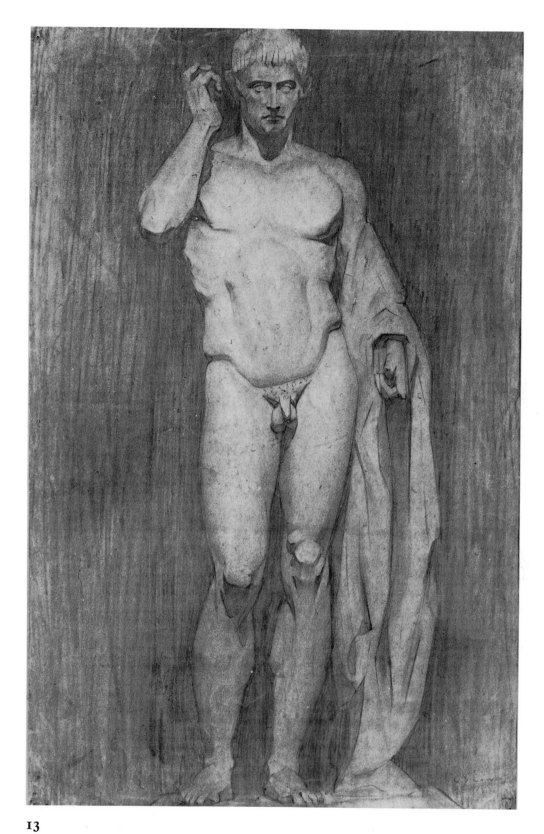

13

STUDY FROM THE ANTIQUE

c. 1911. *Pencil* 53 × 35.5 *cm. Collection: City Art Gallery, Salford.*

A development of the preceding study, but drawn from a different angle.

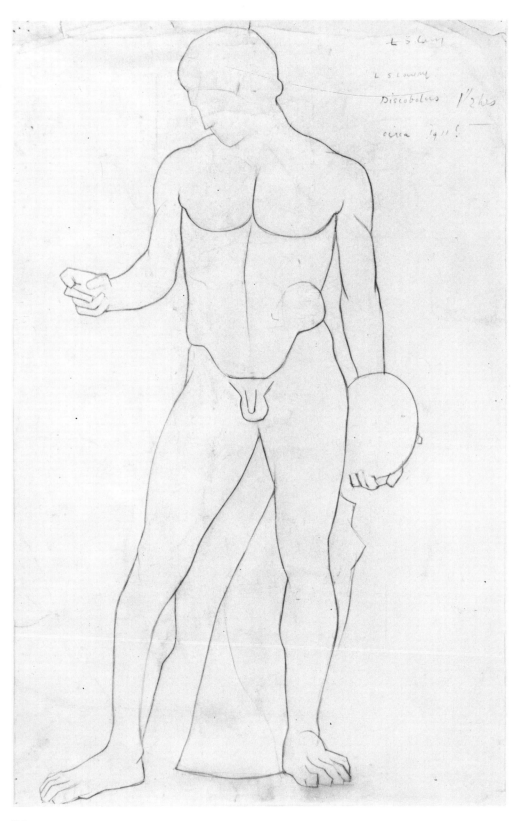

14

STUDY FROM THE ANTIQUE

c. 1911. *Pencil* 55.9 × 36.2 *cm. Private collection.*

A preliminary study from the antique, in which the artist has created a feeling of form by using only the contours of the figure. The drawing is inscribed by the artist: 'Discobolus 1½ Hours'.

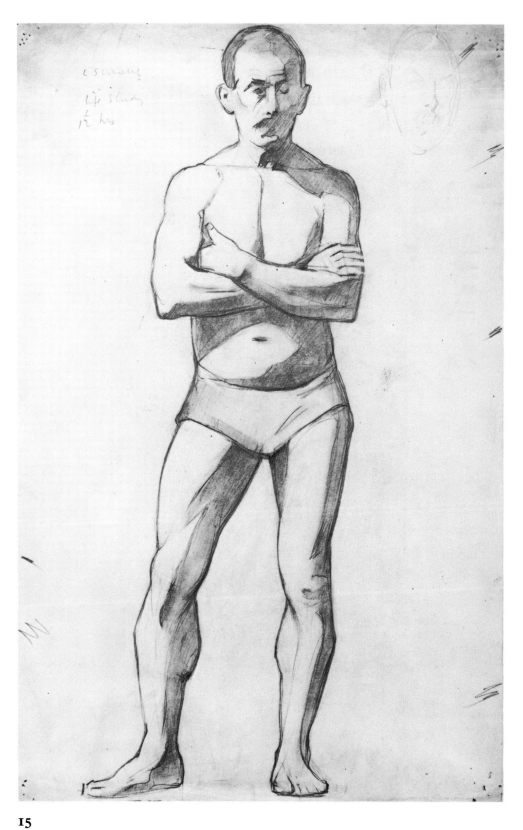

15

LIFE CLASS STUDY

1911. *Pencil 55.9 × 36.2 cm. Private collection.*

A well–anatomized study.

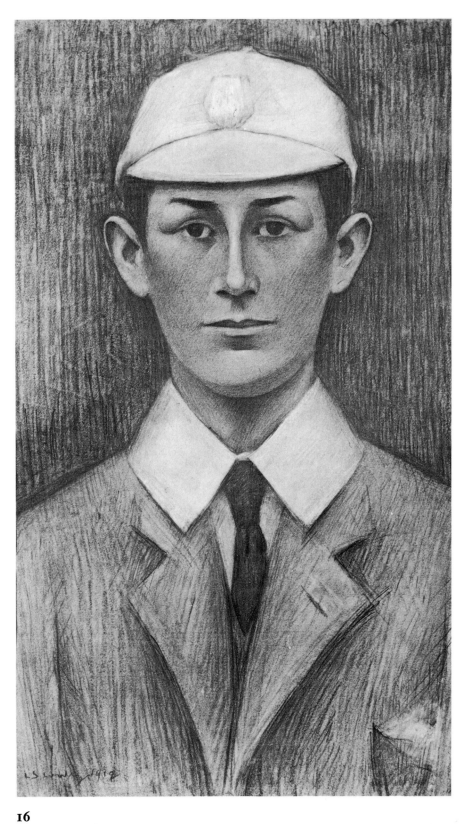

16

BOY IN A SCHOOL CAP

1912. *Pencil and white chalk on tinted paper 43 × 25.5 cm. Collection: City Art Gallery, Salford.*

This delightfully formal portrait is of a friend of the family.

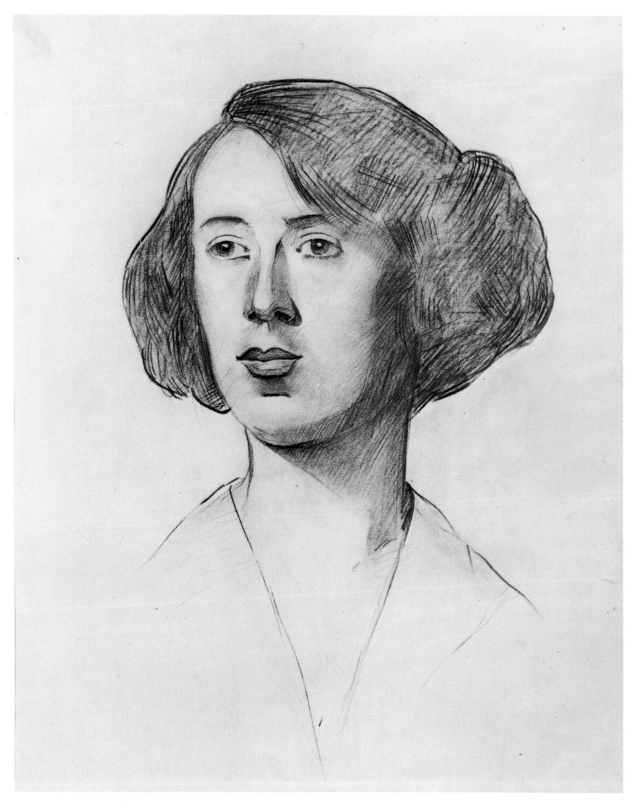

17

GIRL WITH BOUFFANT HAIR STYLE

c. 1912. Pencil 42 × 34 cm. Collection: City Art Gallery, Salford.

A strong, simple drawing in which the artist has built up his darks with a hatching of powerful pencil-strokes. There is great variety in Lowry's technical style.

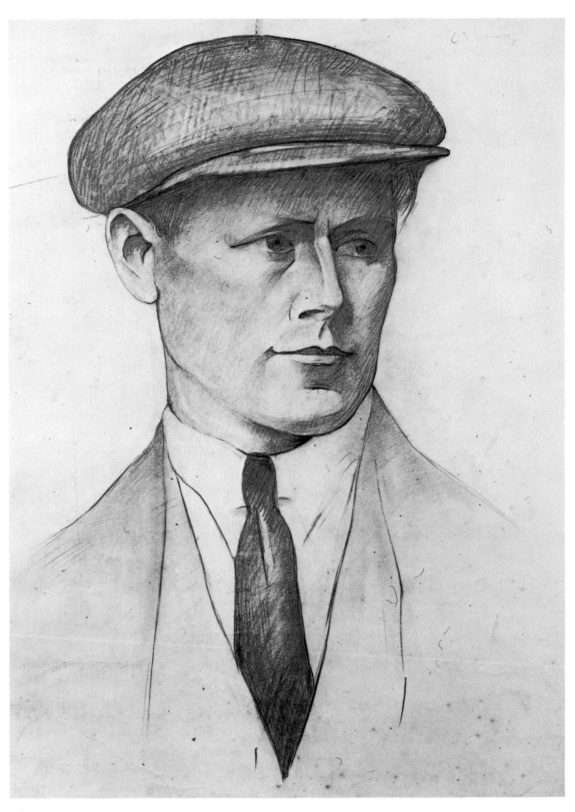

18

HEAD OF A YOUNG MAN IN A CAP

c. 1912. *Pencil 46 × 34 cm. Collection: City Art Gallery, Salford.*

An early appearance of Lowry's favourite head-gear. He himself always preferred to wear a cap, although in later years he often appeared in a battered trilby. But as he once said to the writer, 'You won't find a better shape than a cap, sir!'

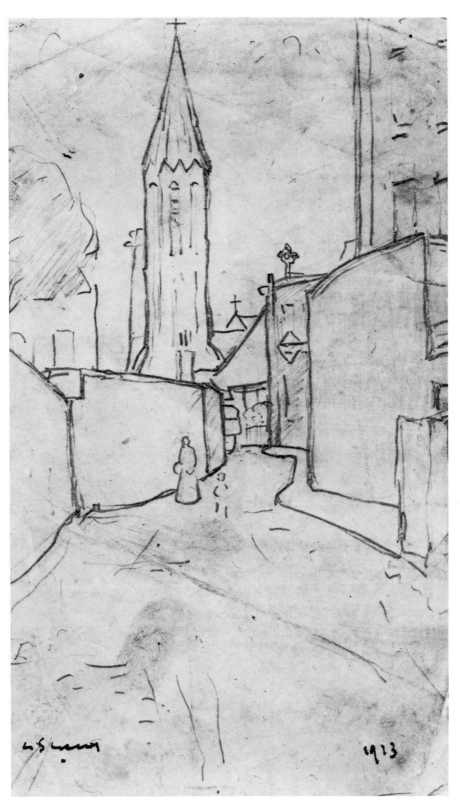

19

ST MARY'S CHURCH, SWINTON

1913. *Pencil 56 × 44 cm. Collection: City Art Gallery, Salford.*

An early street scene in which the artist is struggling to find a drawing style to match the requirements of the subject.

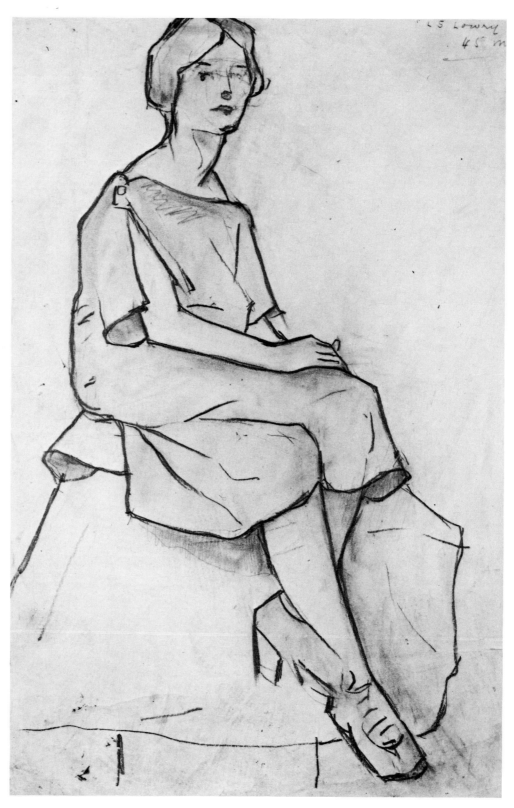

20

SEATED WOMAN

1914. Pencil 52 × 34 cm. Collection: City Art Gallery, Salford.

A powerful and simple use of the pencil. Lowry was always an experimenter, and the style of this drawing is clearly experimental. It differs greatly from his other studies of the period.

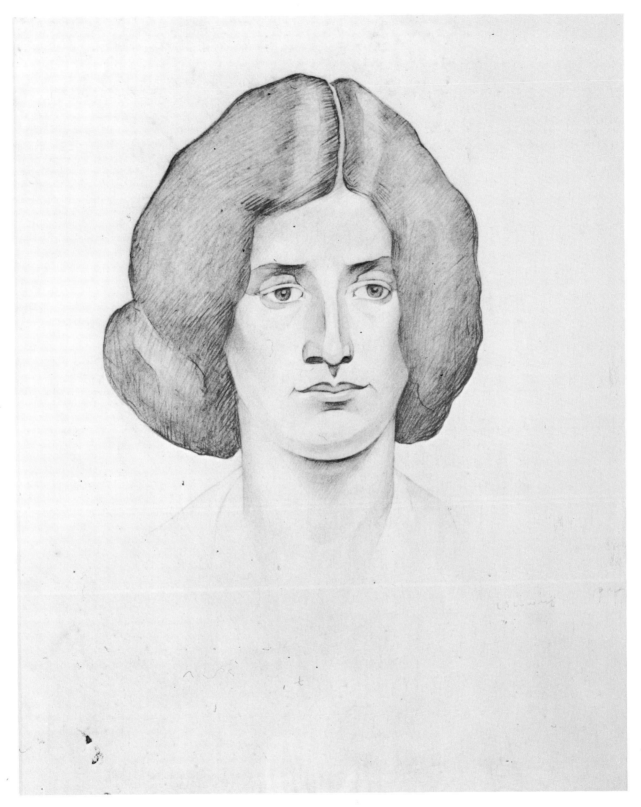

21

STUDY OF A WOMAN'S HEAD

1914. *Pencil 44.5 × 35.5 cm. Collection: City Art Gallery, Salford.*

Here the artist suggests the colour of the hair by an imaginative use of the pencil.

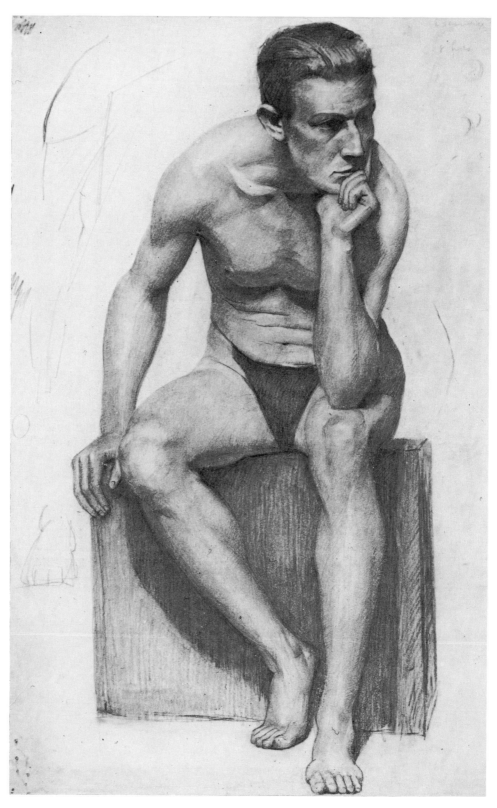

22

SEATED MALE NUDE

1914. Pencil 55 × 35.5 cm. Collection: City Art Gallery, Salford.

A highly finished example of the artist's drawing from the life. The whole area of the drawing has been covered with tone, and the lights picked out with a rubber. Once again the stump has been extensively employed.

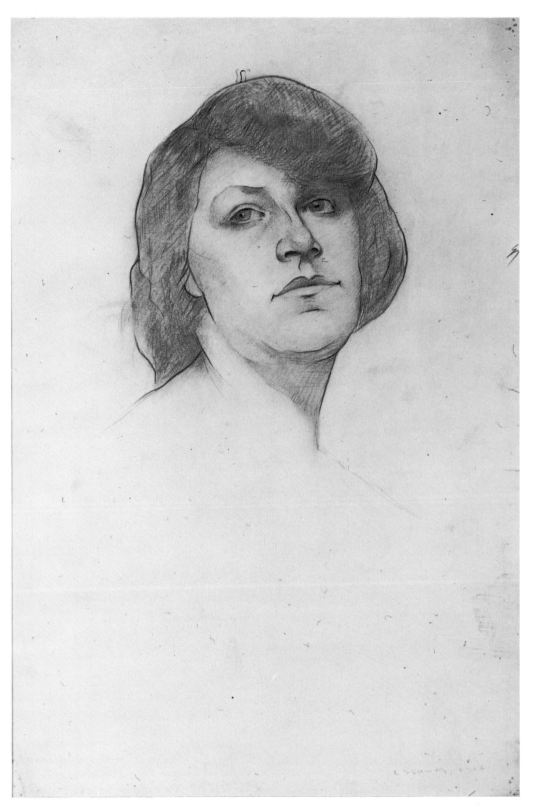

23

WOMAN'S HEAD

1916. Pencil 55.9 × 38.1 cm. Private collection.

This clearly shows the strength of Lowry's academic ability. The drawing possesses immense solidity, and is entirely devoid of the slickness that would have characterized a similar study by Augustus John. Both artists were more or less contemporary, but Lowry is always the better artist – both in vision and in technical style.

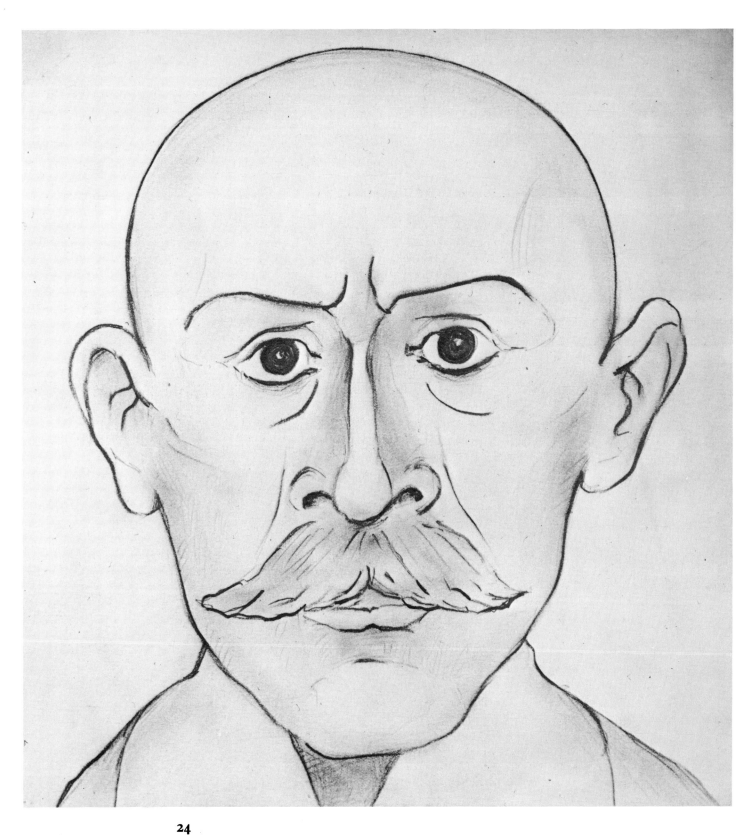

24

MAN'S HEAD

c. 1916. Pencil 20.9 × 20.3 cm. Private collection.

An imaginary head.

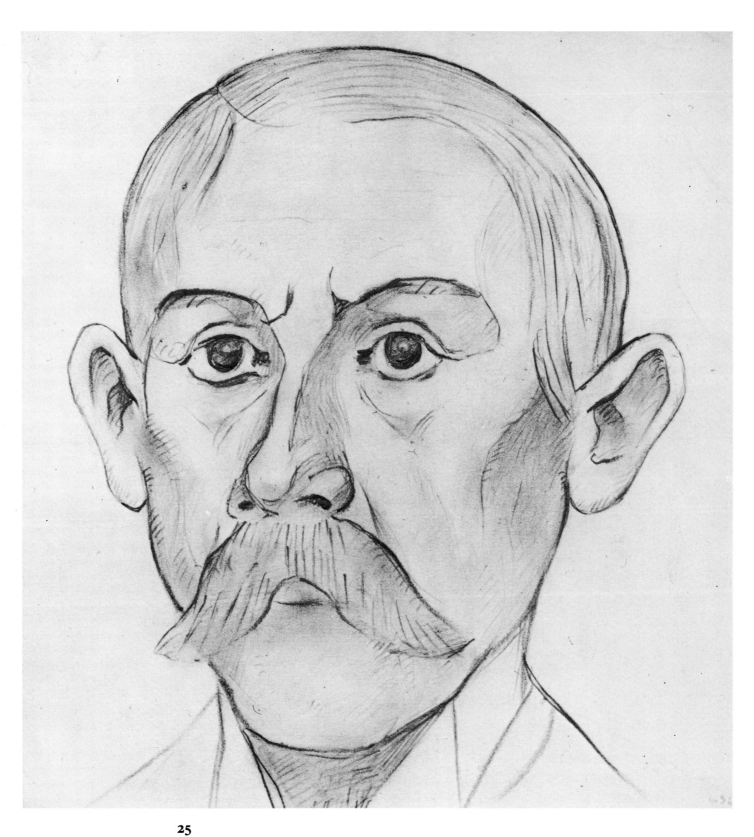

25

MAN'S HEAD

c. 1916. *Pencil 20.9 × 20.3 cm. Private collection.*

A development of the preceding drawing. Both studies explore the intensity of human vacuity.

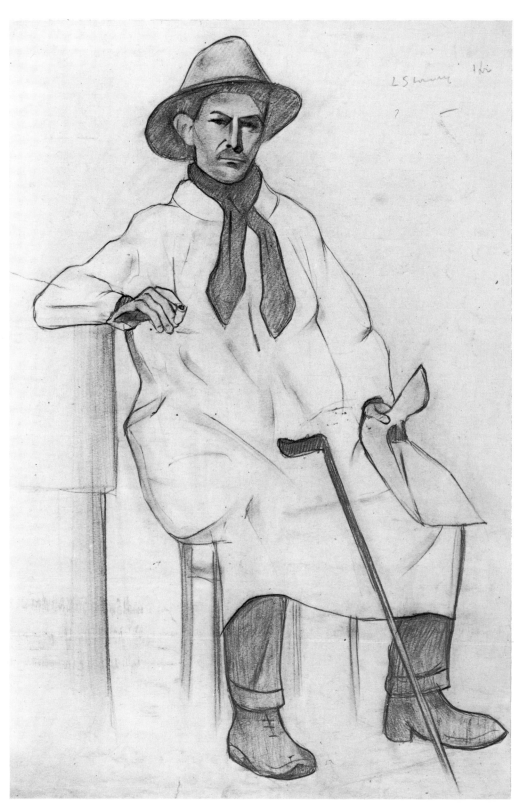

26

MAN WEARING A SMOCK

c. 1916. *Pencil 54 × 36 cm. Collection: City Art Gallery, Salford.*

An earthy subject, rendered in a rough, earthy manner, and once again reminiscent of the peasant drawings of Millet and Van Gogh.

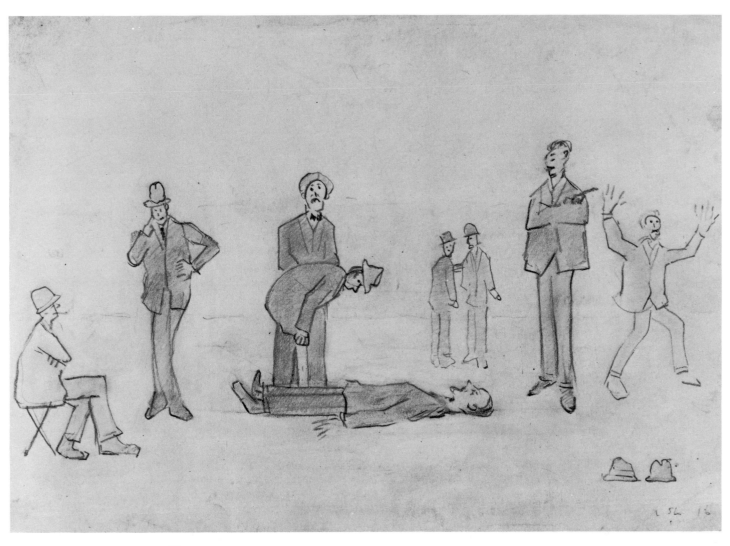

27

THE DUEL

c. 1916. Pencil 24.7 × 34.9 cm. Collection: Lefevre Gallery.

An imaginary episode in contemporary dress. The hats here display almost as much personality as the people.

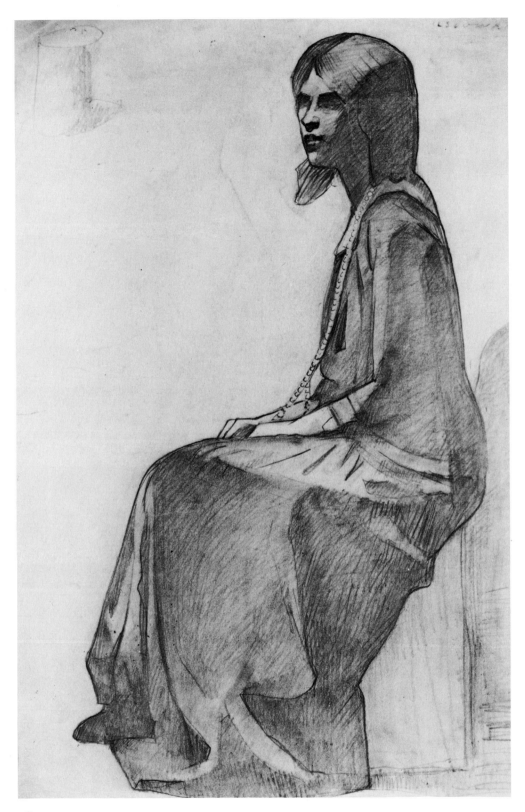

28

GIRL WITH NECKLACE

c. 1917. Pencil 53 × 35.5 cm. Collection: City Art Gallery, Salford.

A study in which the artist uses the form of the drapery to suggest the underlying form of the figure.

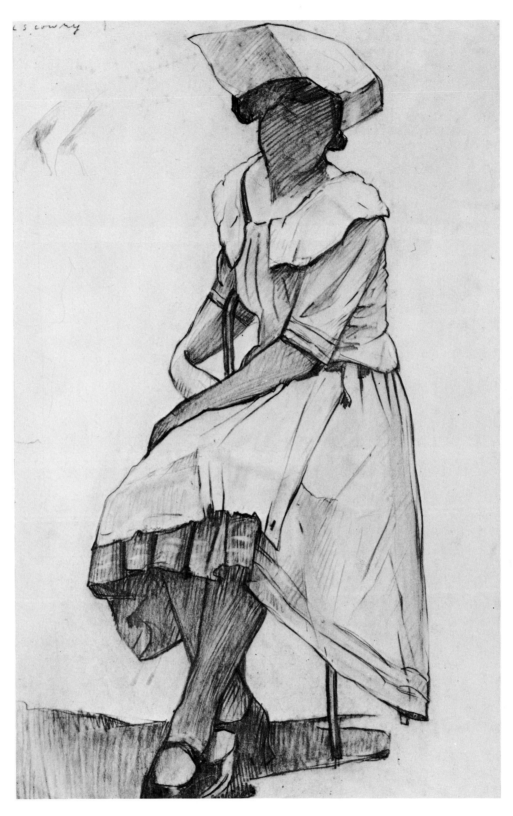

29

SEATED GIRL IN A CAP

1917. *Pencil 52 × 34 cm. Collection: City Art Gallery, Salford.*

This and the two drawings which follow were made at the Manchester College of Art in the same week.

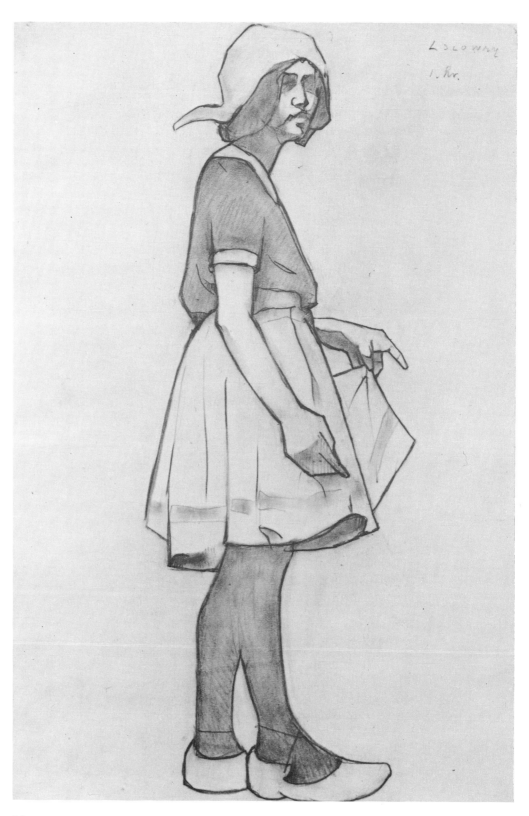

30

MODEL IN DUTCH COSTUME

1917. *Pencil 53 × 35.5 cm. Collection: City Art Gallery, Salford.*

A broadly drawn, peasanty study, in which the artist has endeavoured to represent colour by an imaginative use of the pencil.

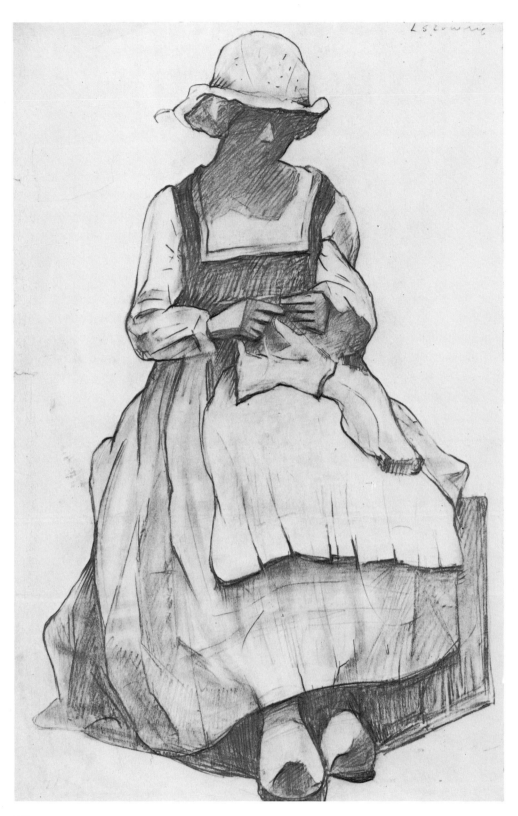

31

STUDY OF GIRL IN PEASANT DRESS

1917. Pencil 54 × 34 cm. Collection: City Art Gallery, Salford.

The subject could have come straight from a Dutch or Breton scene by Van Gogh or Gauguin.

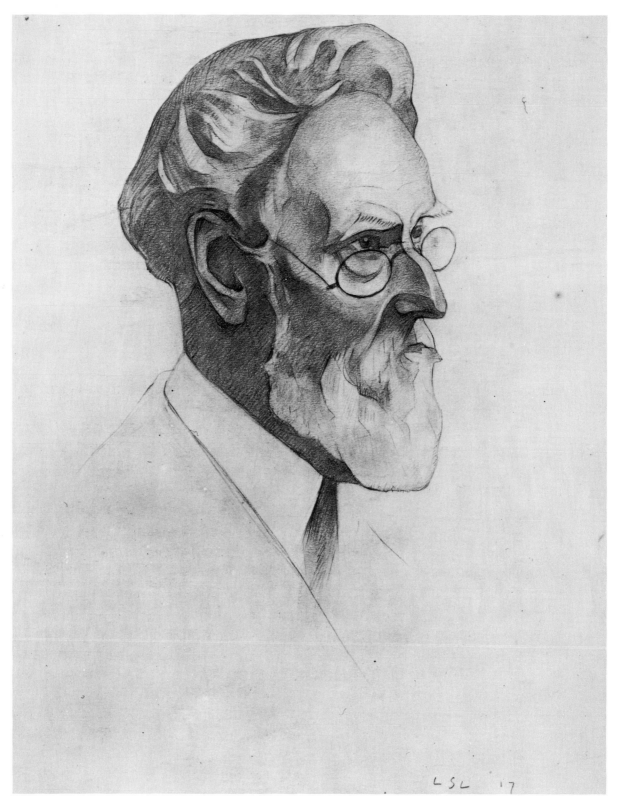

32

HEAD OF A MAN

1917. Pencil 44.5 × 37.5 cm. Collection: City Art Gallery, Salford.

The subject was a Mr Kempton, a model who sat for a private art class organized by Mr Reginald Barber. The artist often attended this additional class while a student at the Manchester College of Art.

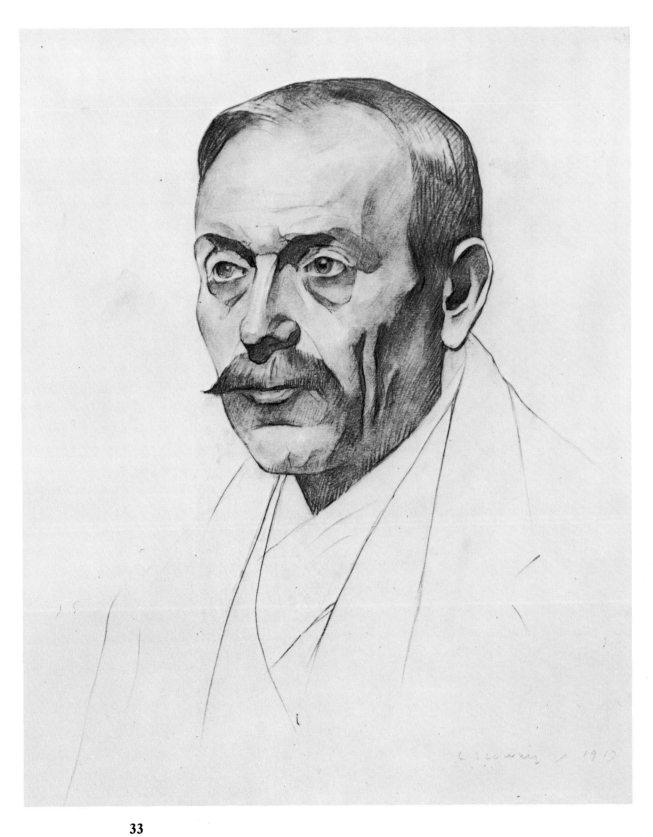

33

HEAD OF A MAN WITH A MOUSTACHE

1917. Pencil 44 × 35 cm. Collection: City Art Gallery, Salford.

A simple exposition of the construction of the head.

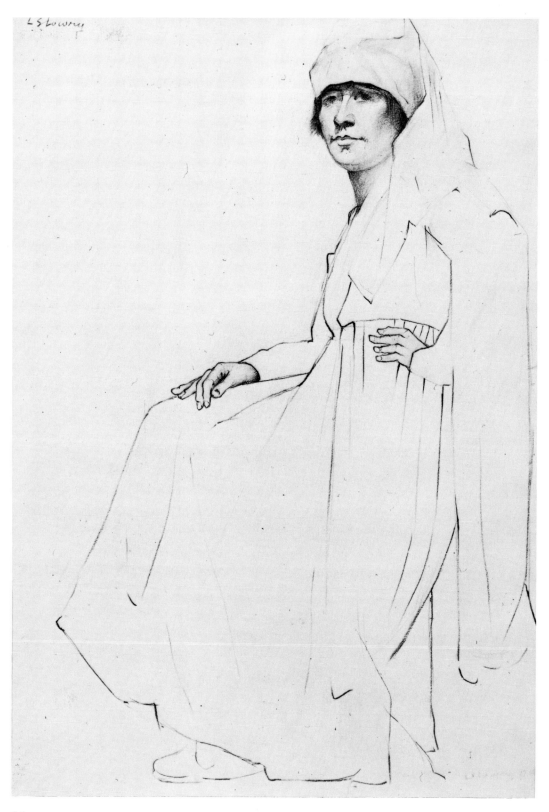

34

MODEL WITH HEAD-DRESS

1918. *Pencil 51.5 × 35.5 cm. Collection: City Art Gallery, Salford.*

A study which reveals the artist's struggle to draw hands – in striking contrast to the accomplishment with which he has drawn the face. Hands he would never be able to draw well, but in later drawings this minimal deficiency would not matter, since it blended very well with the expressionistic manner of his work.

35

FIVE SKETCHES OF PEEL PARK

1919-20. Pencil. Each sketch is 19 × 11.5 cm. Collection: City Art Gallery, Salford.

The centre sketch depicts the old Salford Art Gallery, now rebuilt. Peel Park and its environs was always one of the artist's favourite locations. The Royal Technical College and the Public Library are also shown.

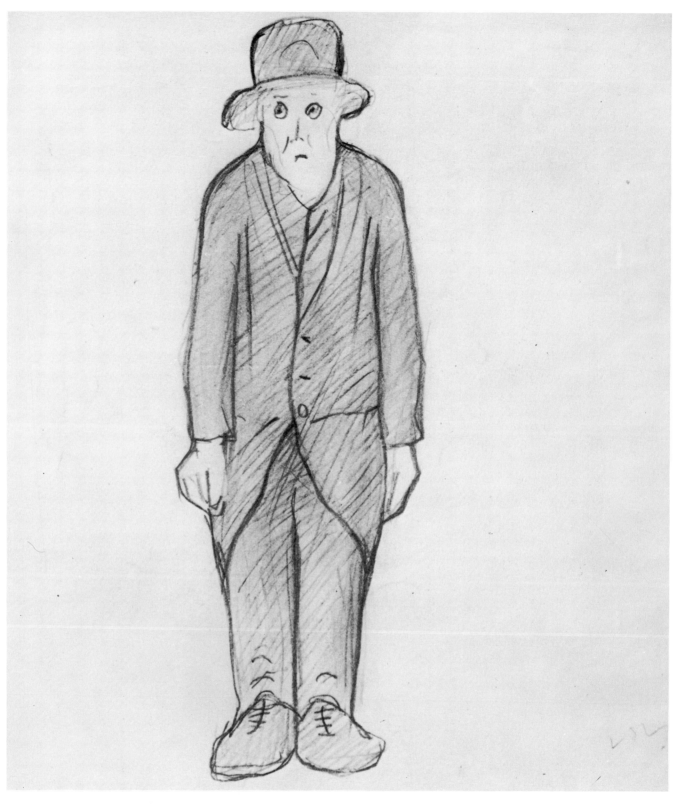

36

A MAN

1920. *Pencil 21 × 19 cm. Private collection.*

Early evidence of Lowry's obsession with the odd, the eccentric, and the grotesque. Characters like this continued to fascinate him throughout his life.

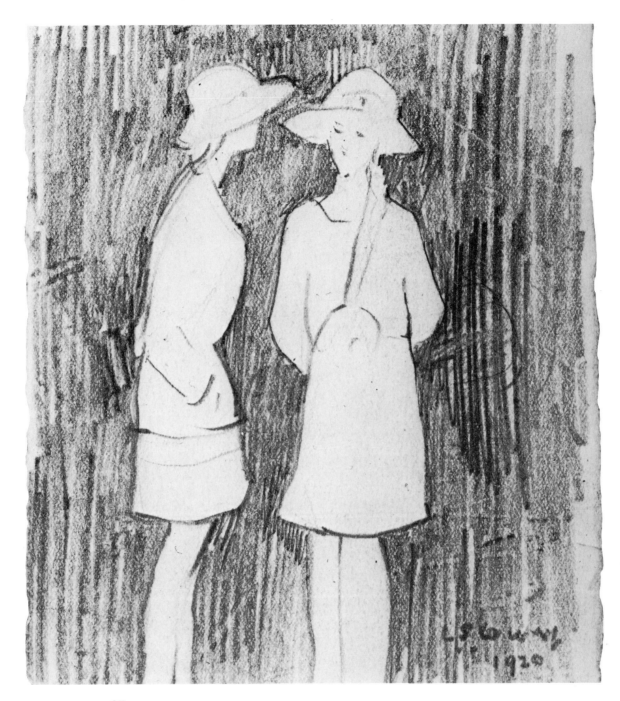

37

PAGE FROM A SKETCH-BOOK

1920. *Pencil 20.9 × 13.3 cm. Private collection.*

This and the following eleven illustrations are all pages from one of the artist's rare surviving sketch-books. They cover a wide variety of subjects, and at many points reveal the growth of the artist's highly personal pattern of stylization. In this sketch-book Lowry is forging the symbols that he will continue to use for the remainder of his life.

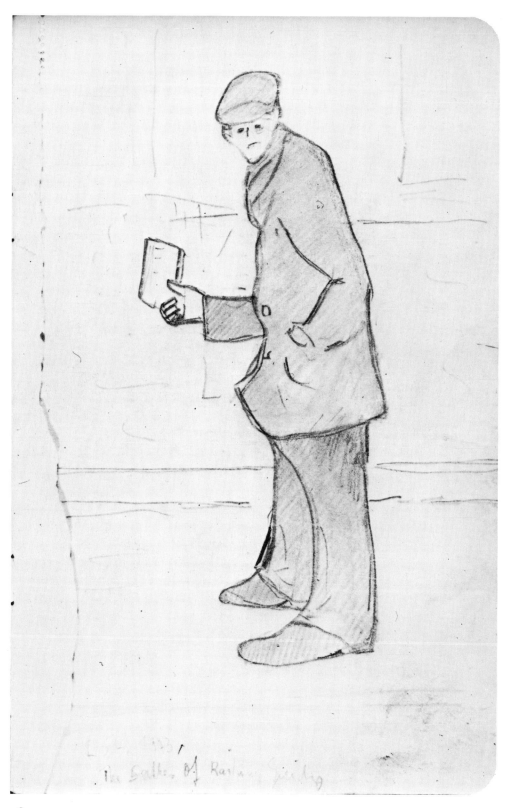

38

PAGE FROM A SKETCH-BOOK

1920. Pencil 20.9 × 13.3 cm. Private collection.

This sketch-book dates from 1920. Considerably later the artist added marginal dates to some of the drawings, but the present owner of the book is quite categorical in his dating of the whole book as 1920.

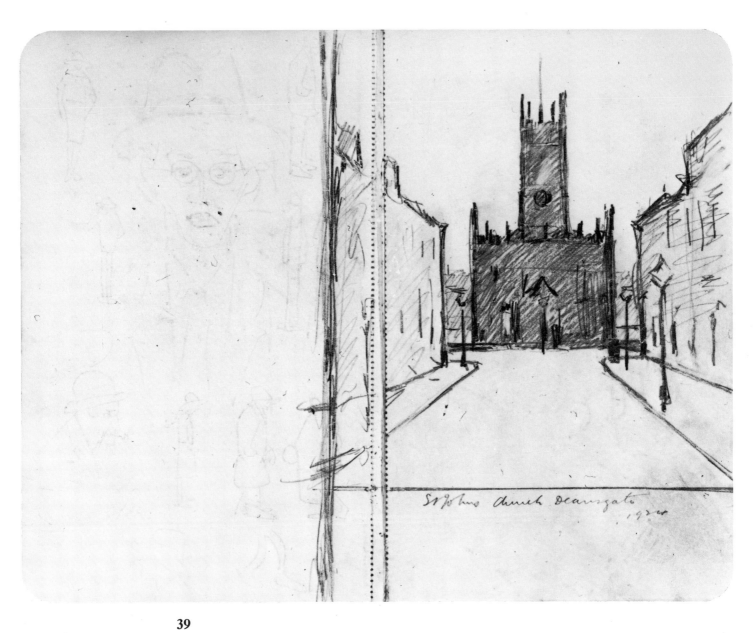

39

PAGE FROM A SKETCH-BOOK

1920. *Pencil 20.9 × 13.3 cm. Private collection.*

40

PAGE FROM A SKETCH-BOOK

1920. *Pencil* 20.9 × 13.3 *cm. Private collection.*

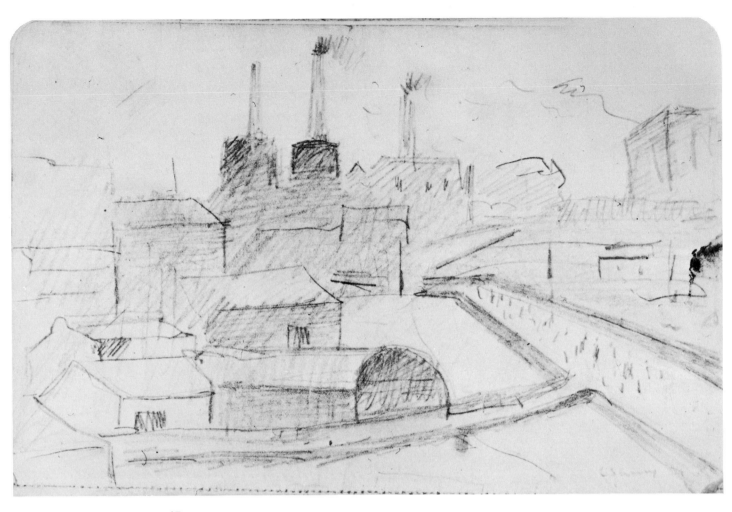

41

PAGE FROM A SKETCH-BOOK

1920. *Pencil 13.3 × 20.9 cm. Private collection.*

42

PAGE FROM A SKETCH-BOOK

1920. *Pencil 20.9 × 13.3 cm. Private collection.*

43

PAGE FROM A SKETCH-BOOK

1920. Pencil 13.3 × 20.9 cm. Private collection.

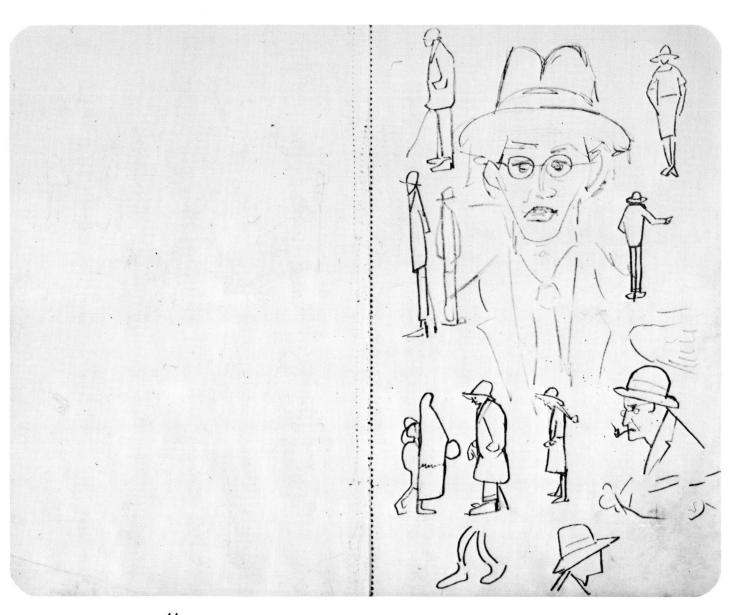

44

PAGE FROM A SKETCH-BOOK

1920. *Pencil 20.9 × 13.3 cm. Private collection.*

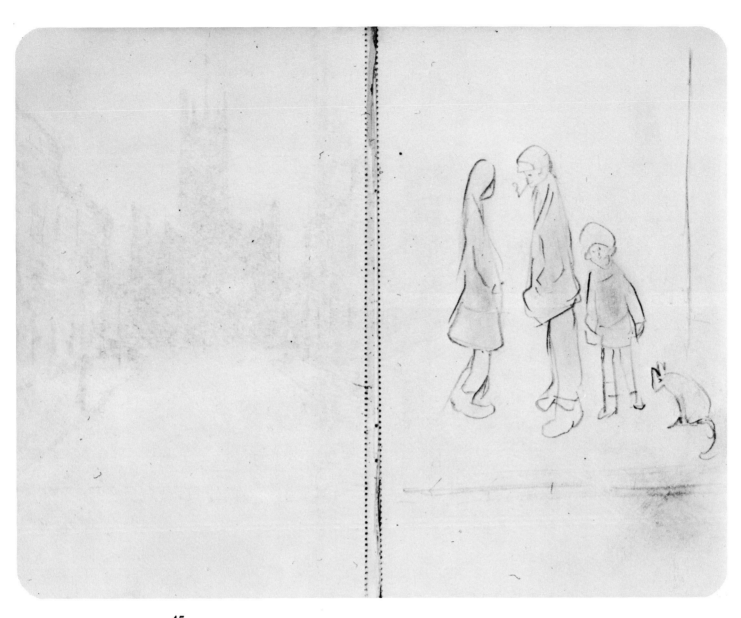

45

PAGE FROM A SKETCH-BOOK

1920. *Pencil 20.9 × 13.3 cm. Private collection.*

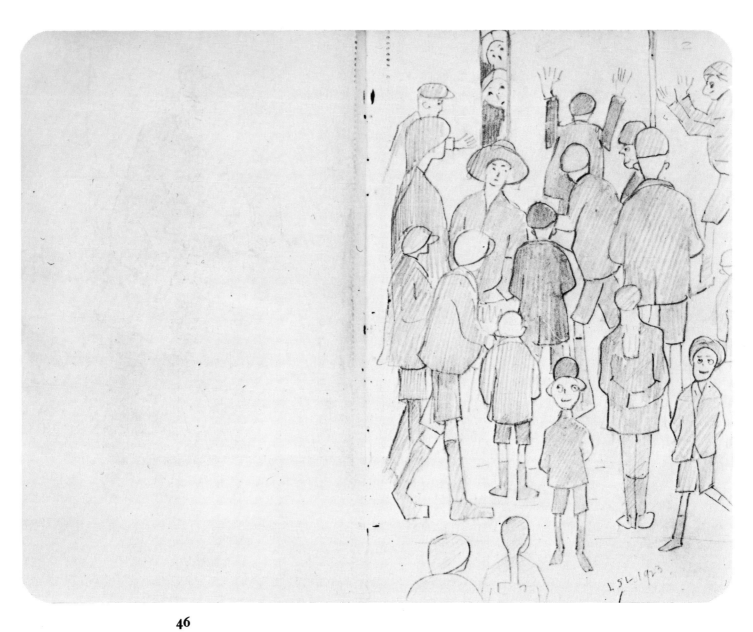

46

1920. *Pencil 20.9 × 13.3 cm. Private collection.*

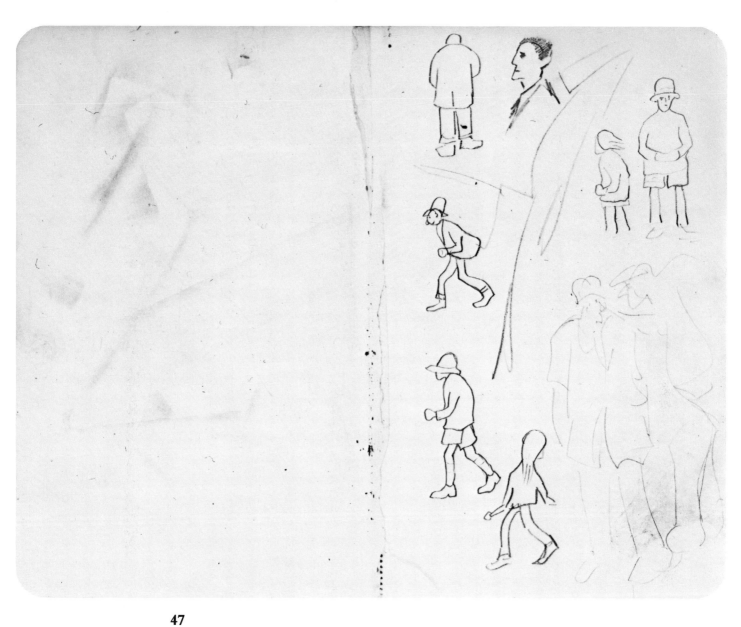

47

PAGE FROM A SKETCH-BOOK

1920. Pencil 20.9 × 13.3 cm. Private collection.

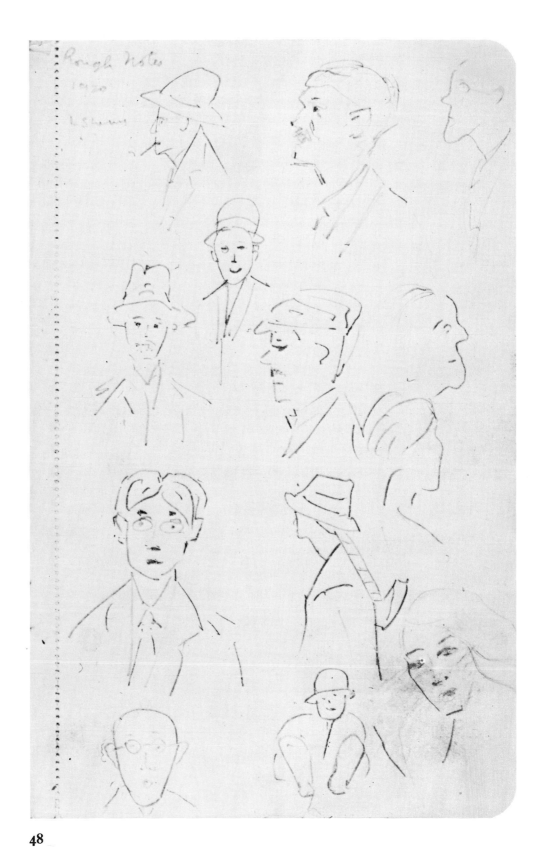

48

PAGE FROM A SKETCH-BOOK

1920. Pencil 20.9 × 13.3 cm. Private collection.

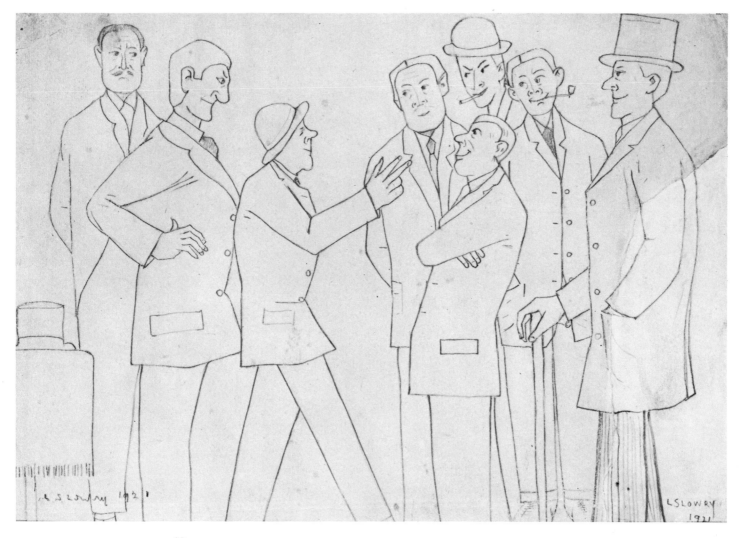

49

THE ARGUMENT

1921. *Pencil 23.4 × 34.3 cm. Private collection.*

Following on from the preceding sketch-book come the line drawings of
the twenties – the most important innovation of the decade for Lowry.
Taking simple subjects, scenes, incidents, he began to explore not only
human psychology (as here) but the aesthetic construction of his subjects.
The mood of the line drawings was essentially classical, and during this
period he drew with a clinical purity reminiscent of Italian masters such as
Lorenzetti, Piero della Francesca, and Uccello.

50

MAN TAKEN ILL

1921. Pencil 35.6 × 25.4 cm. Private collection.

A superbly classical composition in which the human activities are dwarfed by the majesty of the buildings. The lamp-posts which are so often to be found in Lowry's work now start to appear. They may be taken to symbolize the all-seeing eye (of God?), or the artist in his observing detachment, or may simply be viewed as attractive decorative objects.

51

THREE PEOPLE

1921. *Pencil 19.5 × 19.5 cm. Private collection.*

An early figure group in which the artist is concerned with the figures, in their shabby clothes, and not with the surroundings.

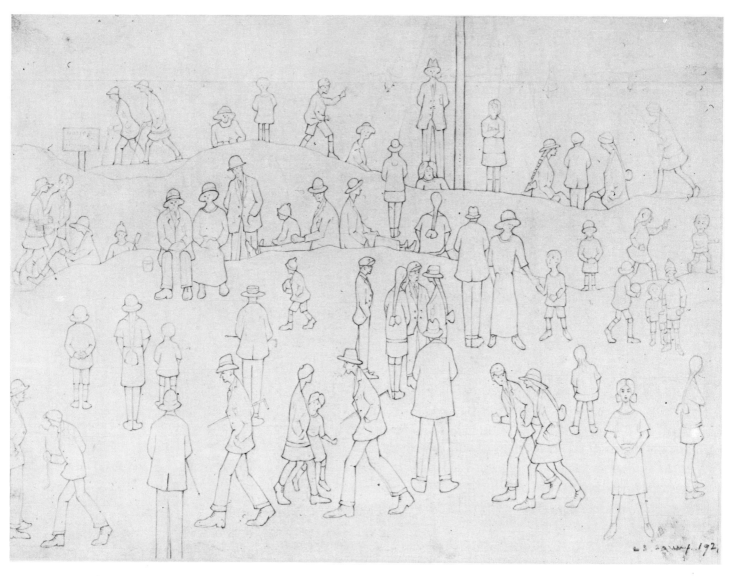

52

ON THE SANDS

1921. Pencil 26.5 × 35.5 cm. Collection: City Art Gallery, Salford.

An early, magnificently austere version of the beach scenes that were to follow, particularly in the forties.

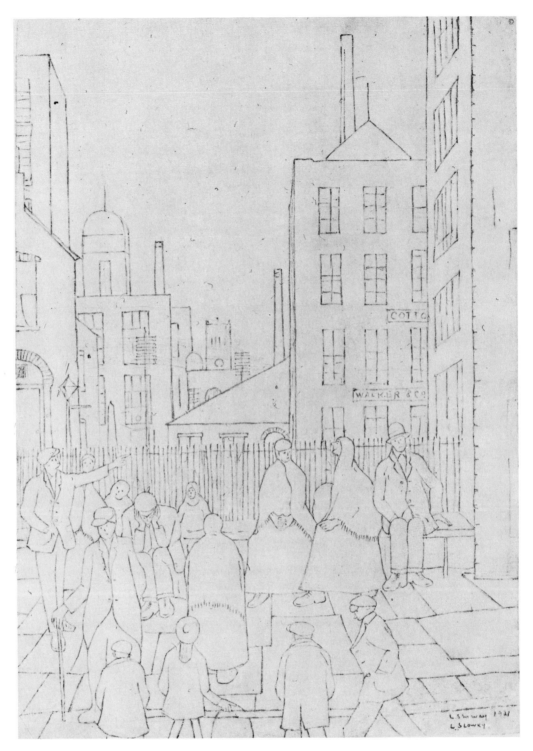

53

OUTSIDE THE MILL

1921. *Pencil 33.6 × 24.1 cm. Private collection.*

Coming to grips with the mill scenes that would soon take over, and would continue to haunt the artist's imagination. A masterpiece of composition. Consider the way in which the outstretched arm of the figure on the extreme left of the picture compels the eye into the centre of the composition. This is also a social document of great importance. Look at the attire of the women.

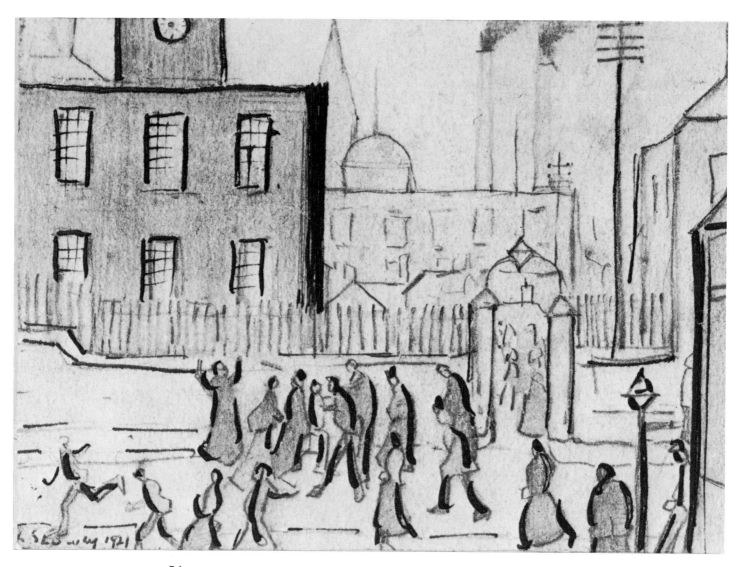

54

MILL SCENE

1921. *Pen and ink and pencil 8.5 × 11.5 cm. Private collection.*

An experimental drawing combining pen and ink and pencil, and incorporating a fine, free sense of movement in the figures that is quite different from the static quality of Lowry's line drawings of this period.

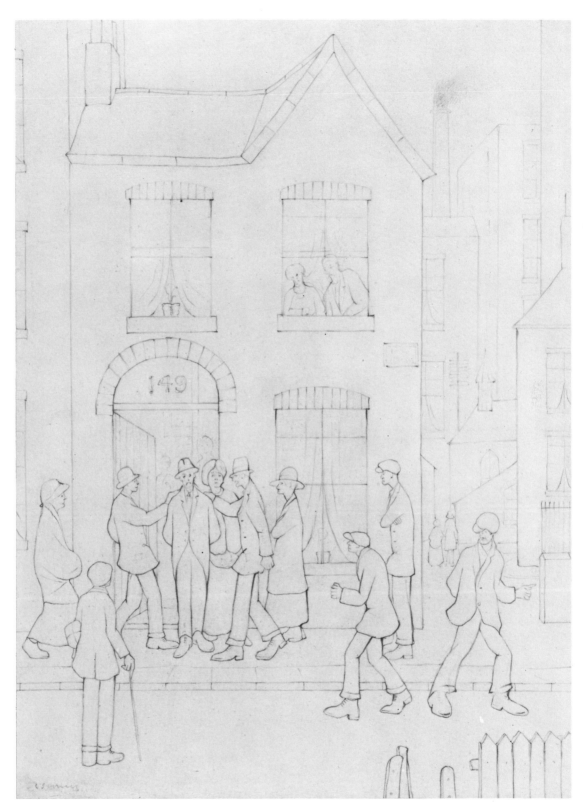

55

AN ARREST

c. 1922. Pencil 34.9 × 25.4 cm. Collection: Lefevre Gallery.

A literary subject with strong emotive undertones, yet treated in a simple, cool manner. The figure of the artist watches on the left of the picture. This and similar subjects were all witnessed by Lowry.

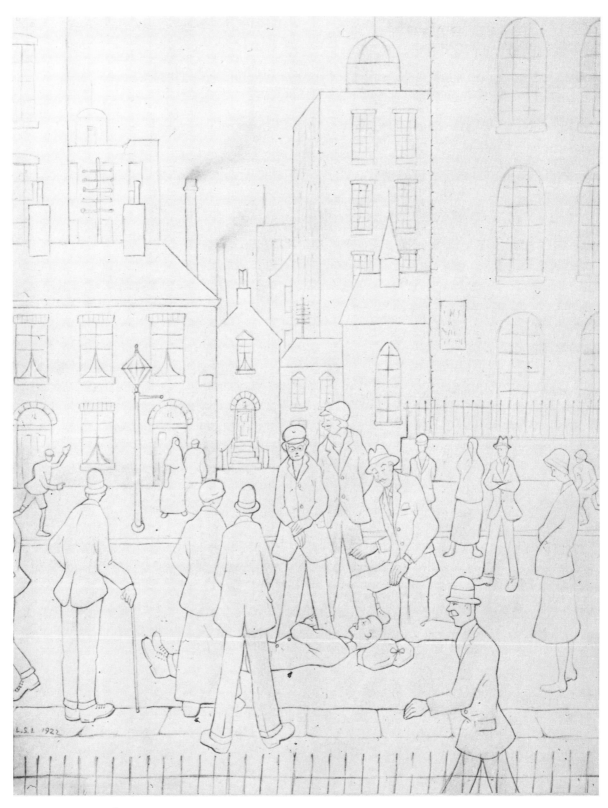

56

MAN TAKEN ILL

1922. Pencil 31.8 × 24.7 cm. Private collection.

During the line-drawing period the artist made continual use of scenes such as this, taken from the life and observed with meticulous care. Sudden illness was always a favourite subject of Lowry's. This drawing is a later version of Plate 50.

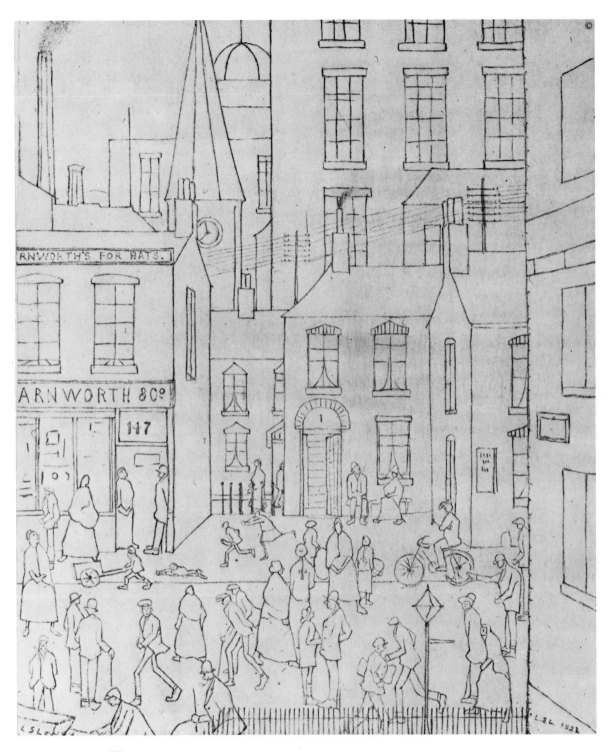

57

STREET SCENE

1922. Pencil 26.7 × 22.2 cm. Private collection.

In the line drawings of the twenties Lowry built up his vocabulary of images – those he would use time and again, no matter what style he was working in. The buildings with their spires and cupolas, the smoking stacks, the lamp-posts (in one form or another), the women in their shawls, all emerge and are carefully stored away for future reference.

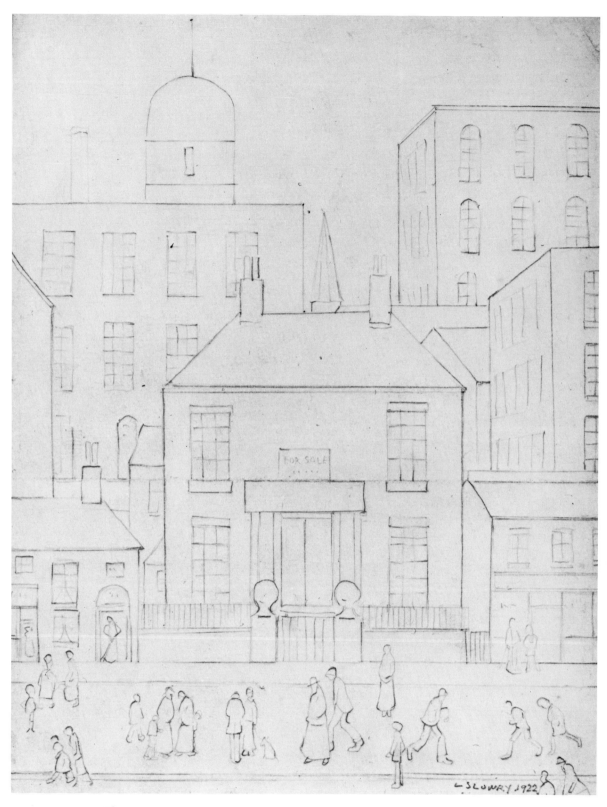

58

HOUSE FOR SALE

1922. Pencil 33 × 25.4 cm. Private collection.

Pencil was the medium best suited to the careful nature of the drawings made by the artist at this time.

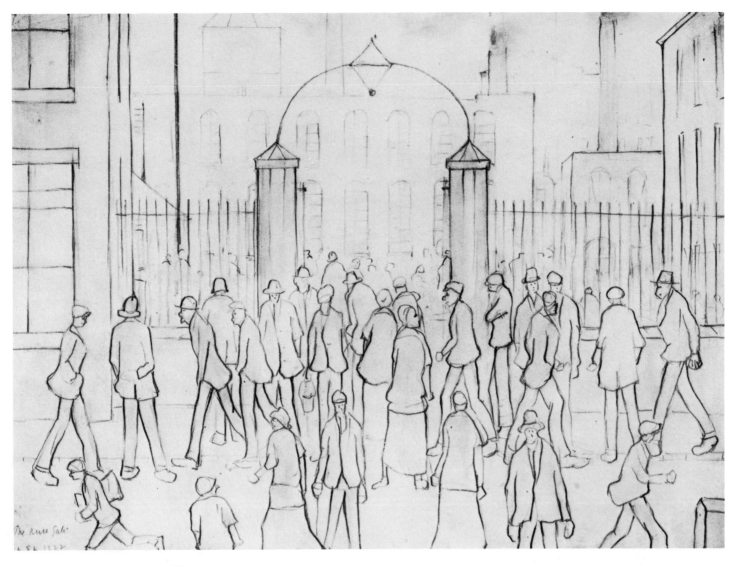

59

MILL GATES

1922. Pencil 25.4 × 35.6 cm. Private collection.

A characteristic line drawing, on this occasion strengthened with a delicate smudging of the pencil-work. The composition is provocative, with the figures to the lower right and left moving out of the picture. Consider also the curve of the iron-work which holds the lamp above the mill gates. How marvellously this off-sets the straight and horizontal lines which are the basis of the composition.

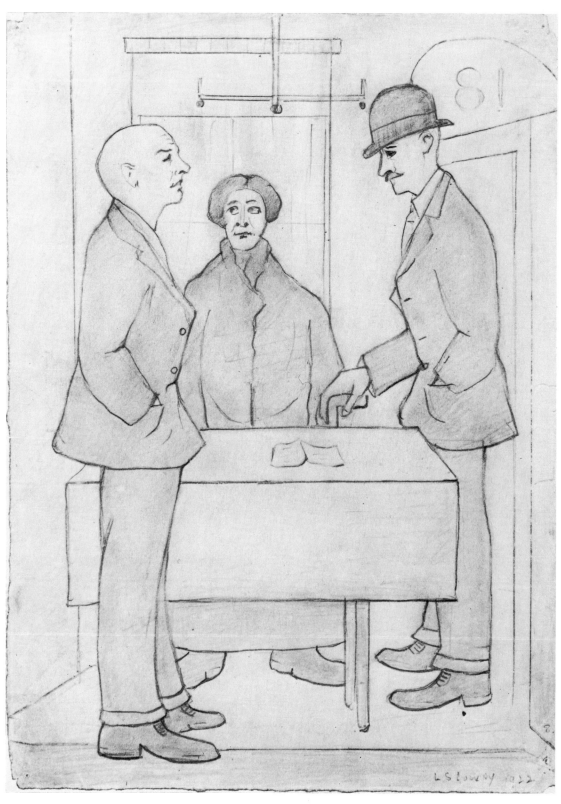

60

THE RENT COLLECTOR

1922. Pencil 36 × 27 cm. Private collection.

At the time this drawing was made Lowry was himself a rent collector for a
Manchester property company – a fact he kept secret throughout his life.
The drawing is therefore autobiographical in spirit, although the figure of
the rent collector on the right is not a physical likeness of the artist.

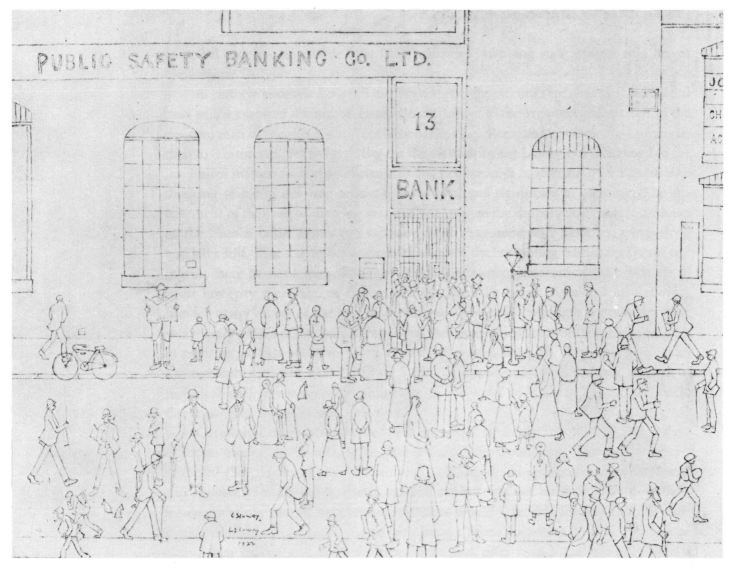

61

BANK FAILURE

1922. Pencil 26.7 × 36.2 cm. Private collection.

A simple subject, brilliantly exploited. The strolling figure of the artist swaggers in from the left-hand side of the picture, briskly twirling his walking-stick. There is humour too in the bank sign.

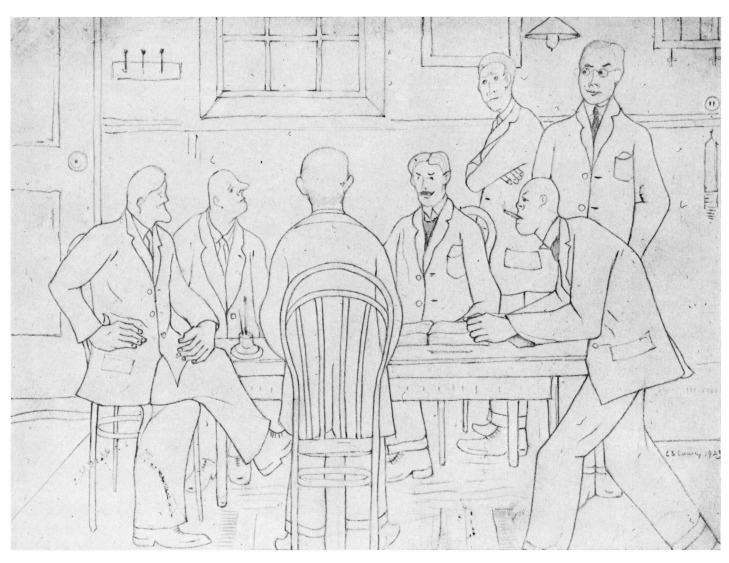

62

A MEETING

1923. *Pencil 24.1 × 31.8 cm. Private collection.*

Here, uncharacteristically, the interest is concentrated in the faces around the table.

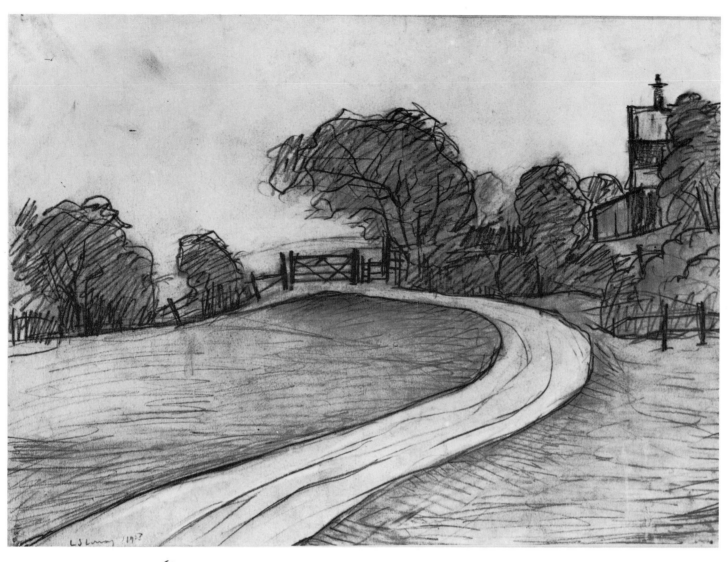

63

LANDSCAPE

1923. *Pencil 47 × 56.5 cm. Collection: City Art Gallery, Salford.*

This sketch from the period of the line drawings shows how varied was the artist's technique. It is rendered with great breadth and freedom.

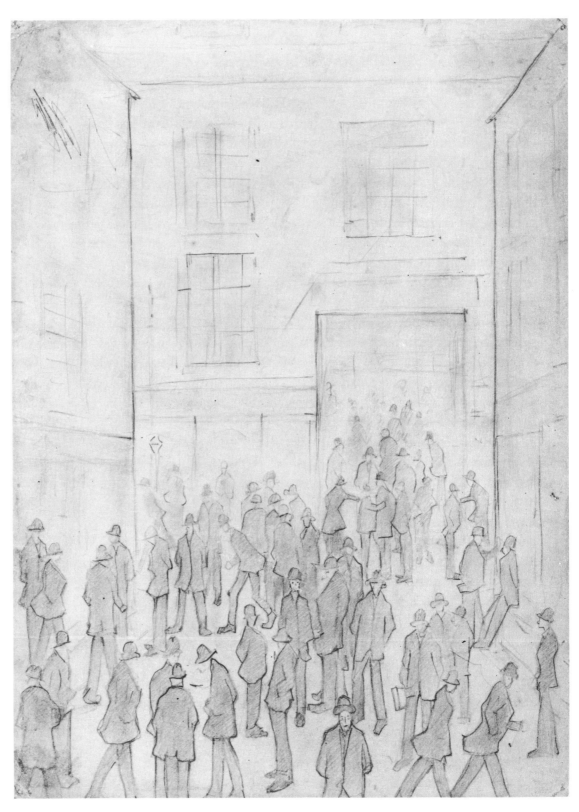

64

MANCHESTER EXCHANGE

1923. Pencil 36.2 × 25.4 cm. Collection: Lefevre Gallery.

A drawing which captures the unhurried, unruffled aspect of men of business dealing with their affairs in a leisurely manner. This is also an important social document showing how the business of the Stock Exchange was carried on at the time.

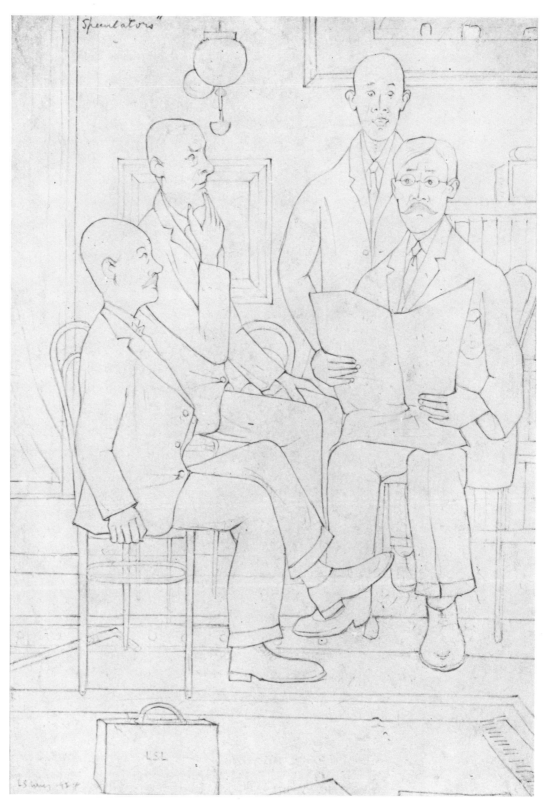

65

SPECULATORS

1924. Pencil 34.9 × 24.1 cm. Private collection.

A typical Lowry subject of the period – simple yet brimming with possibilities. Note the artist's initials on the attaché case. If the drawing seems somewhat wooden, doesn't that perfectly match the bone-headedness of the characters?

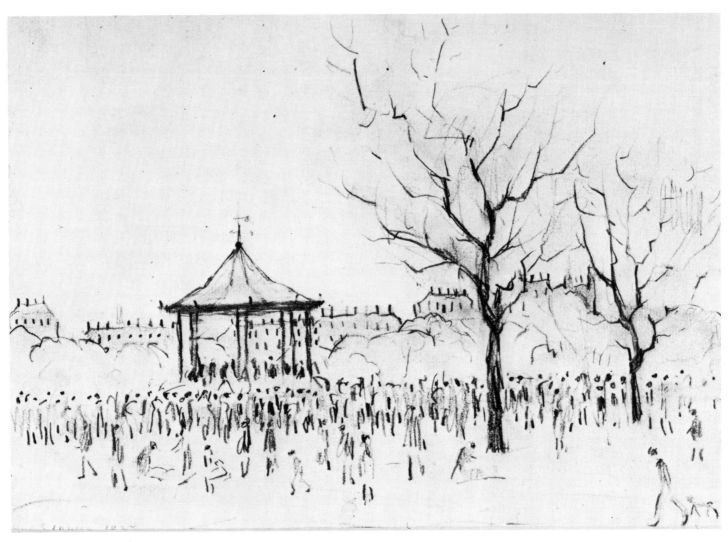

66

BAND STAND, PEEL PARK

1924. Pencil 17 × 25 cm. Collection: City Art Gallery, Salford.

Running simultaneously with the static line-drawings of the twenties were fluent, activated drawings such as this, suggesting a sense of animation. The drawing style is highly impressionistic.

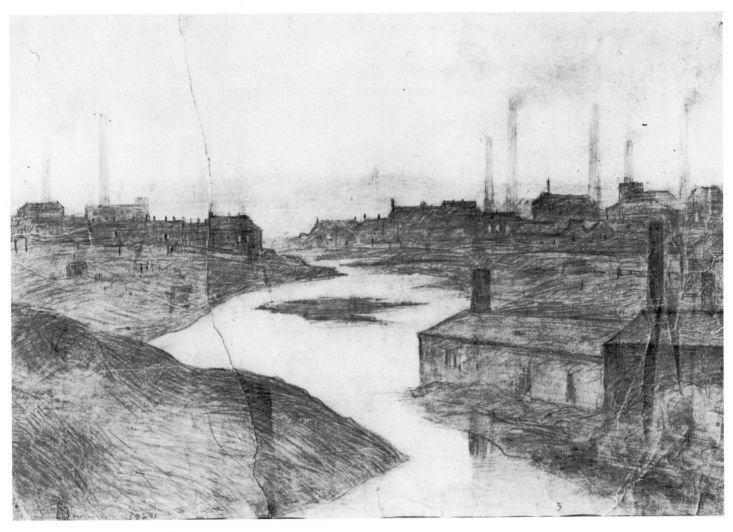

67

THE RIVER IRWELL AT THE ADELPHI

1924. Pencil 35.5 × 55 cm. Collection: City Art Gallery, Salford.

The river Irwell was a key formative image in the evolution of Lowry's industrial vocabulary. The juxtaposition of water and industry always intrigued him.

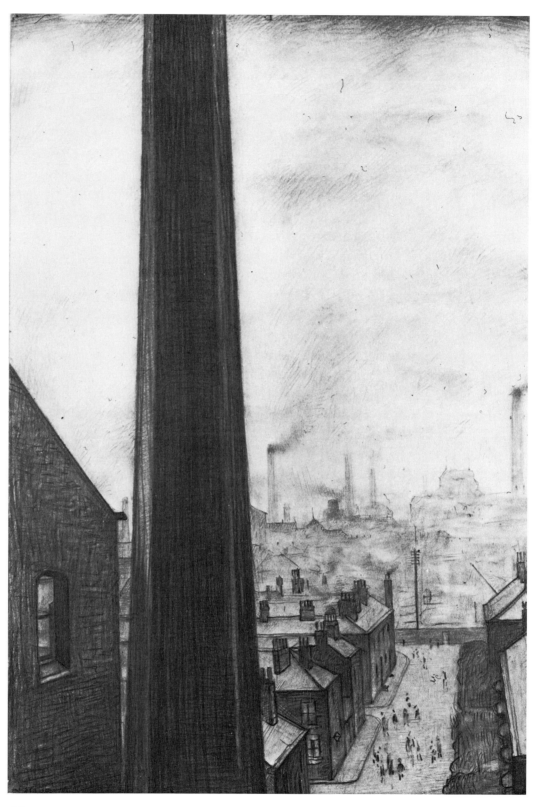

68

VIEW FROM THE WINDOW OF THE ROYAL TECHNICAL COLLEGE, SALFORD

1924. Pencil 54.5 × 37 cm. Collection: City Art Gallery, Salford.

The Technical College at Salford also housed the School of Art, which the artist attended on frequent occasions after the completion of his basic training at Manchester.

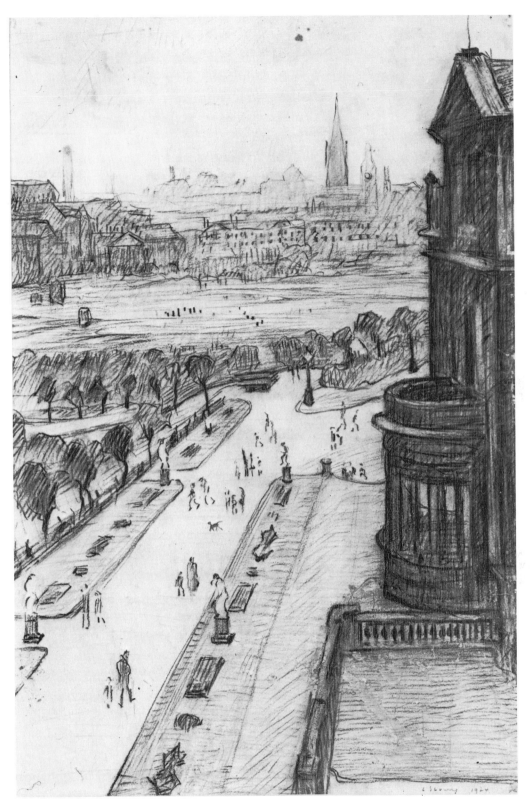

69

VIEW FROM THE WINDOW OF THE ROYAL TECHNICAL COLLEGE, SALFORD

1924. Pencil 55 × 37 cm. Collection: City Art Gallery, Salford.

Another panoramic view of Salford. The figures in the street are rendered with deft impressionistic touches of the pencil.

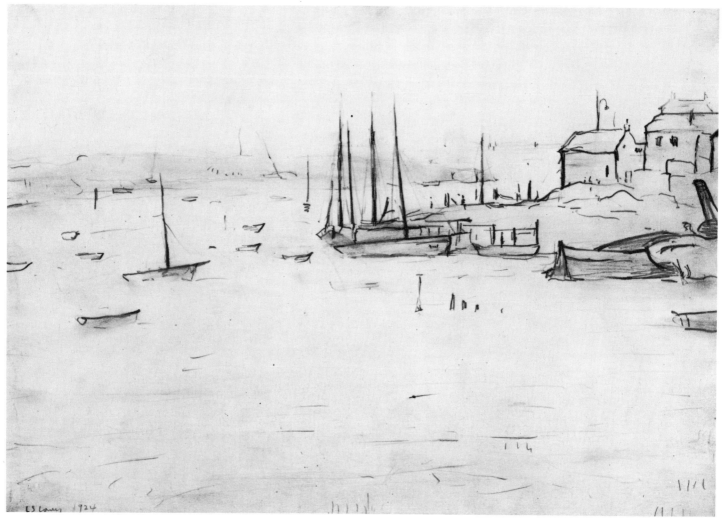

70

RHYL HARBOUR

1924. Pencil 24.7 × 34.9 cm. Collection: Lefevre Gallery.

In 1924 the artist visited Rhyl for the first time and made a few drawings in the vicinity of the harbour. The following year he spent a summer holiday there and made many more drawings. He was always fascinated by harbours and boats.

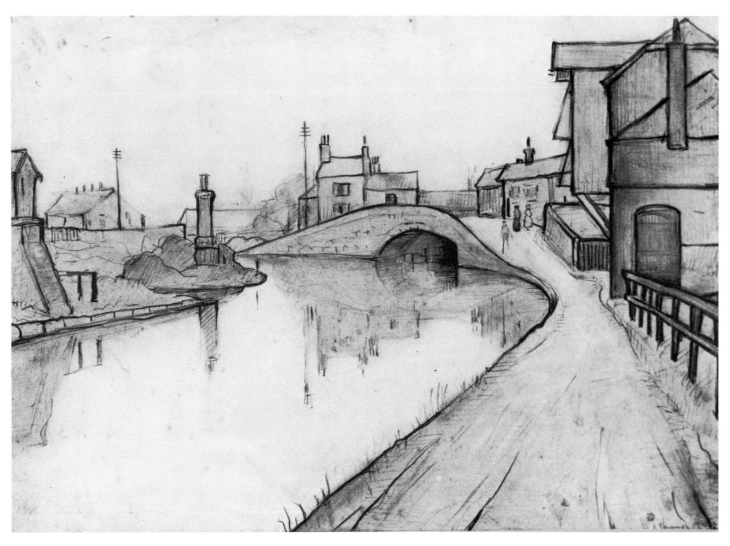

71

CANAL AT WORSLEY

1925. Pencil 44.5 × 54 cm. Collection: City Art Gallery, Salford.

Apart from the line drawings produced in the twenties, Lowry drew extensively from nature, finding great interest in the combination of buildings and landscape. His interest in water also continues to reveal itself during this period. Canals and rivers held a particular fascination for him.

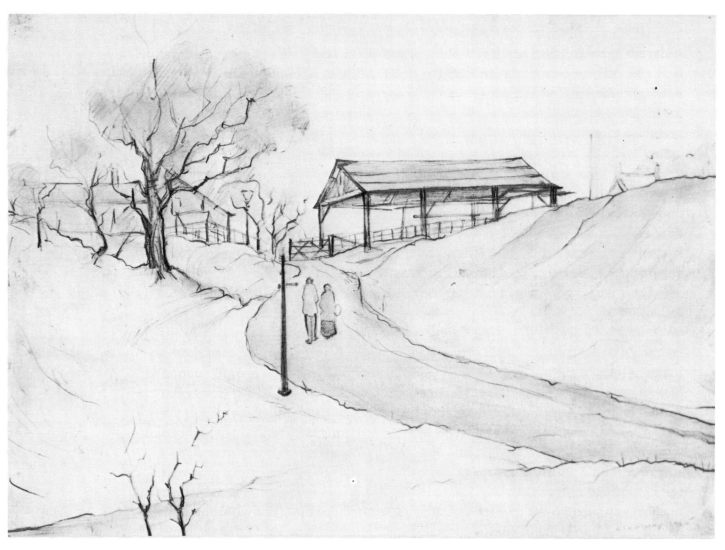

72

DIXON FOLD

1925. Pencil 45 × 54 cm. Collection: City Art Gallery, Salford.

By placing his two lonely figures in close proximity with the uprights of the lamp-standard and the posts of the barn, the artist has intensified the idea of their old age. They are rigid and stiff, like wood and iron.

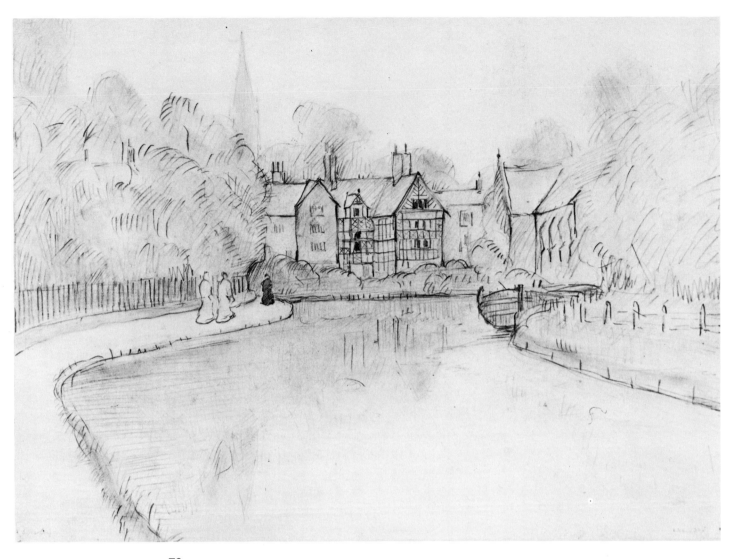

73

WORSLEY: CANAL SCENE WITH A VIEW OF PACKET HOUSE

1925. Pencil 45 × 54 cm. Collection: City Art Gallery, Salford.

Another view of the canal at Worsley, in which the eye follows the two figures on the left to the manor house in the background. The construction of the composition is carefully geared to this objective.

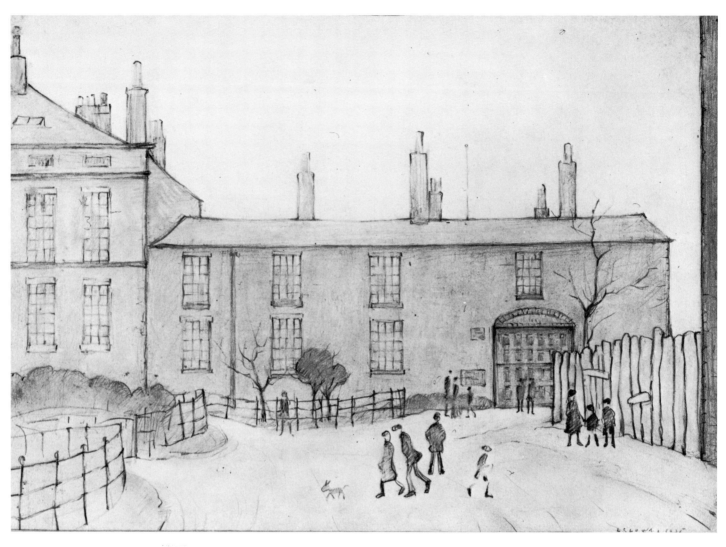

74

BEHIND LEAF SQUARE

1925. Pencil 25 × 35 cm. Collection: City Art Gallery, Salford.

A drawing which emphasizes the significance of buildings and the relative unimportance of people.

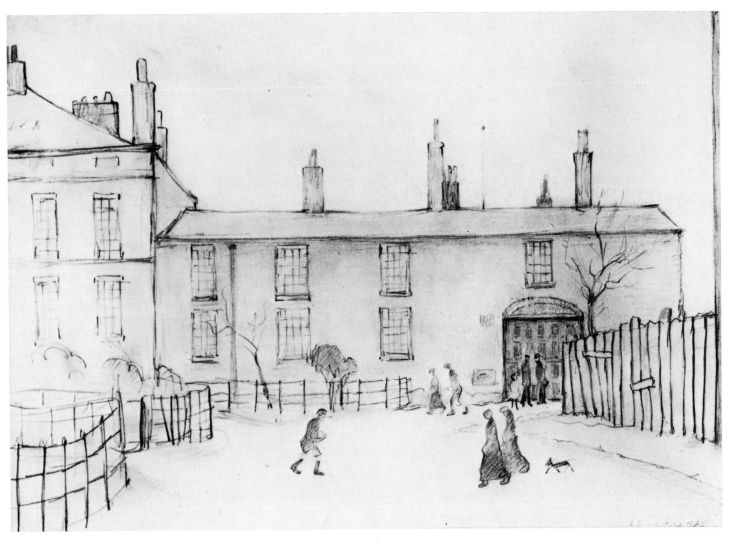

75

BEHIND LEAF SQUARE

1925. Pencil 25 × 35 cm. Collection: City Art Gallery, Salford.

Another version of the preceding drawing. The introduction of additional figures in no way detracts from the overshadowing presence of the buildings, which remain more important than the people – a fact which the artist clearly meant to show.

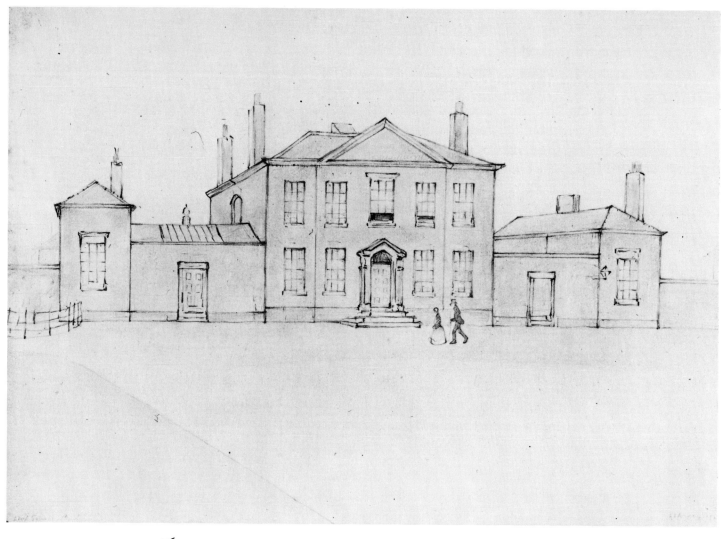

76

BELLE VUE HOUSE, LEAF SQUARE, SALFORD

1925. Pencil 24 × 33 cm. Collection: City Art Gallery, Salford.

Here the buildings are in complete command. The two curious figures in period dress were introduced into the scene because the artist felt the 'atmosphere' required them. They are ghosts.

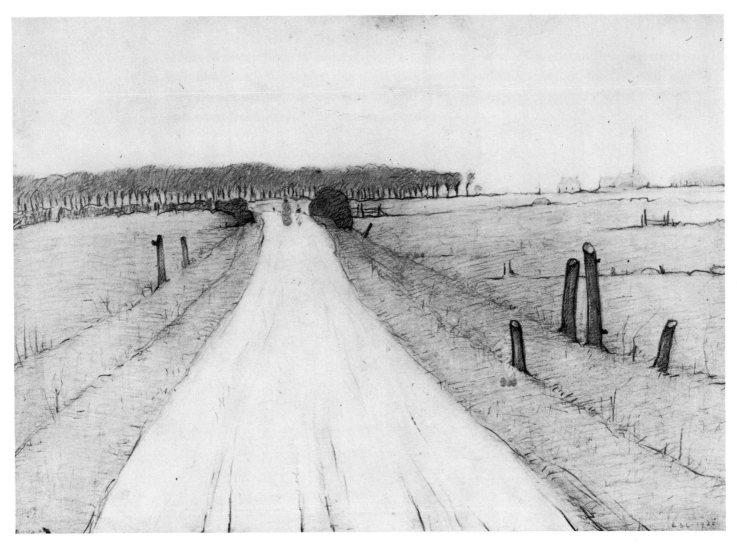

77

COUNTRY ROAD

1925. Pencil 25 × 34.5 cm. Collection: City Art Gallery, Salford.

During the twenties the artist drew a lot from landscape. Such drawings were to lead to the illustrations he made in 1930 for H. W. Timperley's *A Cotswold Book*.

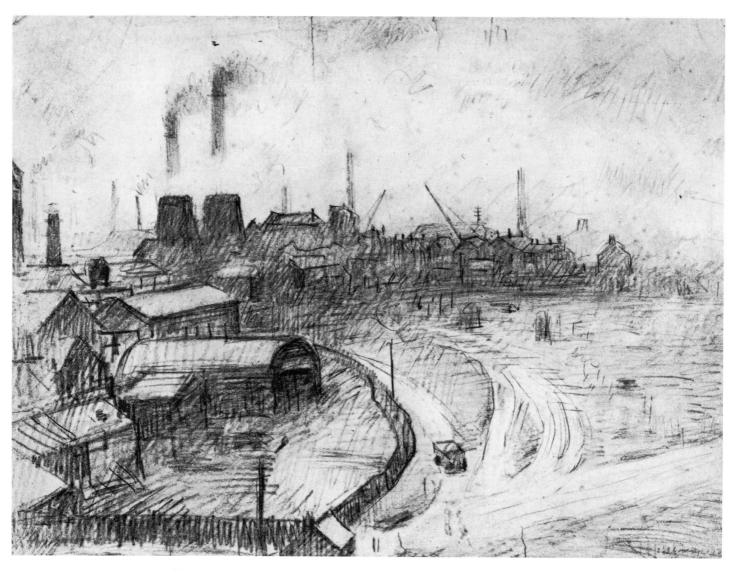

78

VIEW FROM THE WINDOW OF THE ROYAL TECHNICAL COLLEGE,
SALFORD, LOOKING TOWARDS BROUGHTON

1925. Pencil 26.5 × 37 cm. Collection: City Art Gallery, Salford.

A drawing which emphasizes the intense interest the artist was now developing in the industrial landscape. Here he explores the nature of the industrial atmosphere, the character of its pervading grime and gloom.

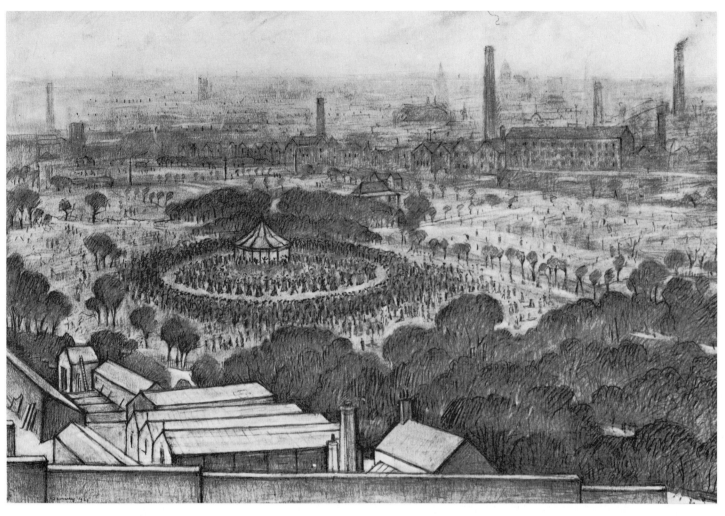

79

BAND STAND, PEEL PARK, SALFORD

1925. Pencil 37 × 52.5 cm. Collection: City Art Gallery, Salford.

A marvellously intricate perspective, and a composition of breath-taking quality. The rich, velvety pencil-work moves gradually from the strong darks of the trees in the foreground to the silvery haze which envelops the distant panorama of buildings and factory chimneys. There is as much 'colour' in a drawing like this as in any painting; Lowry could, in fact, create an 'atmosphere' of colour with just a pencil. Band stands also figure prominently in his art. They are splendid decorative objects, and always fascinated him.

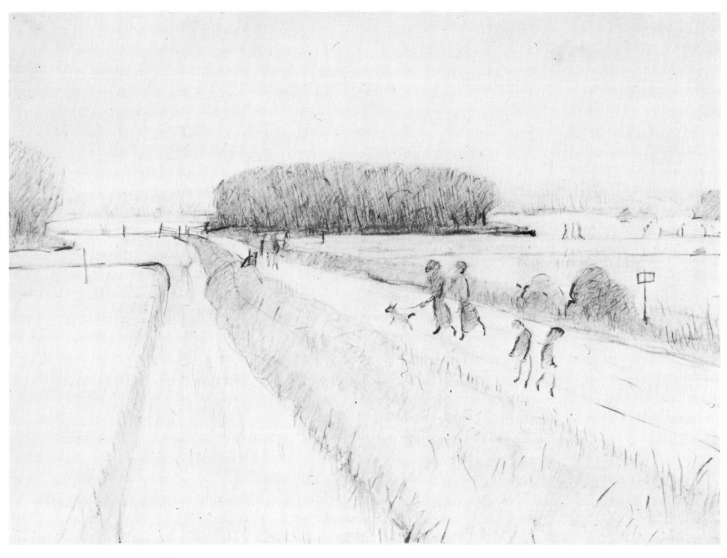

80

COUNTRY ROAD NEAR LYTHAM

1925. *Pencil 25.5 × 35.5 cm. Collection: City Art Gallery, Salford.*

Lytham St. Annes, where the Lowry family often spent their summer holidays, and to which the artist returned from time to time.

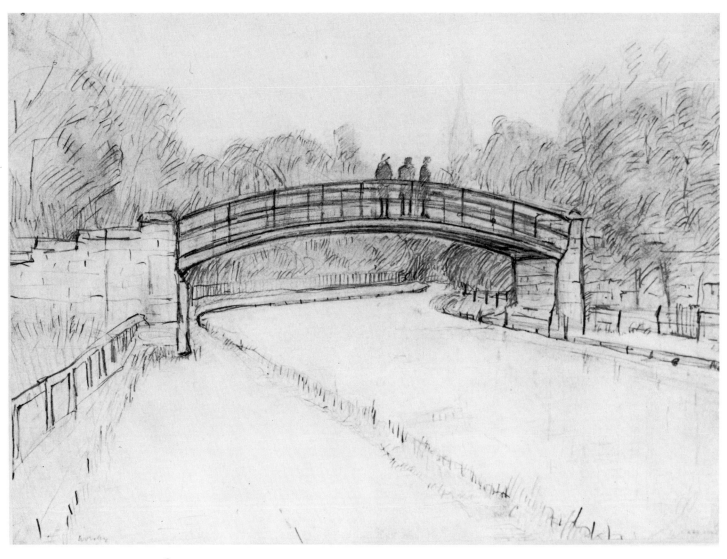

81

THE IRON BRIDGE AT WORSLEY

1925. Pencil 45 × 54 cm. Collection: City Art Gallery, Salford.

A freely expressed pencil study in which the three figures on the bridge are a neat foil for the reflective mood of the drawing.

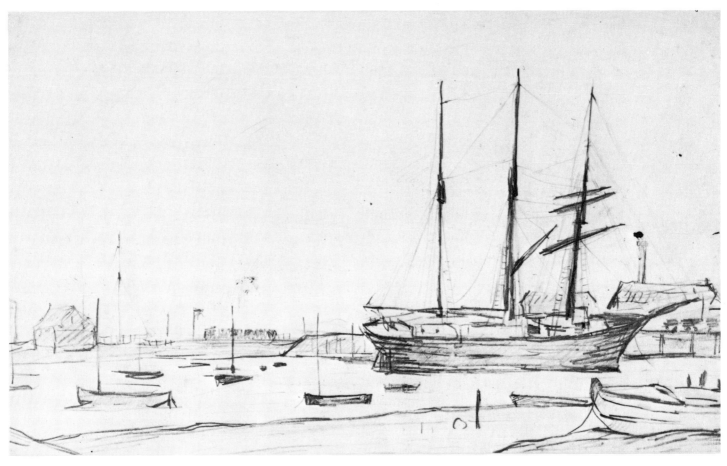

82

RHYL HARBOUR

1925. Pencil 23.5 × 38 cm. Collection: City Art Gallery, Salford.

In 1925 the artist spent a summer holiday at Rhyl in North Wales and made a number of drawings of the boats lying in the harbour. This particular study is expressed with great economy.

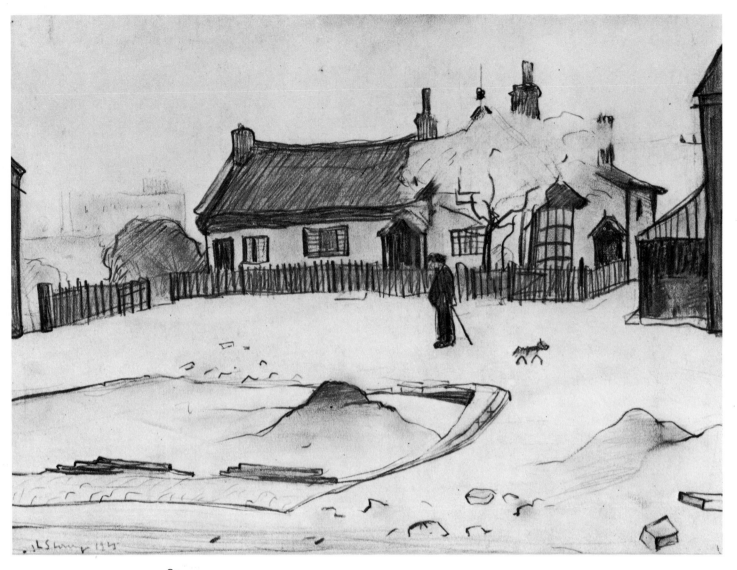

83

OLD FARM IN PENDLEBURY

1925. *Pencil 44.5 × 52.5 cm. Collection: City Art Gallery, Salford.*

This farm was close to the artist's home in Pendlebury, where he lived until his move to Mottram-in-Longdendale in 1948.

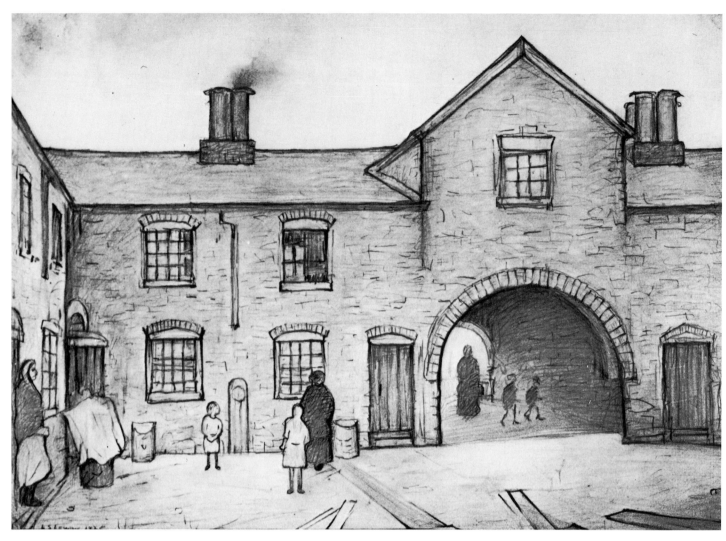

84

OLD HOUSES, FLINT

1925. Pencil 25 × 35 cm. Collection: City Art Gallery, Salford.

Here the buildings seem to have more personality than the people: the 'eyes' of the windows, the stoutness of the chimney pots, and the solidity of the doors give them immense character. Lowry was always able to invest his buildings with personality.

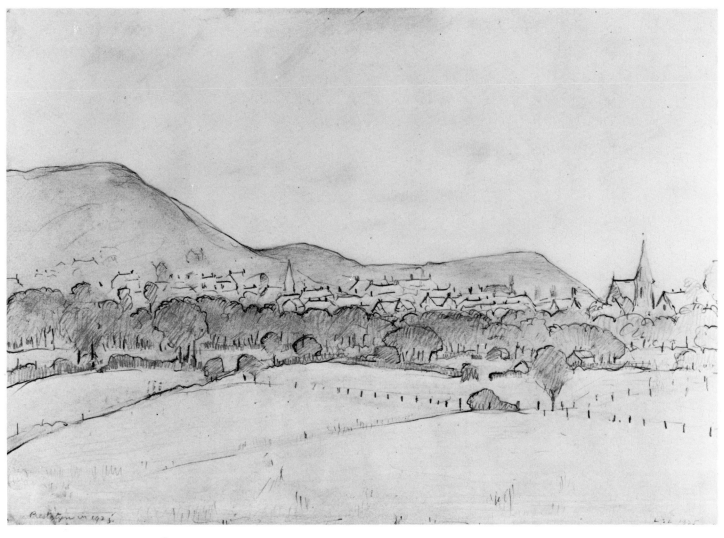

85

PRESTATYN, NORTH WALES

1925. *Pencil 24.7 × 34.9 cm. Collection: Lefevre Gallery.*

A finely evoked sense of space. The drawing is rendered in a free, loose style, and the artist is now drawing with masterly accomplishment.

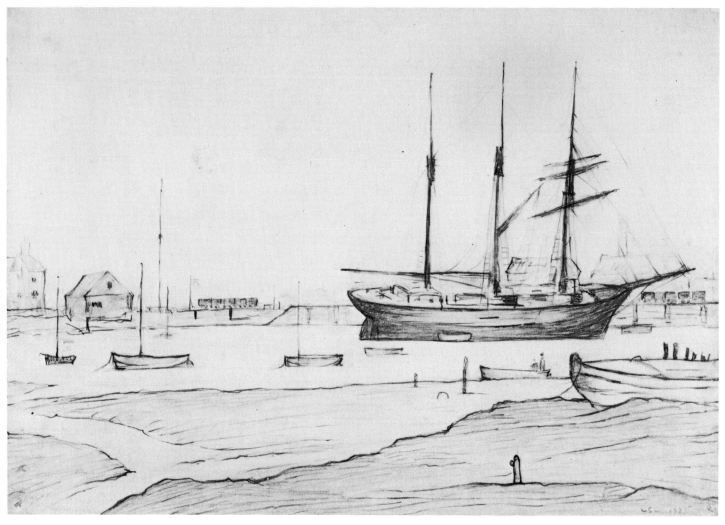

86

RHYL HARBOUR

1925. Pencil 26 × 38.7 cm. Collection: Lefevre Gallery.

One of the most majestic of the Rhyl Harbour scenes.

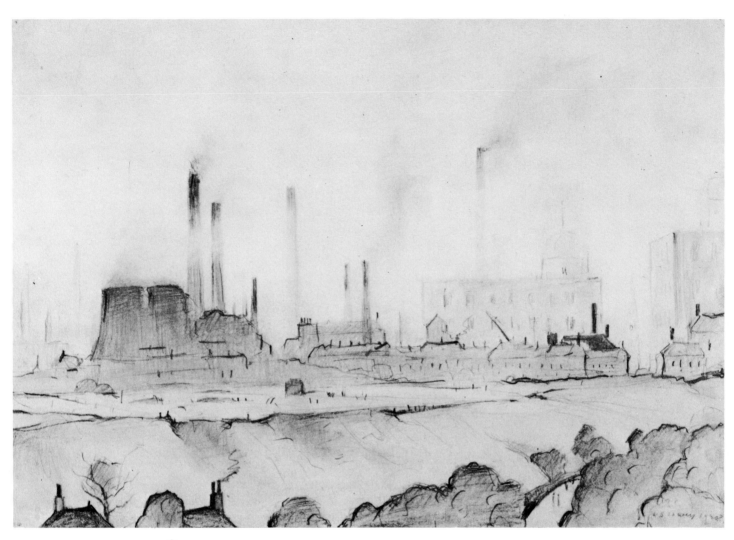

87

INDUSTRIAL LANDSCAPE

c. 1925. Pencil 24.7 × 34.9 cm. Collection: Lefevre Gallery.

See note for Plate 78.

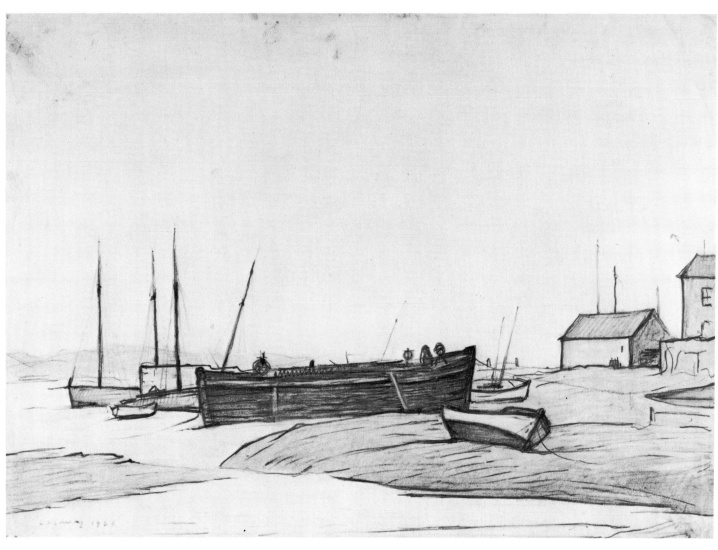

88

BOATS AT RHYL

1926. *Pencil 27.3 × 37.5 cm. Collection: Lefevre Gallery.*

One of the last of the artist's drawings of Rhyl Harbour.

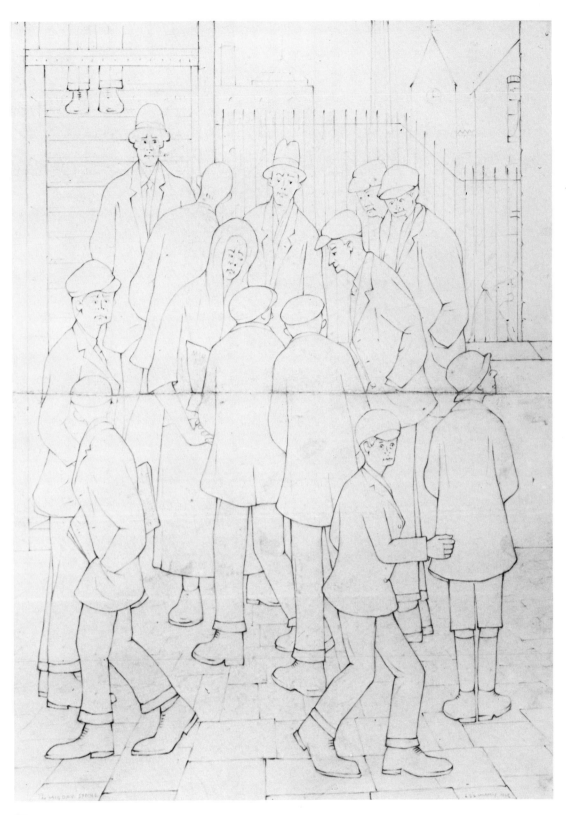

89

THE MID-DAY SPECIAL

1926. Pencil 38 × 28 cm. Collection: City Art Gallery, Salford.

A characteristic genre subject of the line-drawing era. The subjects are usually simple and literary, and in this sense they are still 'Victorian'. Lowry was always very much a story-telling artist.

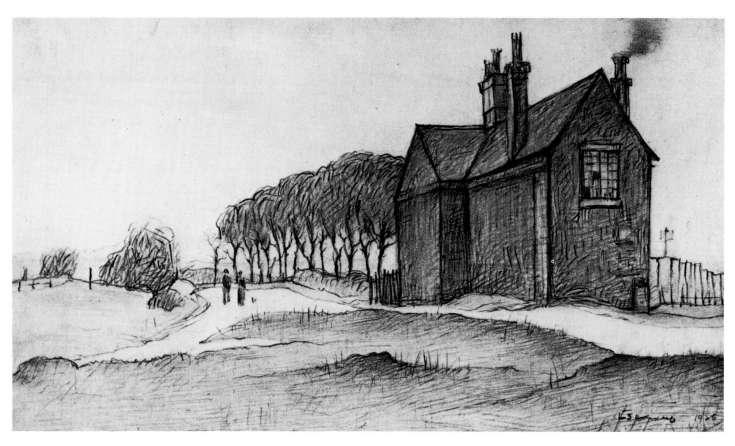

90

HOUSE ON BOTANY, CLIFTON

1926. *Pencil 41 × 55 cm. Collection: City Art Gallery, Salford.*

The littleness of man vividly contrasted with the majesty of nature and buildings.

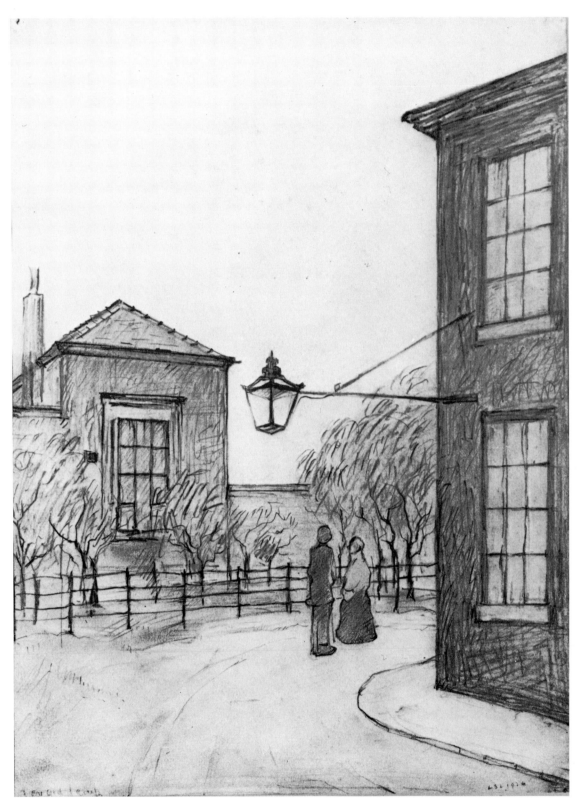

91

BEHIND LEAF SQUARE

1926. Pencil 35.5 × 26.5 cm. Collection: City Art Gallery, Salford.

Another aspect of Leaf Square, in which considerable prominence is given to the street lamp. This was an image that continually haunted Lowry's imagination. You will find it repeated in one form or another throughout his entire work.

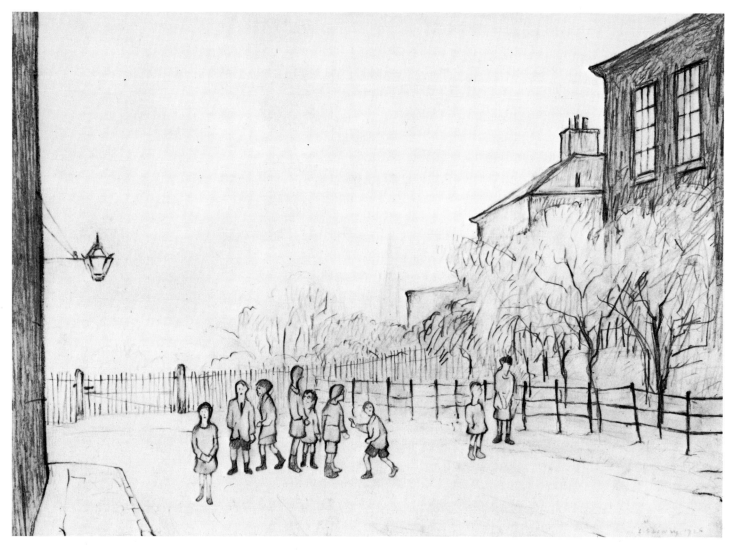

92

BEHIND LEAF SQUARE

1926. Pencil 35.5 × 26.5 cm. Collection: City Art Gallery, Salford.

Yet another aspect of the Square, here taken over by a group of school-children 'snapped', as it were, in the limbo of not knowing what to do. The artist could crystallize the essence of a subject in the simplest and most telling terms.

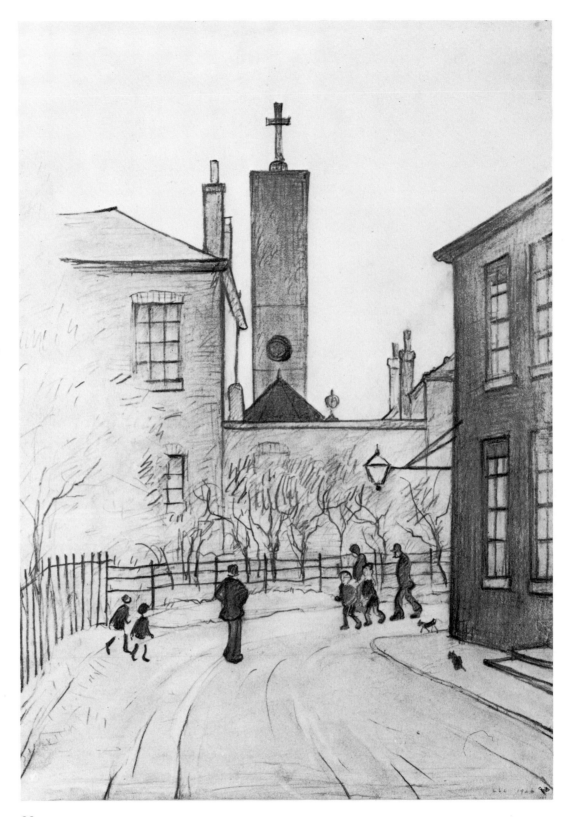

93

THE TOWER

1926. Pencil 35.5 × 25.5 cm. Collection: City Art Gallery, Salford.

A cunning suggestion of colour by varied pencil-work.

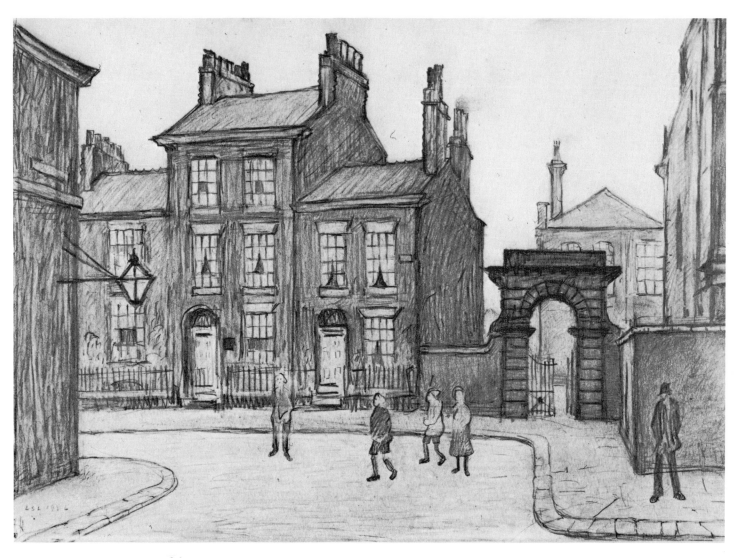

94

BY THE COUNTY COURT, SALFORD

1926. Pencil 25.5 × 35.5 cm. Collection: City Art Gallery, Salford.

Although many of Lowry's later townscapes were 'composite', he also made
a number of valuable factual recordings of his home locality. In many
instances the original buildings have disappeared, so that his documentations
are of considerable importance.

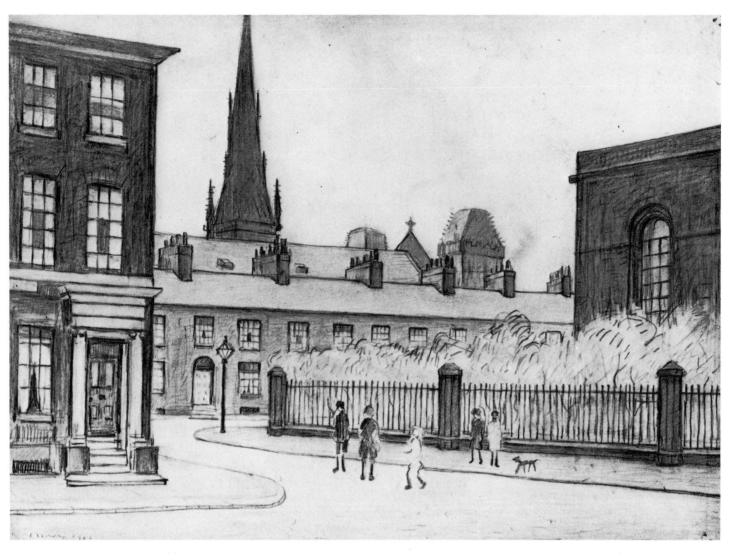

95

BY ST PHILIP'S CHURCH, SALFORD

1926. Pencil 25.5 × 35.5 cm. Collection: City Art Gallery, Salford.

A fine example of the artist's topographical recording. The variety of the pencil-work adds great flavour to the drawing.

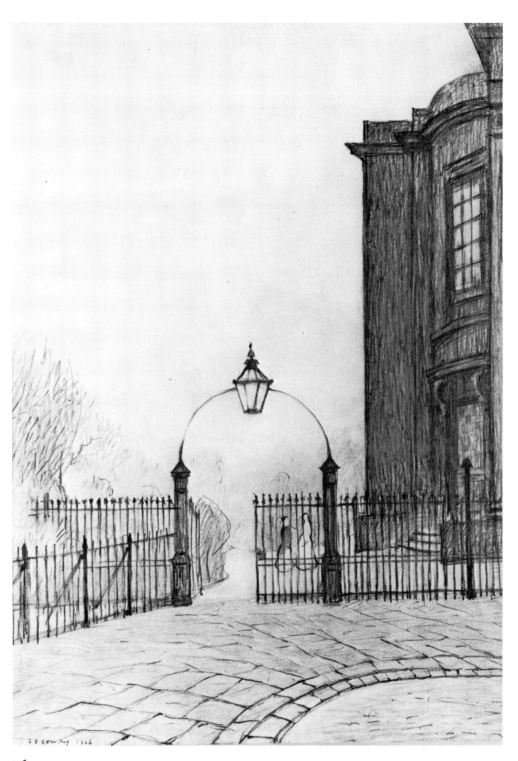

96

BY CHRIST CHURCH, SALFORD

1926. Pencil 35.5 × 25.5 cm. Collection: City Art Gallery, Salford.

Consider the subtlety of the composition: look at the way in which the curve of the pavement and the arch of the lamp-fitting off-set the straight lines of the railings and the buildings behind, giving an elegant, decorative effect. In the background again are the strange, ghostlike figures in period dress whom Lowry often depicted near old buildings. They are a vision.

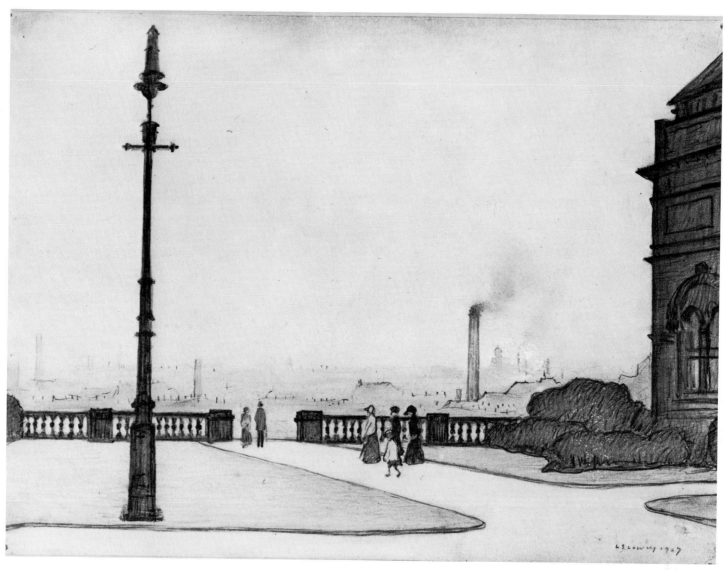

97

THE TERRACE, PEEL PARK

1927. Pencil 26 × 35 cm. Collection: City Art Gallery, Salford.

A superb opposition of horizontal and vertical lines to create a composition of striking and simple elegance. Consider the delicate impressionism of the background.

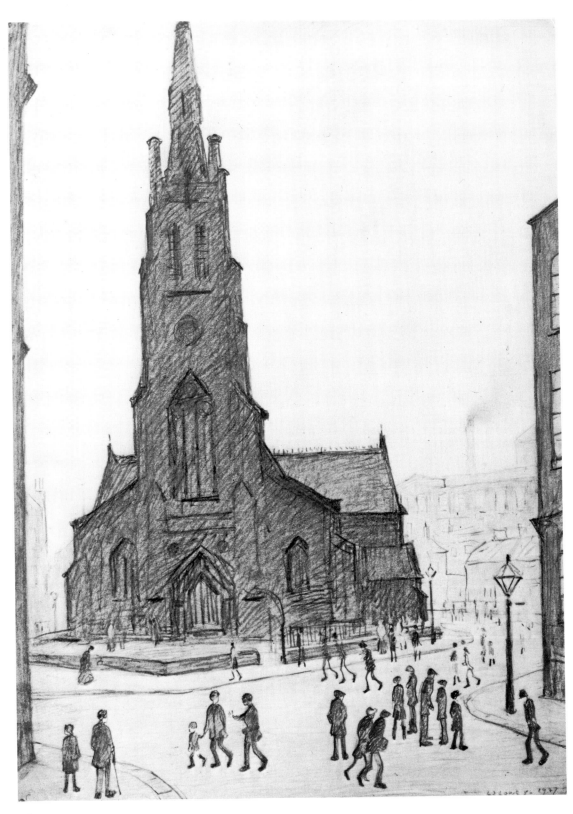

98

ST SIMON'S CHURCH

1927. Pencil 35.5 × 25.5 cm. Collection: City Art Gallery, Salford.

This drawing was made at the request of the artist's father. The church was demolished shortly afterwards, and in 1928 the artist made a painting based on this drawing (Plate 96, *The Paintings of L. S. Lowry*). Both now hang close together in the Art Gallery at Salford.

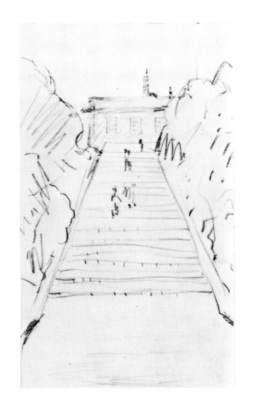

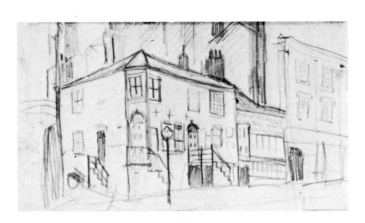
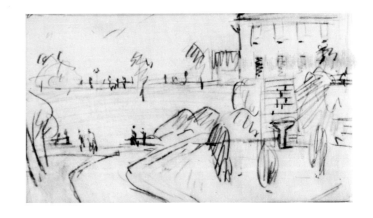

99

TWO SKETCHES OF PEEL PARK AND ONE OF GREAT ANCOATS
STREET, MANCHESTER

1927. Pencil. Each sketch is 20 × 12.5 cm. Collection: City Art Gallery, Salford.

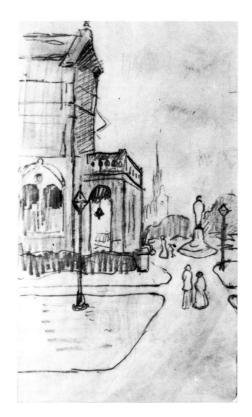 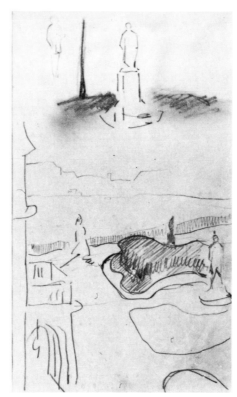

100

THREE SKETCHES FOR THE ARTIST'S PAINTING OF PEEL PARK

c. 1927. Pencil. Each sketch is 20 × 12 cm. Collection: City Art Gallery, Salford.

See Plate 4, The Paintings of L. S. Lowry.

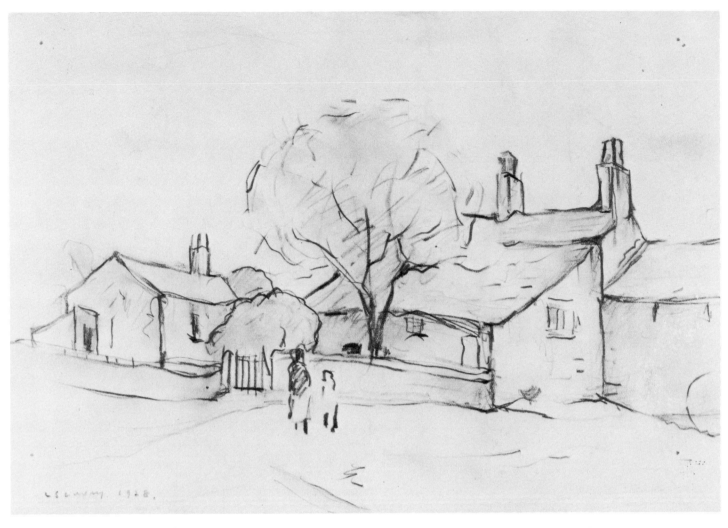

IOI

THE VILLAGE

1928. Pencil 17.1 × 24.7 cm. Collection: Lefevre Gallery.

During this period Lowry found great interest in the shapes of country houses and cottages, which made a pleasant contrast to the harsher architecture of the town.

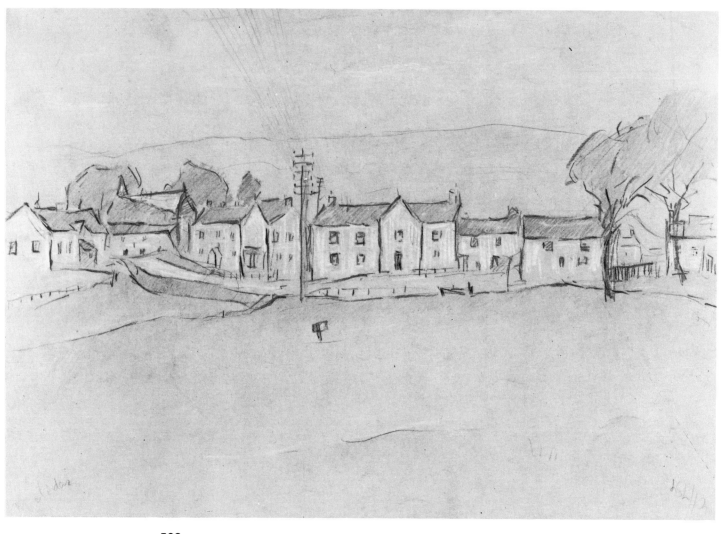

102

NEAR PRESTATYN, NORTH WALES

1928. Crayon and white chalk 24.7 × 34.9 cm. Collection: Lefevre Gallery.

A straggling cluster of houses, as dull and uninteresting as such scenes often are. The artist has captured the very feel of monotony, and seems to be saying, 'Not *everything* is interesting.'

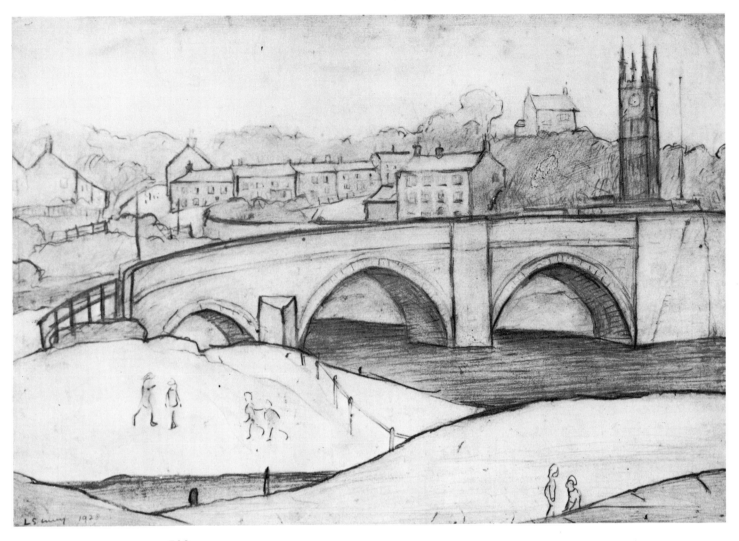

103

RINGLEY

1928. Pencil 47 × 58 cm. Collection: City Art Gallery, Salford.

An undulating composition using the swelling curves of the hills in the fore-
ground and the bridge behind to create a sense of strength and power.

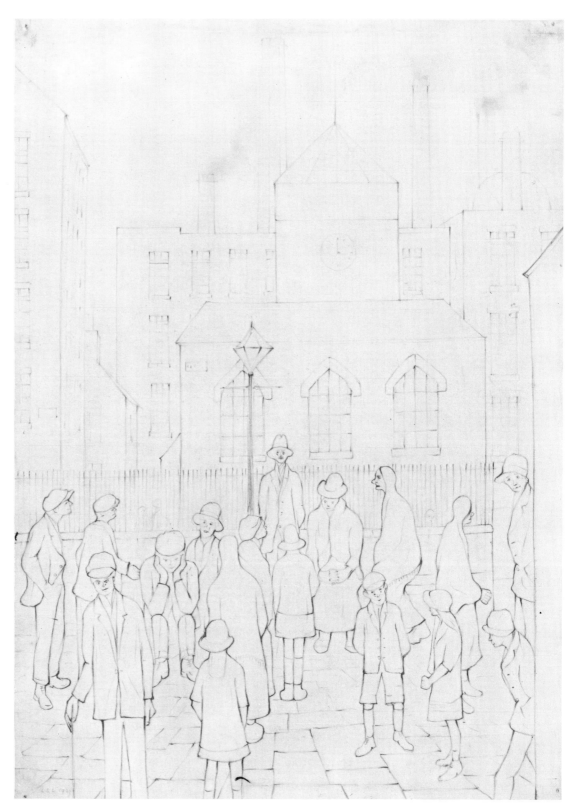

104

AN OPEN SPACE

1929. Pencil 37.5 × 26.7 cm. Collection: Lefevre Gallery.

Just as buildings can be monotonous, so can groups of people. This un-
interesting scene from everyday life epitomizes the humdrum routine of
human comings and goings. The very choice of title seems to suggest tedium.
Nothing is happening. Art does not always have to be exciting.

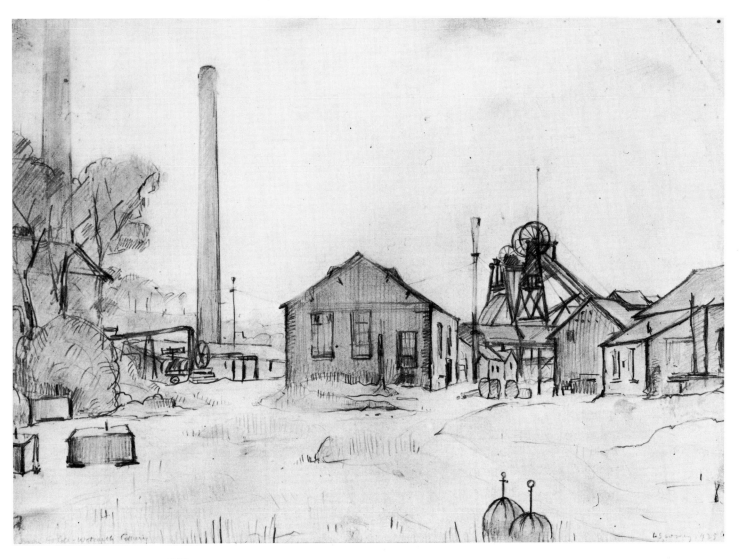

105

WETEARTH COLLIERY, DIXON FOLD

1929. Pencil 25 × 34.5 cm. Collection: City Art Gallery, Salford.

Here the artist shows the encroachment of industrial decay into the province of nature: a strange, antagonistic contrast – and an inevitable one.

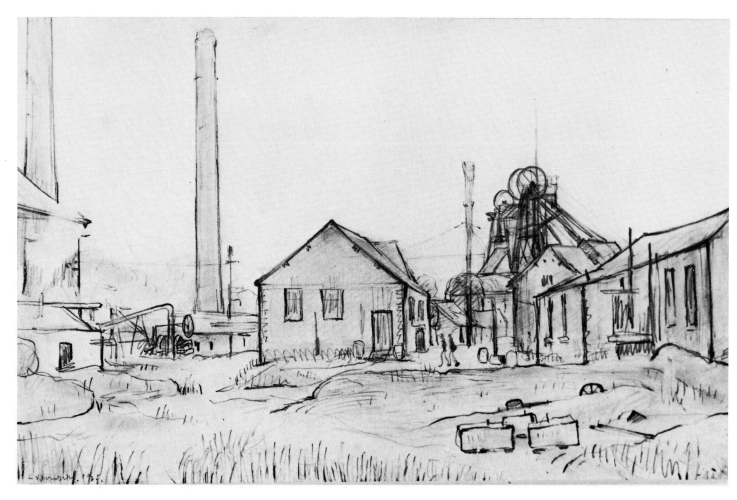

106

WETEARTH COLLIERY, DIXON FOLD

1929. Pencil 25 × 34.5 cm. Collection: City Art Gallery, Salford.

Another view of the colliery showing the encroachments of industry into the rural scene. Although the artist later dated this drawing 1925, it is the opinion of the curator of the City Art Gallery, Salford, that the drawing was in fact made in 1929 (cf. Plate 105).

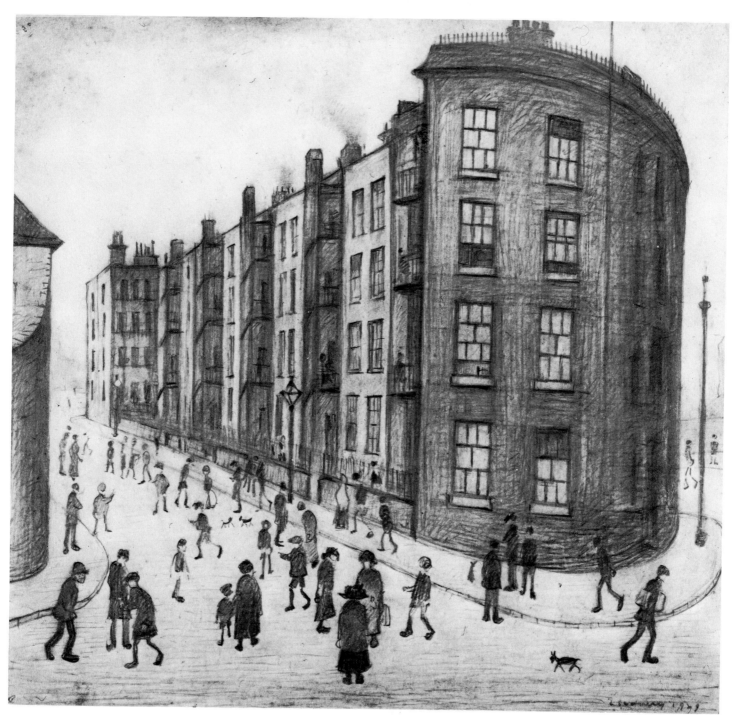

107

OLDFIELD ROAD DWELLINGS

1929. Pencil 36 × 38 cm. Collection: City Art Gallery, Salford.

The location of this drawing is Ordsall Lane, Salford. A painting of the same subject is in the Tate Gallery, London.

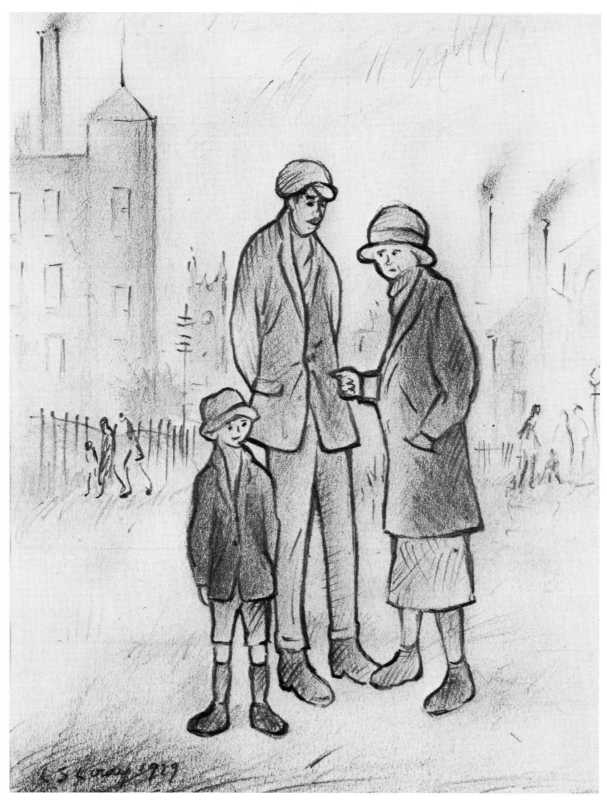

108

A FAMILY DISCUSSION

1929. Pencil 21.6 × 17.1 cm. Private collection.

A striking period depiction of local types. Note the clumsy, ill-fitting garments typical of the Depression era.

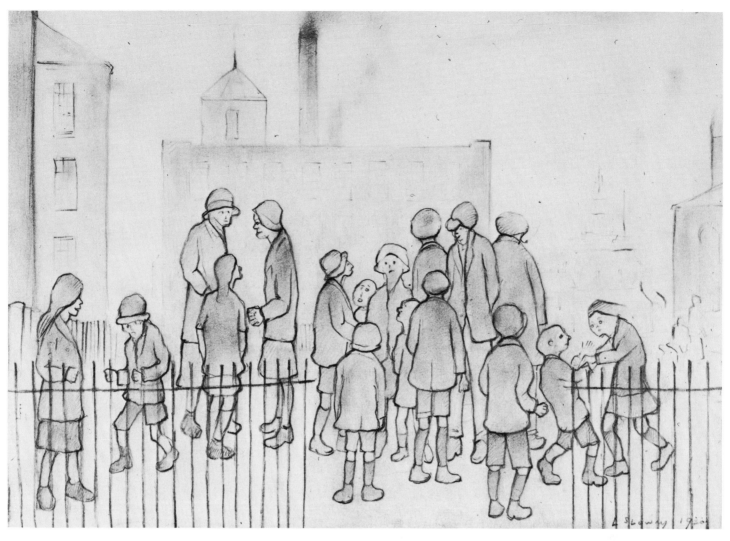

109

WAITING FOR THE NEWSPAPERS

1930. *Pencil 25 × 34 cm. Collection: City Art Gallery, Salford.*

Another highly informative social document showing the dress of working people and their children.

110

VIEW OF MORTON MOSS

c. 1930. Pencil 44 × 56 cm. Collection: City Art Gallery, Salford.

A spirited landscape drawing which shows how freshly and spontaneously the artist could draw, and how variable was his technique. Compare the style of this drawing with that of the preceding study.

III

FARM AT WARDLEY MOSS

1930. *Pencil 44 × 56 cm. Collection: City Art Gallery, Salford.*

During this period Lowry was working in a variety of styles. This is another example of his free, spontaneous method of drawing.

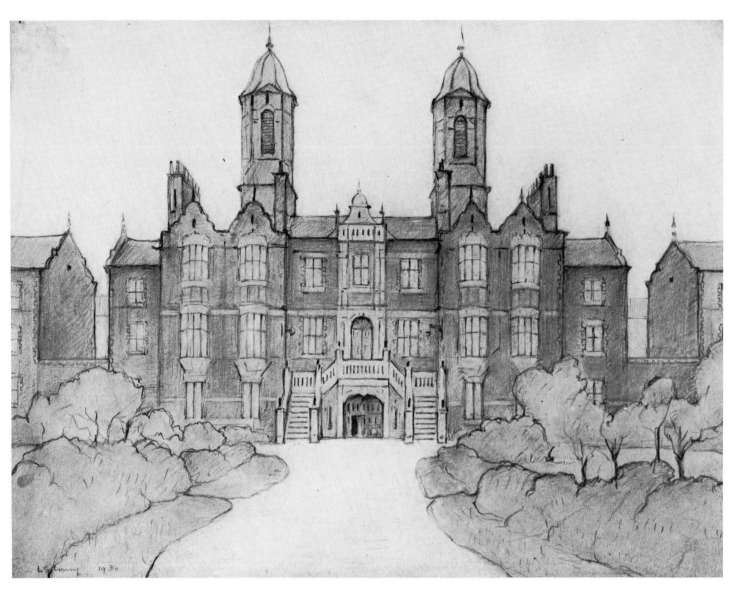

112

1930. Pencil 48 × 56 cm. Collection: City Art Gallery, Salford.

A brilliantly majestic drawing executed with meticulous care and elaborate detail.

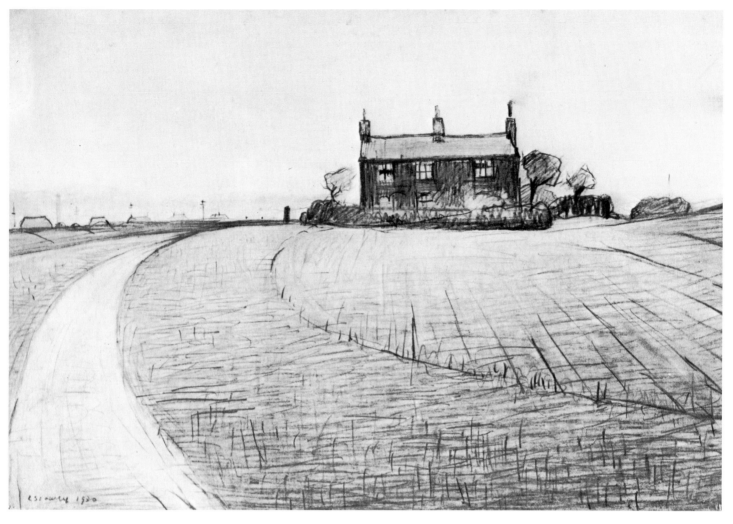

113

THE GAMEKEEPER'S COTTAGE, SWINTON MOSS

1930. *Pencil 46 × 56.5 cm. Collection: City Art Gallery, Salford.*

Lowry's ability to create 'space' was phenomenal. Here he has intensified the quality of space by isolating the cottage and reducing its surroundings to a minimum.

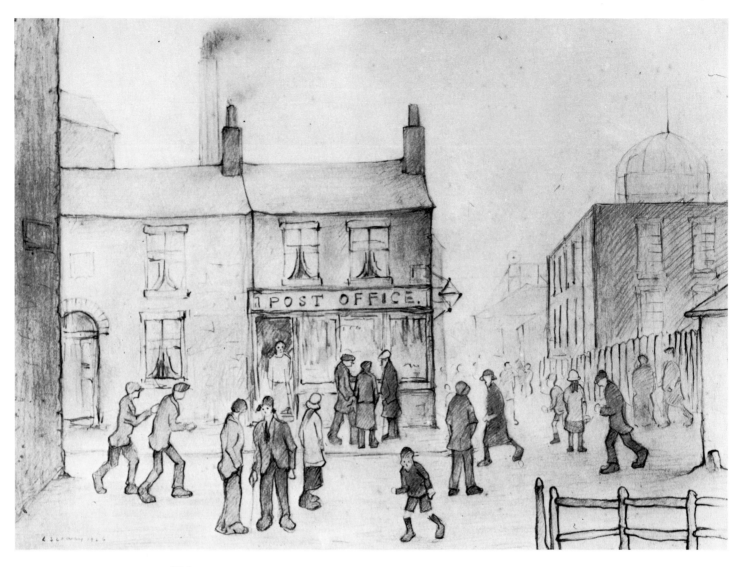

114

WAITING FOR THE NEWSPAPERS

1930. Pencil 25 × 34 cm. Collection: City Art Gallery, Salford.

A similar subject to Plate 109. Here Lowry has introduced buildings and has constructed a more elaborate composition. (Signed and dated later by the artist, inaccurately, as 1926.)

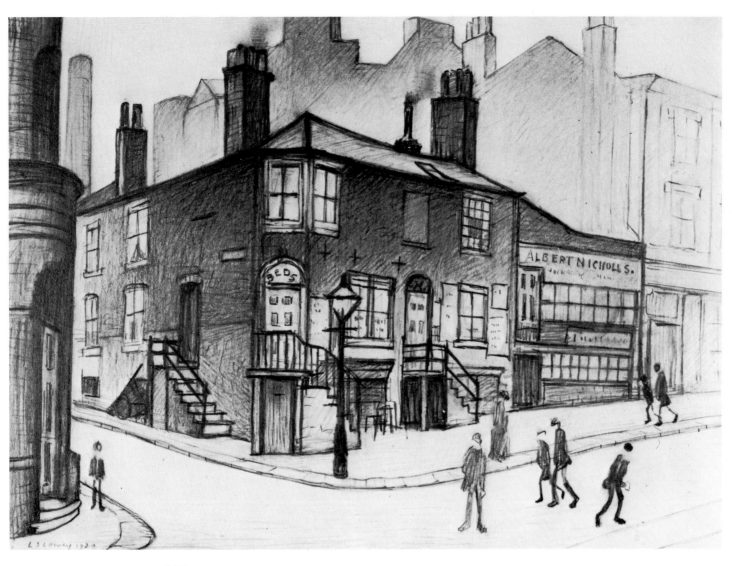

115

GREAT ANCOATS STREET, MANCHESTER

1930. *Pencil 27.5 × 37.5 cm. Collection: City Art Gallery, Salford.*

A fine topographical document drawn with great care and attention to detail. The spacing of the figures is very subtle, and the perspective of the scene superb. From this drawing alone one can see how well Lowry had mastered the elements of academic – and scientific – drawing by this time.

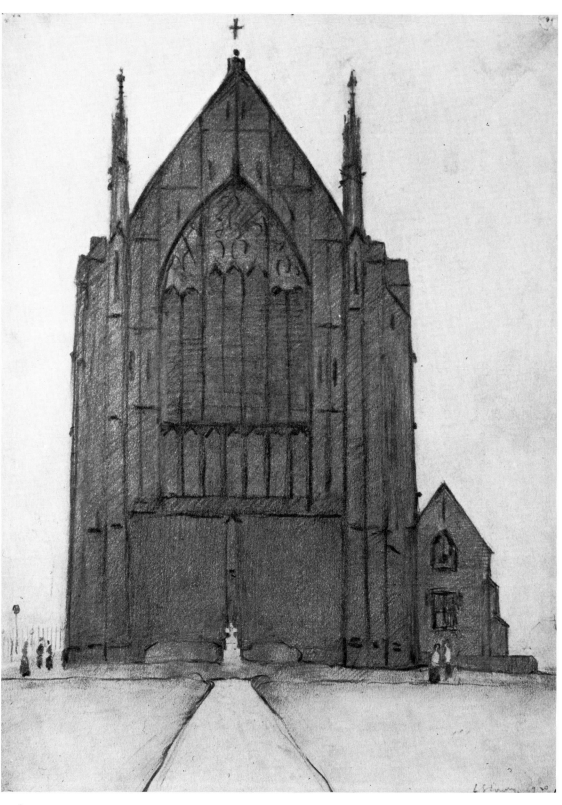

116

ST AUGUSTINE'S CHURCH, PENDLEBURY

1930. Pencil 35.5 × 26 cm. Collection: City Art Gallery, Salford.

A remarkable example of the extent to which Lowry could invest his buildings with 'personality'. This towering edifice, dwarfing the tiny human figures, has enormous presence.

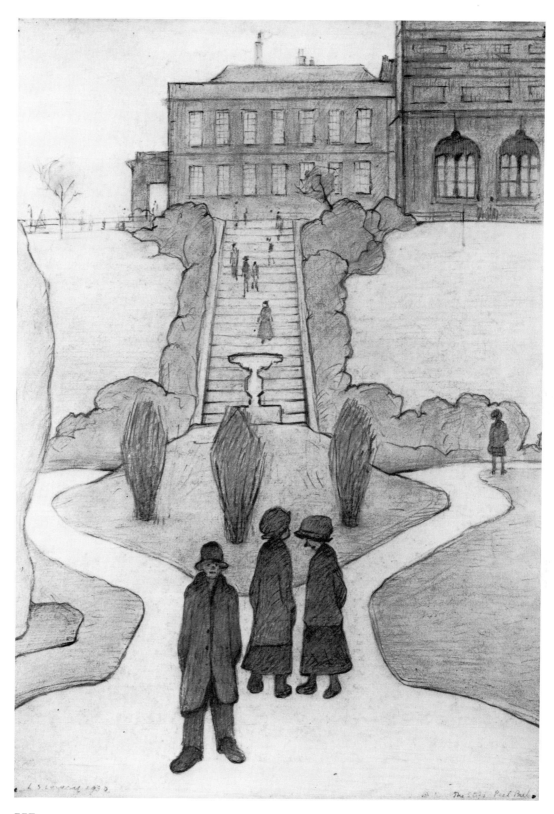

117

THE STEPS, PEEL PARK

1930. Pencil 38.5 × 26.5 cm. Collection: City Art Gallery, Salford.

An important topographical document, since the building on the left has long since been demolished.

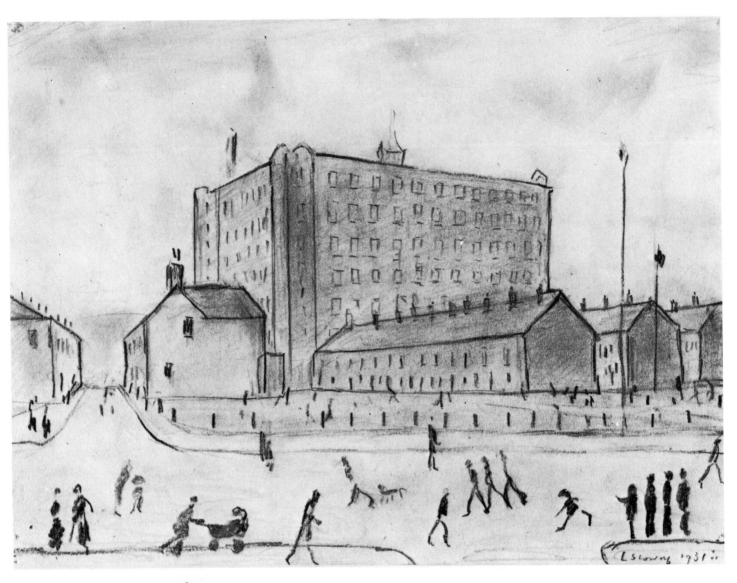

118

PENDLEBURY SCENE

1931. Pencil 49 × 57 cm. Collection: City Art Gallery, Salford.

Here the artist concentrates upon the vitality of the people rather than upon the buildings. The figures are drawn in a fresh, brisk, annotated style.

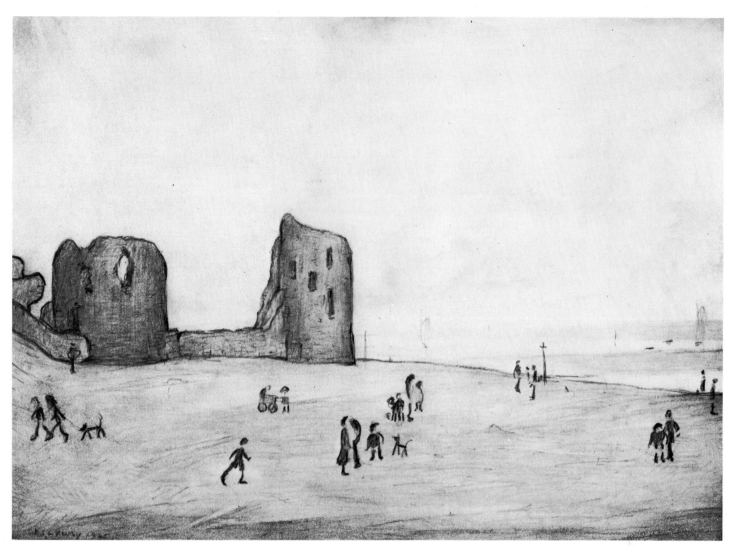

119

FLINT CASTLE

1935. Pencil 25.4 × 35.6 cm. Collection: Lefevre Gallery.

A factual drawing, but one in which the figures are drawn with a rugged expressionism. By this time Lowry had devised a masterly symbol for the dog.

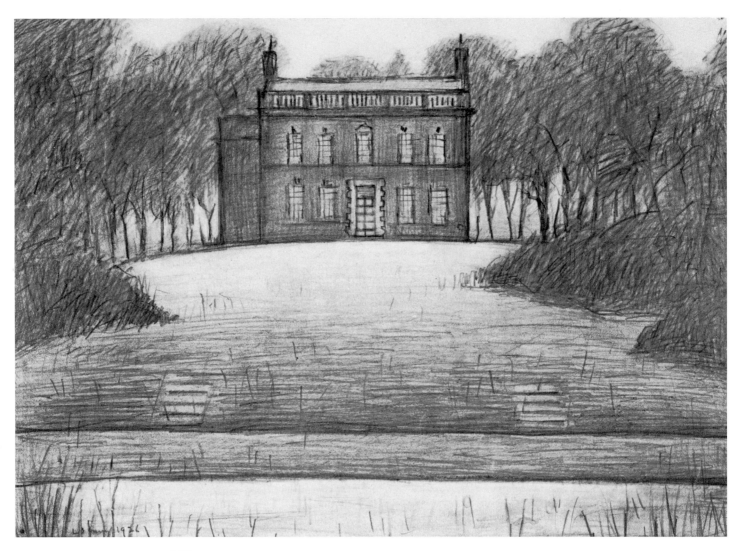

120

OLD HOUSE

1936. *Pencil 24.7 × 34.9 cm. Collection: Lefevre Gallery.*

This and the following drawing belong to a group of drawings and paintings all made at about the same time, and taking an old house as the theme. The architectural features of the house often vary, and it is mainly a composite image. (Dated later by the artist as 1926.)

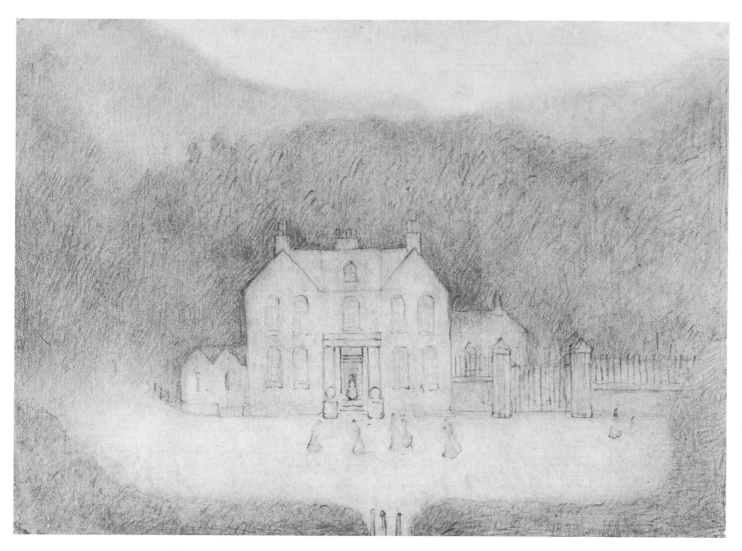

121

OLD HOUSE

c. 1936. Pencil 25.4 × 35.6 cm. Collection: Lefevre Gallery.

Here the artist has introduced a few ghostly figures in period dress into the scene.

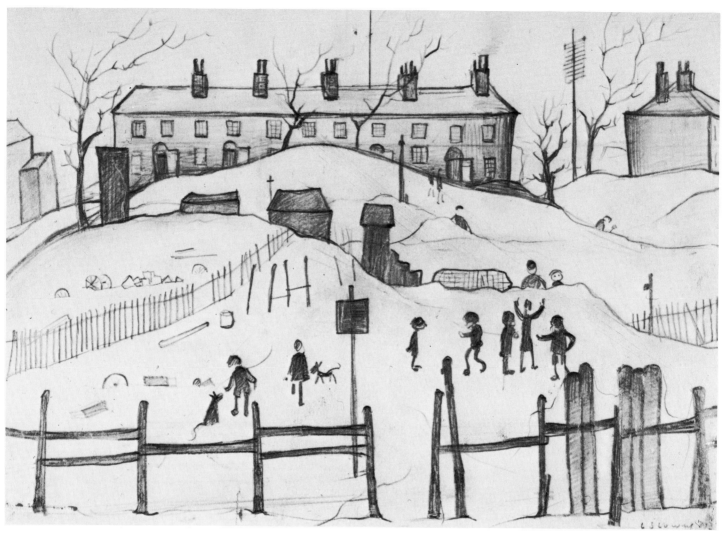

122

HOUSES IN BROUGHTON

1937. Pencil 25 × 35.5 cm. Collection: City Art Gallery, Salford.

This drawing is really devoted to the subject of children at play. The artist was always very fond of children and found that their movements made 'interesting shapes'.

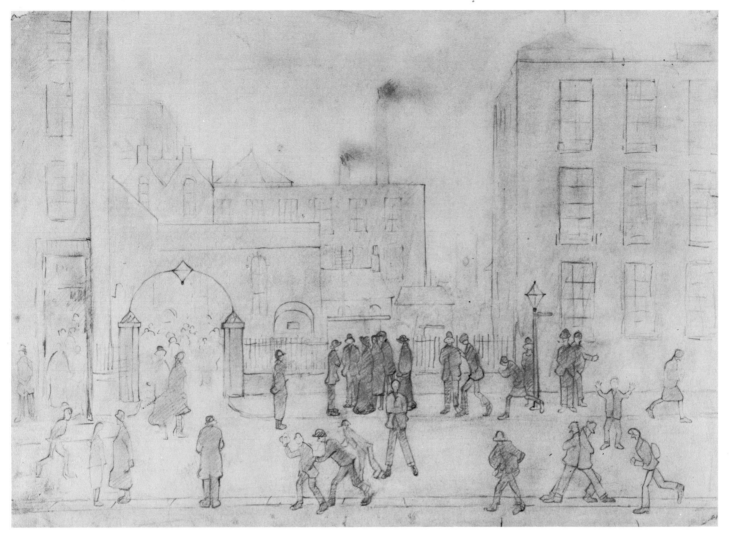

123

MILL GATES

c. 1938. Pencil 24.7 × 34.9 cm. Collection: Lefevre Gallery.

The main interest of this drawing is contained in the activities of the figures.
The setting is now predictable and is firmly established in the mythology of
the artist's standard imagery. But the antics of the figures sound a highly
amusing note.

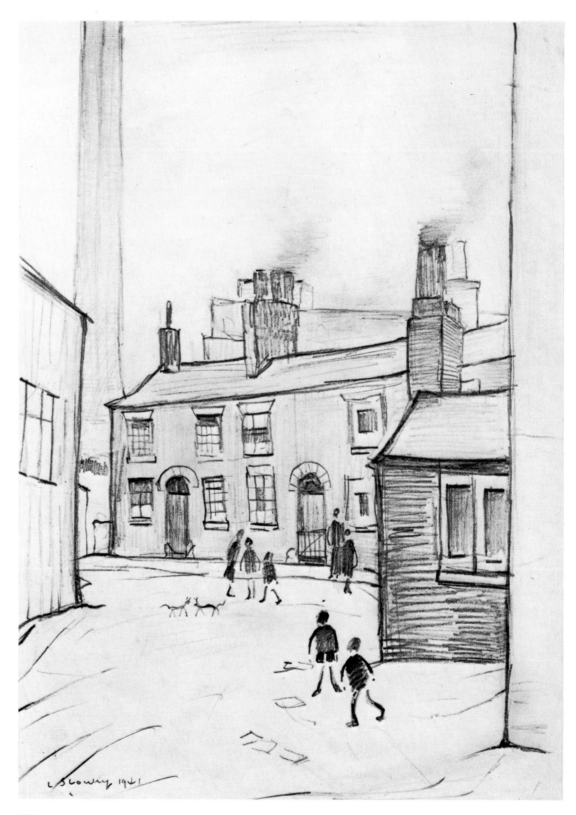

124

INDUSTRIAL SCENE, DROYLSDEN

1941. *Pencil 27.9 × 20.3 cm. Private collection.*

As in Plate 122, children are here the main focus of the artist's interest.

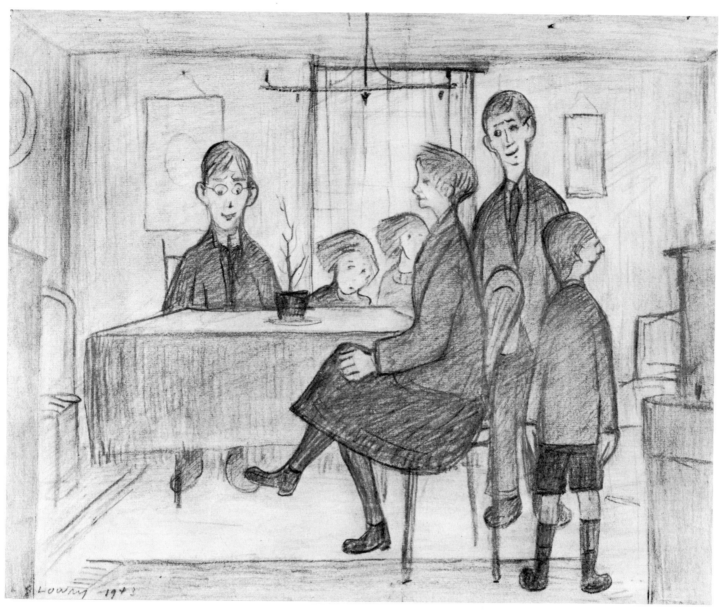

125

THE FAMILY

1943. *Pencil 28 × 35 cm. Private collection.*

Between the mid 1930s and the mid 1940s the artist made a number of
'composite' drawings and paintings on the theme of 'The Family'. Many
are stiff and formal, but this one is conceived in a much lighter and more
humorous vein. The subject is the problem of communication. Here the
characters actually seem to be on the brink of establishing contact with
one another.

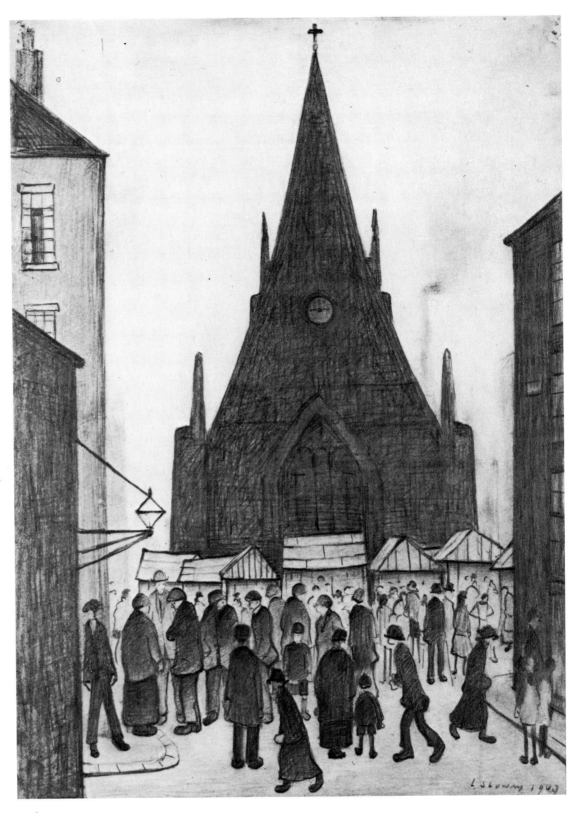

126

MARKET DAY

1943. Pencil 38.1 × 27.9 cm. Private collection.

A drawing which has a strange, unreal quality about it. The church broods over the people, its presence almost sinister. The element of the surreal was sometimes created by Lowry.

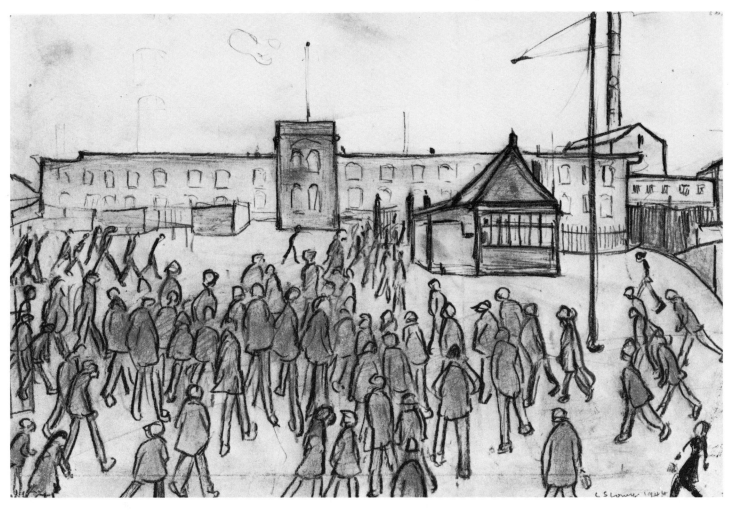

127

EARLY MORNING

c. 1944. *Pencil 24.1 × 35.6 cm. Collection: Lefevre Gallery.*

A vigorous rendering of a scene which calls for a vigorous approach. Here the artist has captured the feel of people hurrying briskly to work, full of energy. It would hardly look like this today! However, to be fair, one must bear in mind that this drawing was made during the war years, when the people of this country had a purpose in life.

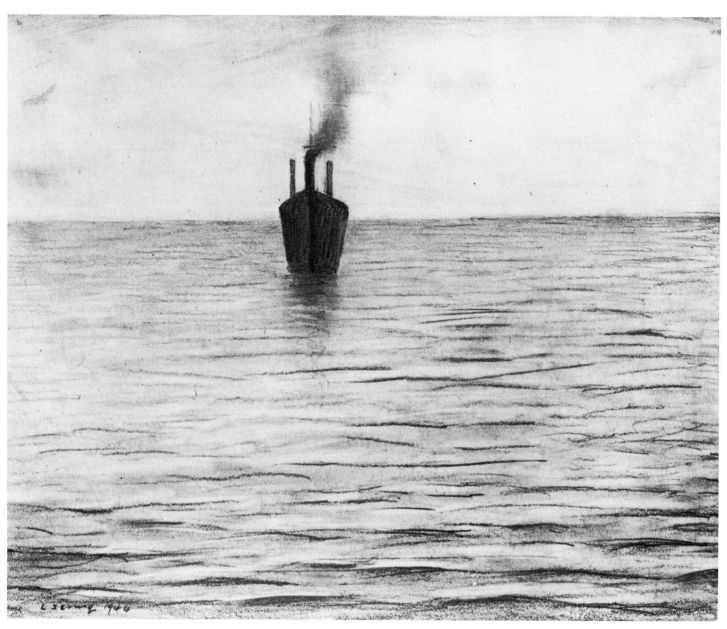

128

SEASCAPE

1944. Pencil 29.2 × 35.6 cm. Collection: City Art Gallery, Salford.

The placement of the ship in the expanse of sea, and the way in which it cuts the horizon line, shows how well the artist could compose his pictures.

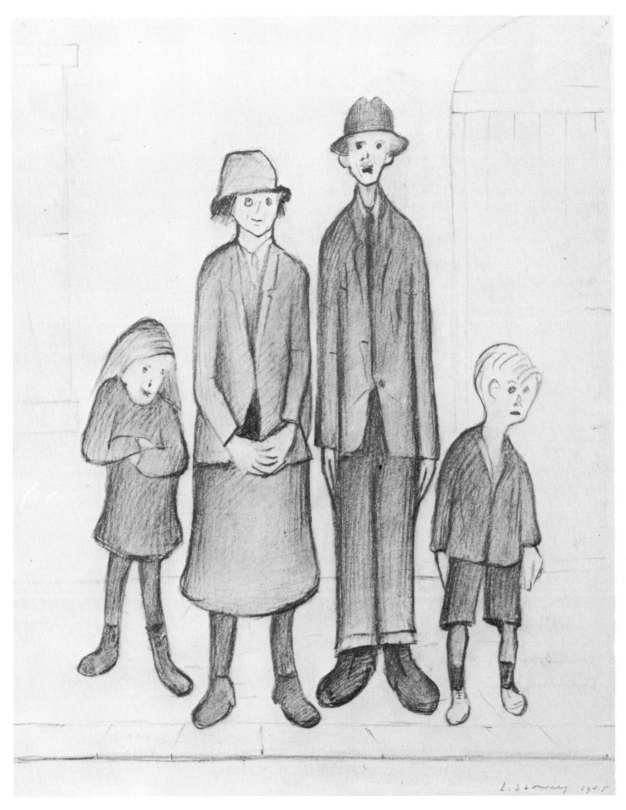

129

A FAMILY OF FOUR

1945. Pencil 34.9 × 27.9 cm. Collection: Lefevre Gallery.

Lowry frequently saw the family unit as idiotic – their general mood conditioned by a subtle cross-fertilization of idiocy. This is a delightful study of infectious and genetic imbecility. The very title is withering.

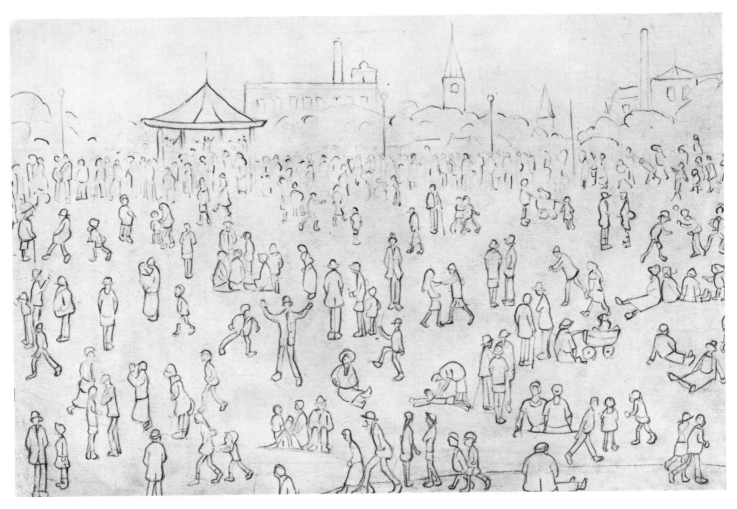

130

IN A PARK

c. 1945. Pencil 24.7 × 36.2 cm. Collection: Lefevre Gallery.

An experimental figure composition, full of humour and eccentricity. Lowry always had a keen eye for the compulsive paranoiacs of the average park scene. Look at the high-stepping figure of the man in the centre.

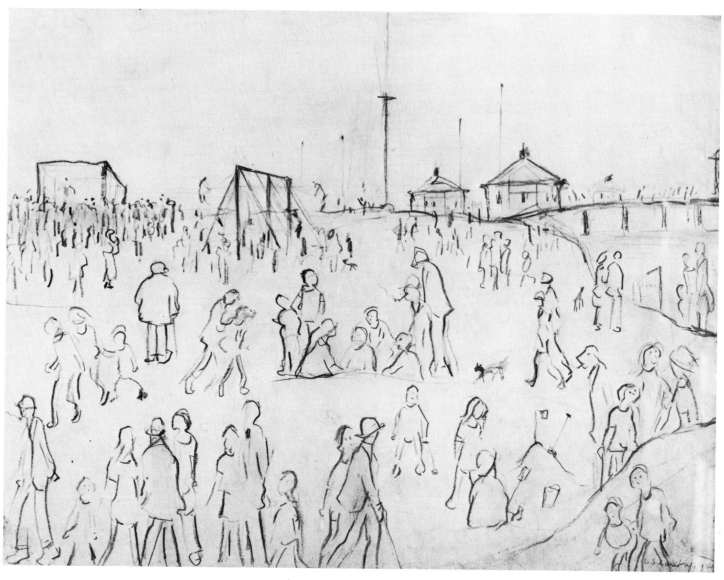

131

BEACH SCENE

1945. Pencil 29.5 × 39.5 cm. Collection: Arnold and Lydia Solomon.

One of a series of beach scenes drawn in the same year and differing only in composition. Here the artist explores the problems of relating figures to one another and to their setting. Trace for yourself the subtle rhythms which hold the composition together.

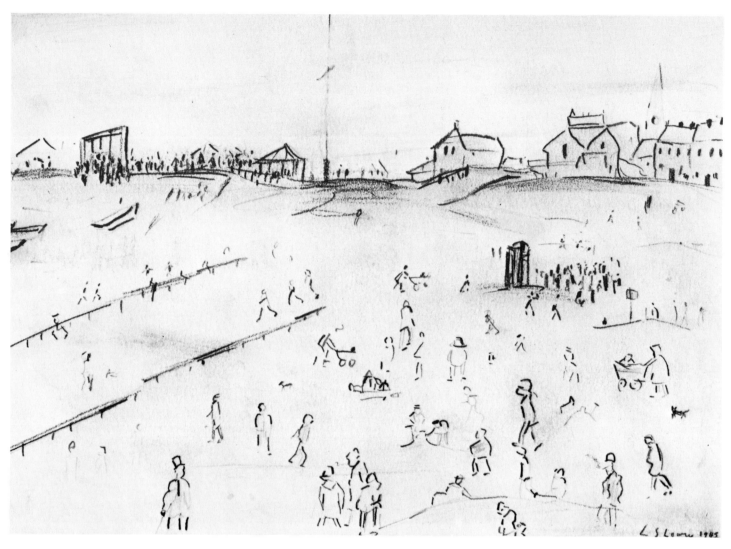

132

BEACH SCENE

1945. *Pencil 17.1 × 24.1 cm. Private collection.*

See note for the previous plate.

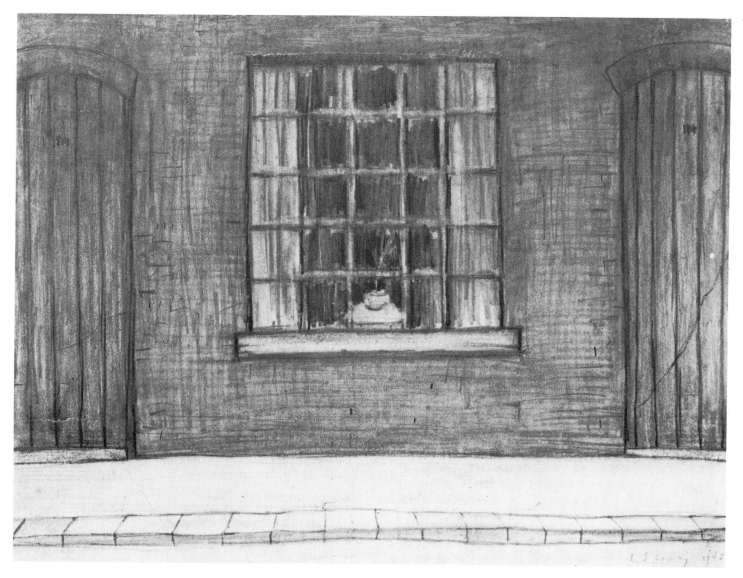

133

FLOWERS IN A WINDOW

1945. Pencil 25.4 × 34.3 cm. Private collection.

A subject of the greatest simplicity, yet one possessing immense presence. Here the artist shows how much can be extracted from what appears to be very little. This is the essence of great art. Van Gogh did exactly the same thing with little more than his chair.

134

NECROPOLIS, GLASGOW

1946. Pencil 29.8 × 36.8 cm. Collection: City Art Gallery, Salford.

A superbly moody and glowering cemetery scene. By omitting any figures the artist has greatly increased the 'atmosphere'.

135

THE DRIVE, OAKLANDS

1947. Pencil 35.6 × 25.4 cm. Collection: City Art Gallery, Salford.

To get the most out of Lowry's drawings, one should constantly compare the styles in which he could work. There is great variety in his repertoire. Here he uses a powerful system of cross-hatching to create his effect.

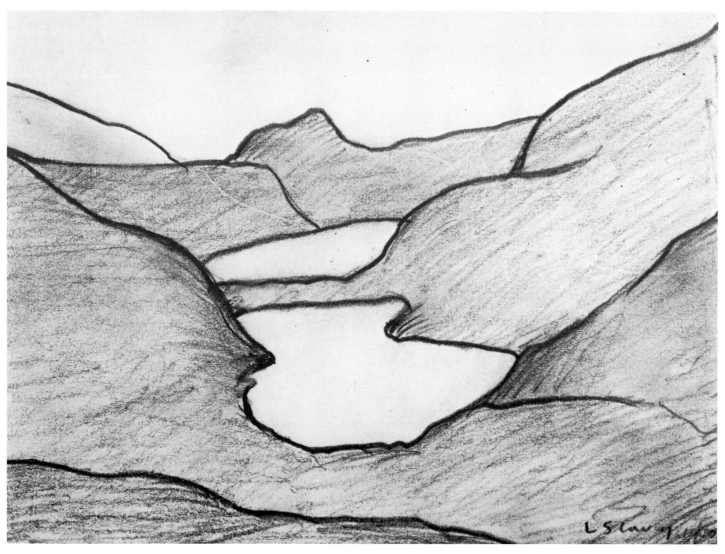

136

LAKE SCENE

1950. *Pencil 12.7 × 17.1 cm. Private collection.*

A drawing in which the artist explores the relationship between the shapes of the water and the shapes of the surrounding hills.

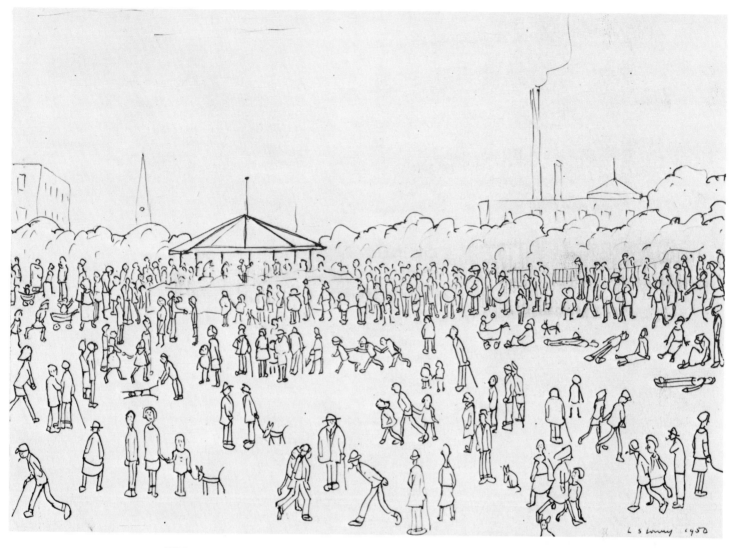

137

BAND STAND

1950. *Ballpoint 26 × 36.2 cm. Private collection.*

A late return to the line style of the twenties, but here the method of expression is much freer and more relaxed. The drawing brims with humour, and contains a number of caustic asides on the appearance of poor *Homo sapiens*.

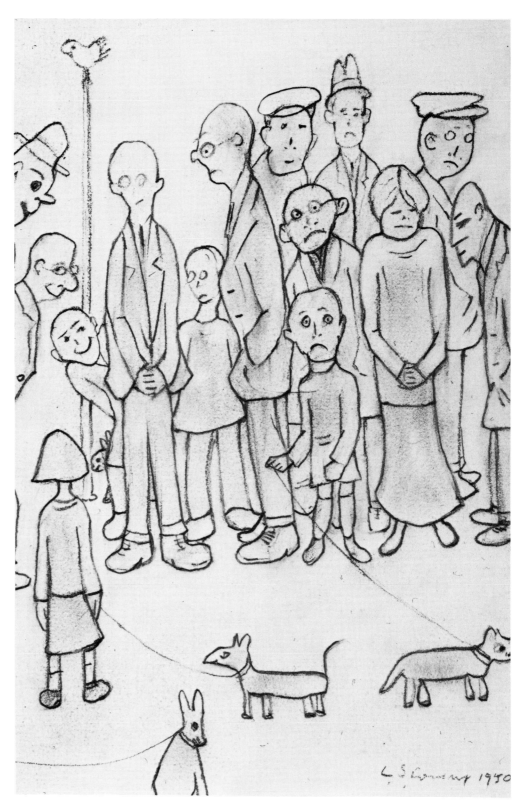

138

A CROWD

1950. Pencil 25.4 × 17.8 cm. Private collection.

When he wished Lowry could be extremely cruel about his fellow men.
There is always a lot to be cruel about, and he saw it, and drew it – relent-
lessly. This drawing is a testament to human idiocy. Even the animals are
absurd.

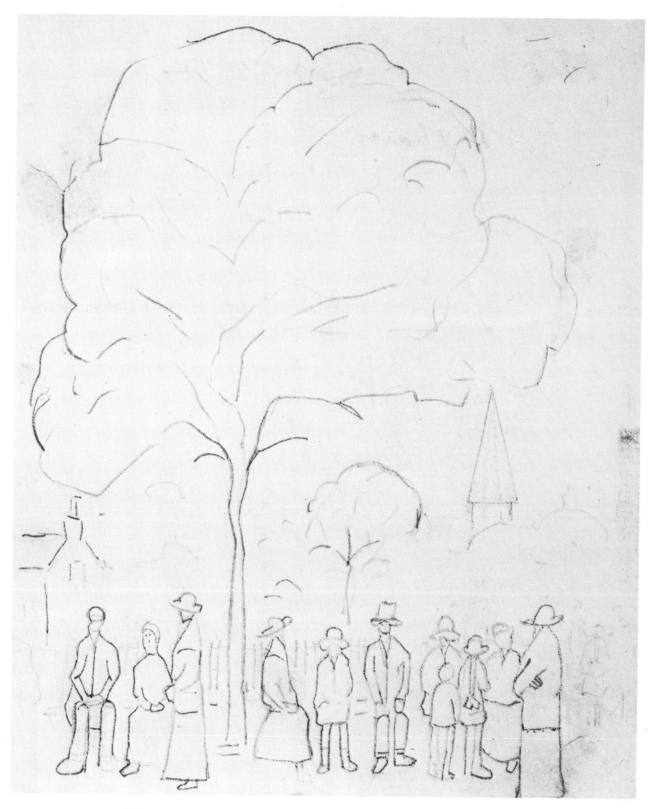

139

FIGURES IN THE PARK

c. 1950. Pencil. Size unknown. Private collection.

An intentionally clumsy drawing, peasant-like in feel. It is another point at which one can place Lowry among the artists of the earthy school: the Barbizon painters such as Millet, and later Van Gogh.

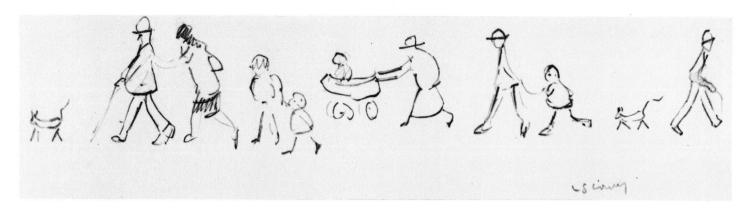

140

THE WALK

c. 1952. Pencil 10 × 27.2 cm. Collection: Simone Solomon.

Simply a panorama of life, with one individual, the artist (far right), contemptuously turning his back on it all.

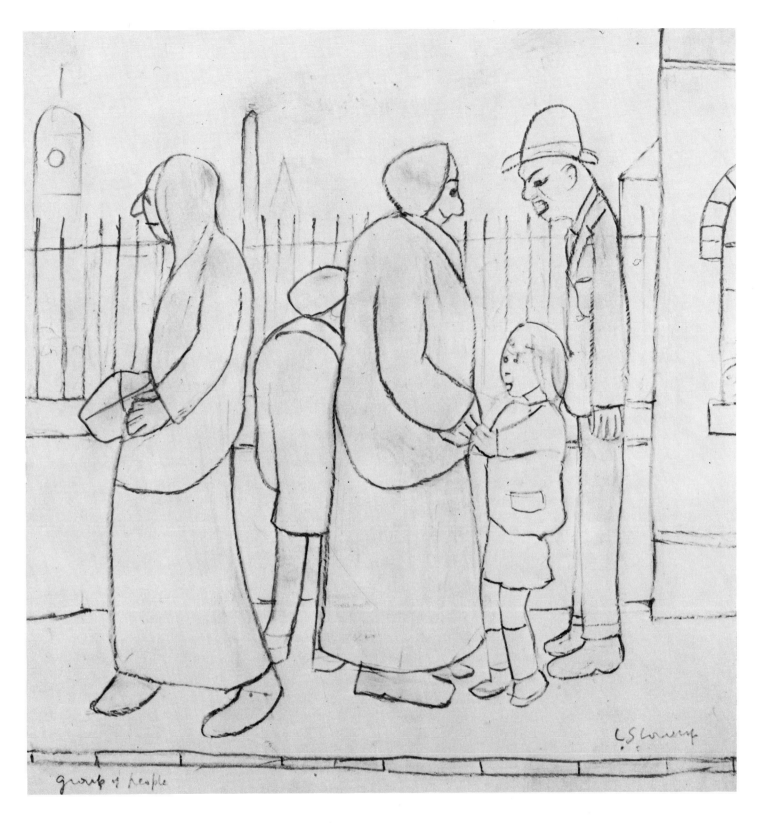

group of people

141

GROUP OF PEOPLE

c. 1952. Pencil 21.6 × 20.3 cm. Private collection.

Another study of human imbecility. The style of the drawing is expressionistic. Lowry often employed the expressionist method of distortion, almost as a caricaturist does. In this way he intensified the significance of his imagery.

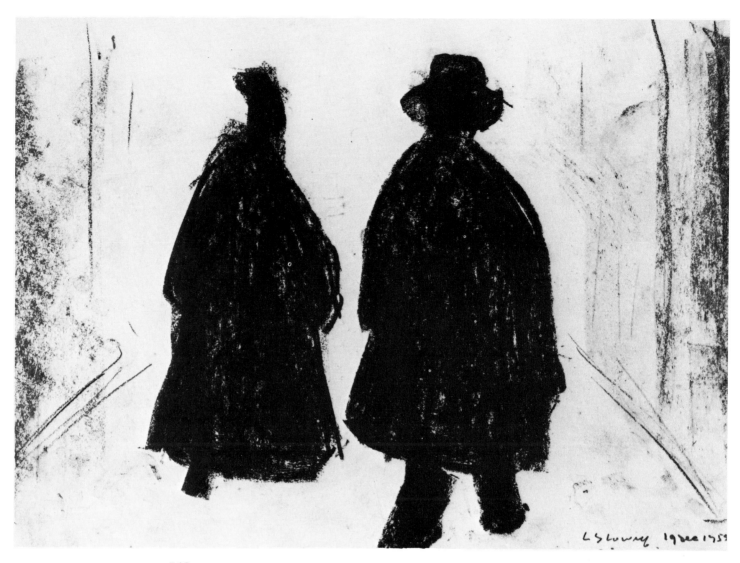

142

AN OLD COUPLE

1953. Black chalk 26.7 × 36.2 cm. Private collection.

By distorting the silhouette shapes of these two characters, the artist has
conveyed the clumsy shapelessness of old age. Chalk was used only occa-
sionally by Lowry, but here he has made full use of the broad potential of
the medium to create a simple, bold sense of bulk.

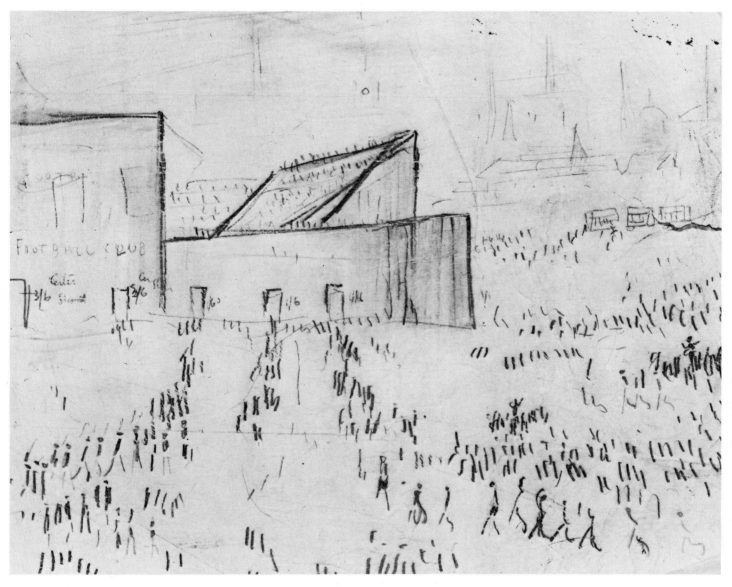

143

GOING TO THE MATCH

1953. Pencil 20.3 × 25.4 cm. Private collection.

This is a first notation for a painting of the same title, which was also painted in 1953. The drawing of the crowd is brilliantly impressionistic.

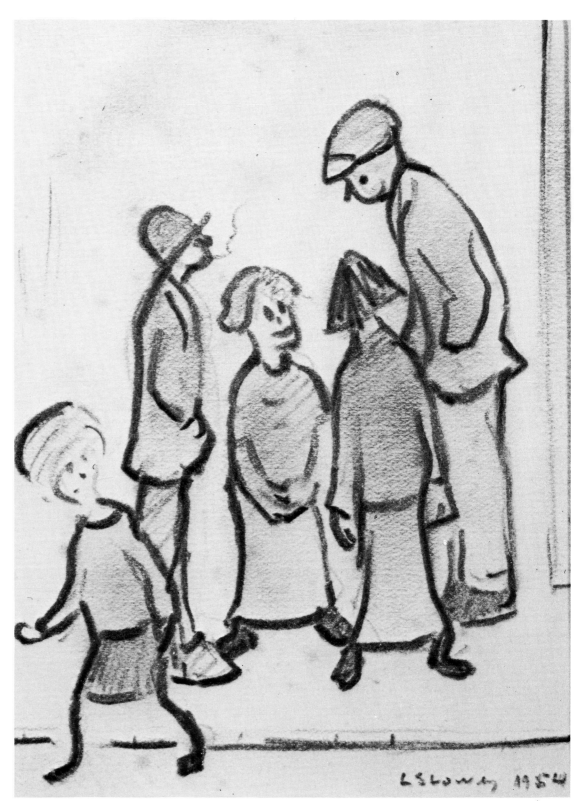

144

A GROUP

1954. *Pencil 11.5 × 8.9 cm. Private collection.*

Just people. The drawing is virtually a caricature. In fact the artist would have made a fine cartoonist.

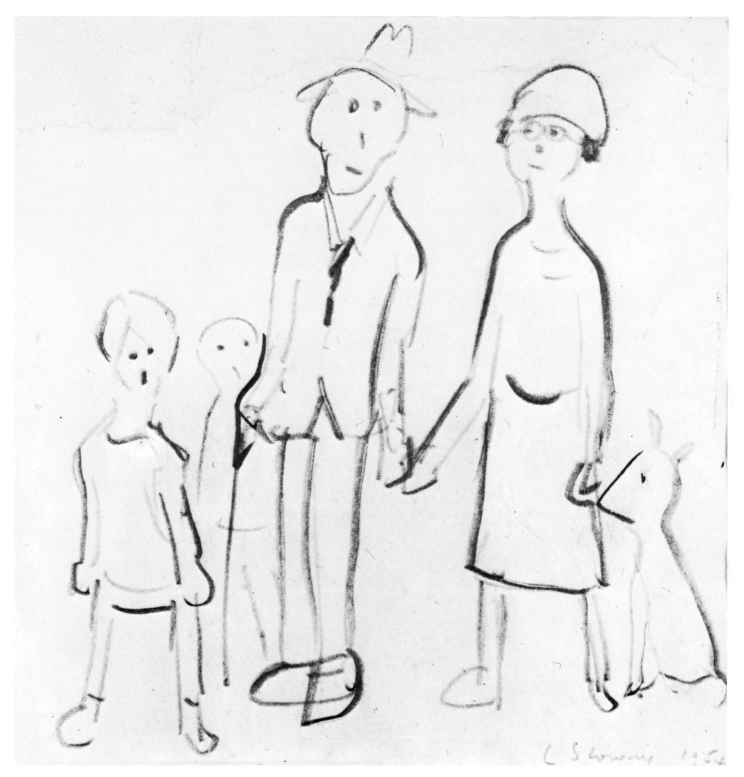

145

FAMILY GROUP

1954. Pencil 15.2 × 15.2 cm. Private collection.

By the skill of his editing, by the process of leaving out, Lowry squeezes the very essence of the subject raw onto the paper. This is the average family *in extremis.*

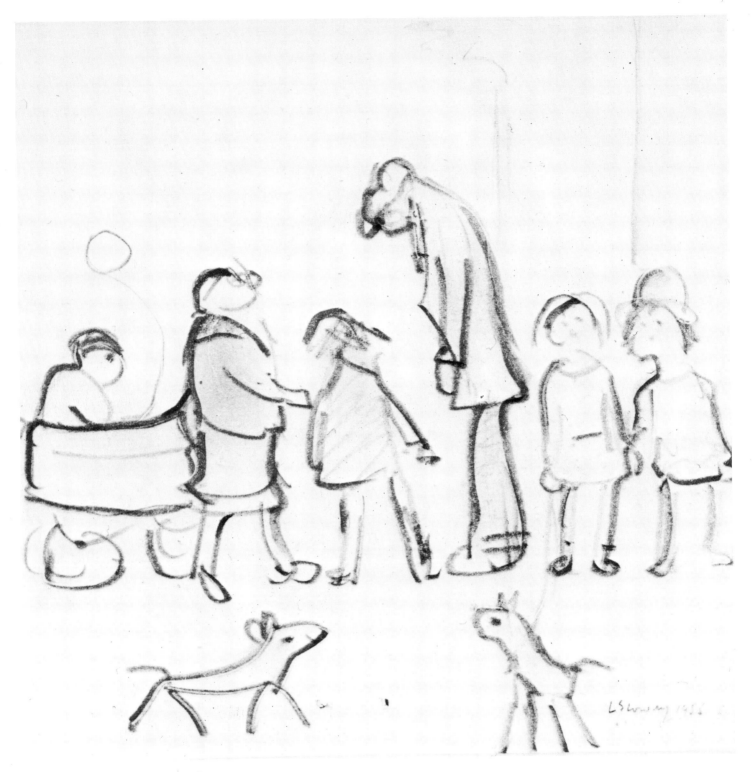

146

THE NAUGHTY HUSBAND

1955. *Pencil 15.2 × 15.2 cm. Private collection.*

As in the previous drawing the artist here takes a basic subject and, by editing out the superfluous detail, conveys the exact mood of the situation. It is humorous and cruel – and that is life.

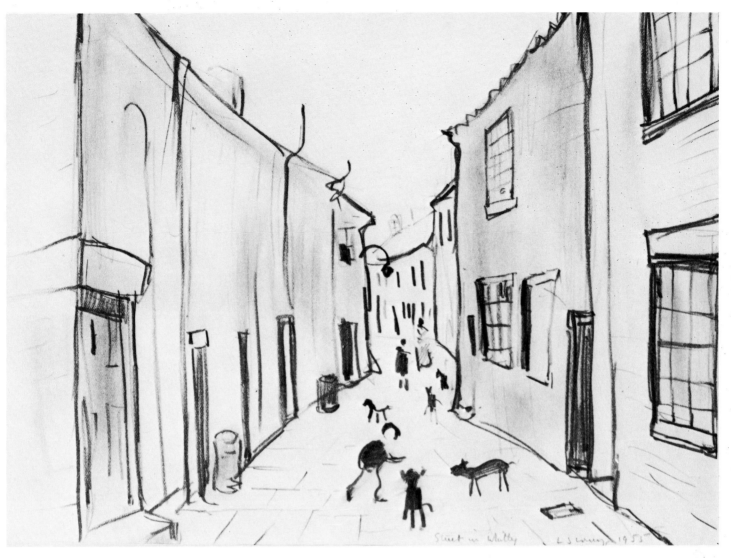

147

STREET IN WHITBY

1955. *Pencil 20 × 27 cm. Private collection.*

Drawn at the close of the artist's 'high' period, and moving towards the relaxed, free style that he was to develop towards the close of the fifties. The style is informal, the conception of the child and the animals delightfully mischievous. Or perhaps 'cheeky' would be a better description?

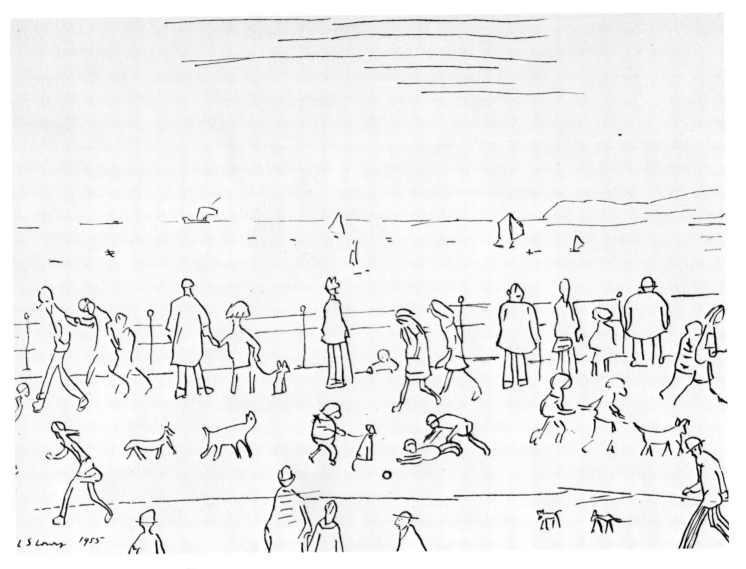

148

ON THE PROM

1955. Felt-tip pen 26 × 35.6 cm. Private collection.

Figures on the Promenade always fascinated Lowry and provided him with a prime source of inspiration in his later years. This is one of many similar drawings made at Sunderland. There is great humour in the figures and their activities.

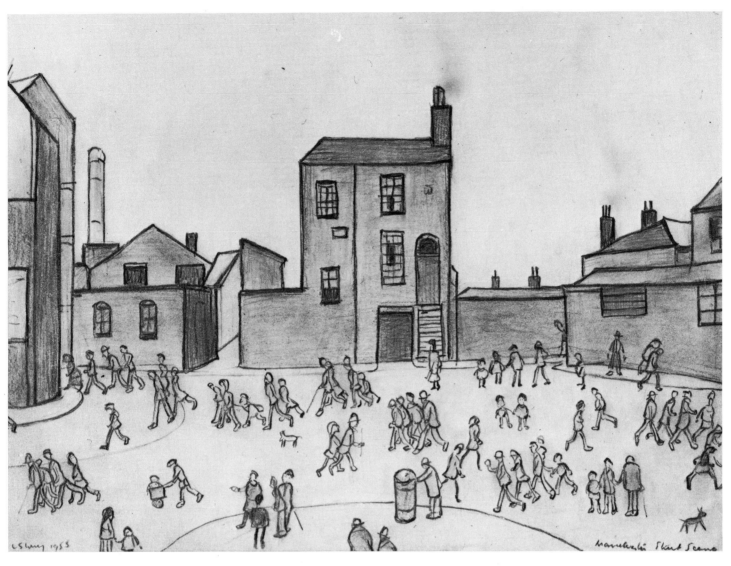

149

MANCHESTER STREET SCENE

1955. *Pencil 27.9 × 37.5 cm. Private collection.*

An amusingly satirical portrayal of 'man on the move'. The picture is full of interest and repays close scrutiny.

150

HEAD OF A YOUNG MAN

1955. Pencil 35.6 × 26 cm. Private collection.

An imaginary portrait which seems to stem from the self-portraits of the thirties. Most of the artist's portrait drawings of later years were either imaginary, 'composite', or autobiographical.

151

AN ARTIST AT WORK

1955. Pencil 33 × 24.1 cm. Collection: Lefevre Gallery.

Lowry was always deeply suspicious of people who *looked* like artists. This
drawing is a delicious satire on the bohemian type. I can hear him saying,
'Oh, good God, sir! He'll never do anything on that canvas one half as
interesting as he looks himself! D'you think he'd be any good? Well, he
couldn't be - could he - not looking like that!'

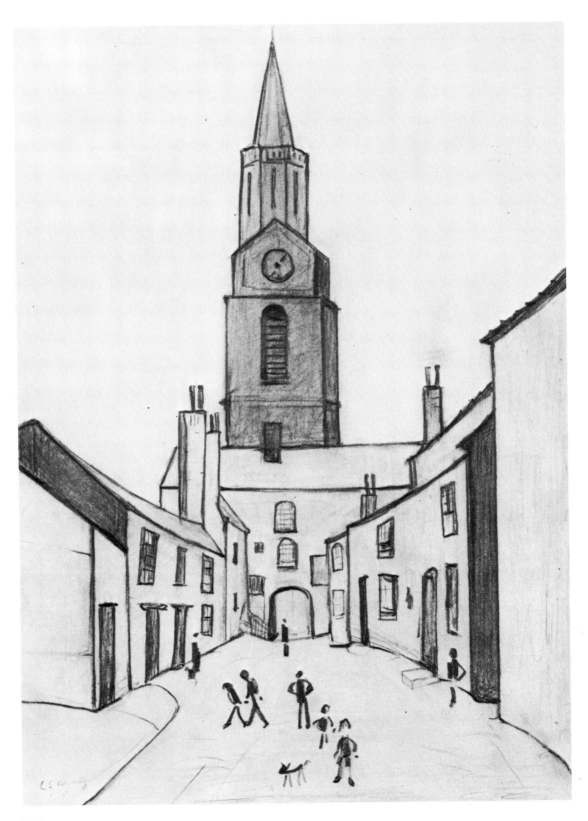

152

OLD BERWICK

c. 1956. Pencil 34.3 × 24.1 cm. Collection: Lefevre Gallery.

A gentle, restful view of an old town, somewhat reminiscent of Maurice Utrillo.

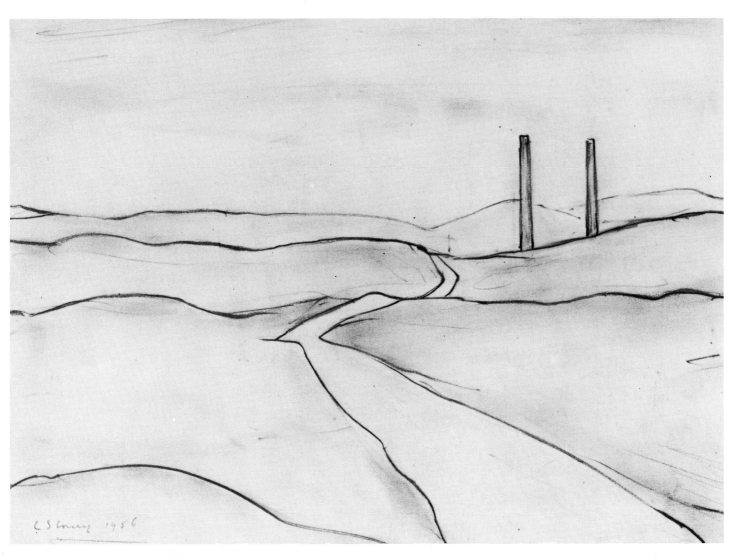

153

CORNISH TIN MINES

1956. *Pencil 38.1 × 45.7 cm. Private collection.*

A ruggedly drawn landscape using a very simple technique: strong lines, and a delicate smudging of the pencil-work.

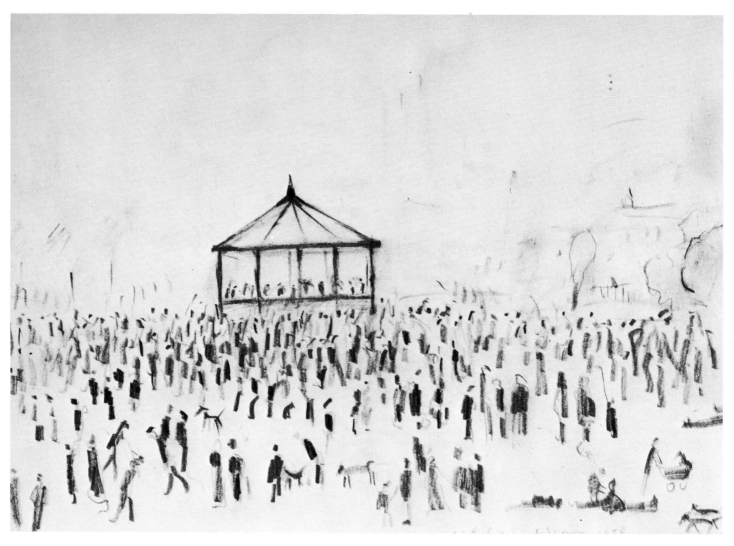

154

BAND STAND

1956. Pencil 26 × 35.6 cm. Private collection.

One of Lowry's favourite subjects. The figures are drawn in the impressionistic manner which he often used for crowds. Colour is also suggested by a subtle varying of the strength of the pencil-work.

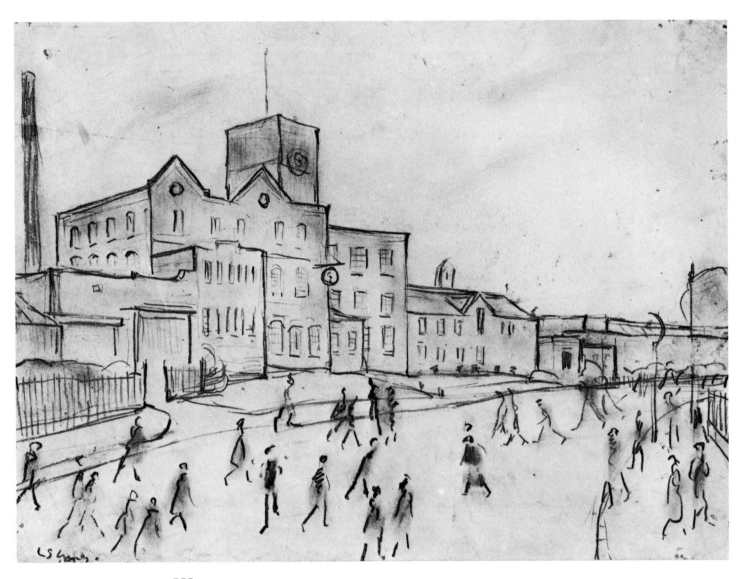

155

DEANS MILL, SWINTON

c. 1956. Pencil 47.5 × 57 cm. Collection: City Art Gallery, Salford.

Movement brilliantly suggested by brisk stabbing strokes of the pencil and
a spot of judicious rubbing. Once again one can see here something of the
great variety of styles the artist operated in in the making of his drawings.

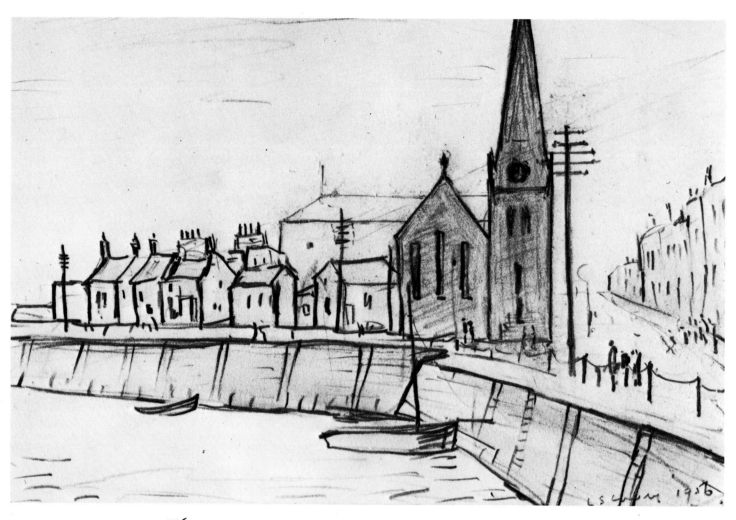

156

MARYPORT

1956. *Pencil 17.8 × 26.7 cm. Private collection.*

Like all really good artists, Lowry could make a picture out of the dullest of subjects. Of particular interest is the way in which he has drawn the figures with an absolute minimum of means.

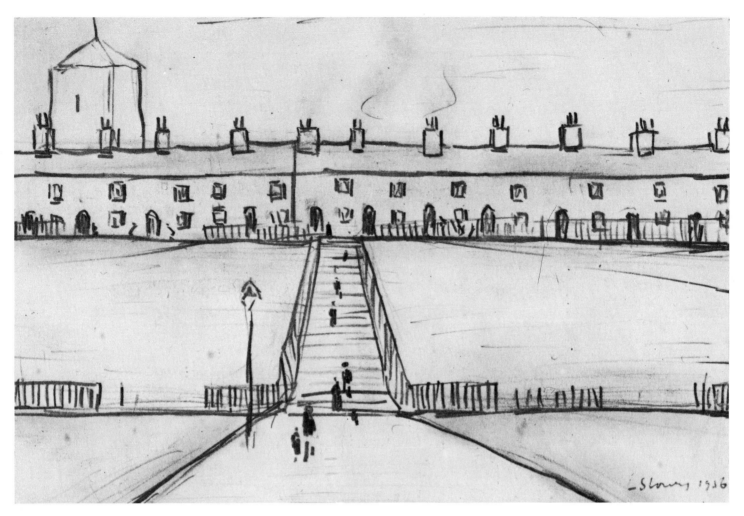

157

HOUSES AT MARYPORT

1956. *Pencil 18.4 × 27.3 cm. Private collection.*

A drawing which emphasizes the tedium of the urban townscape. Lowry was always a profound commentator on human affairs and the environment in which man lives out his destiny.

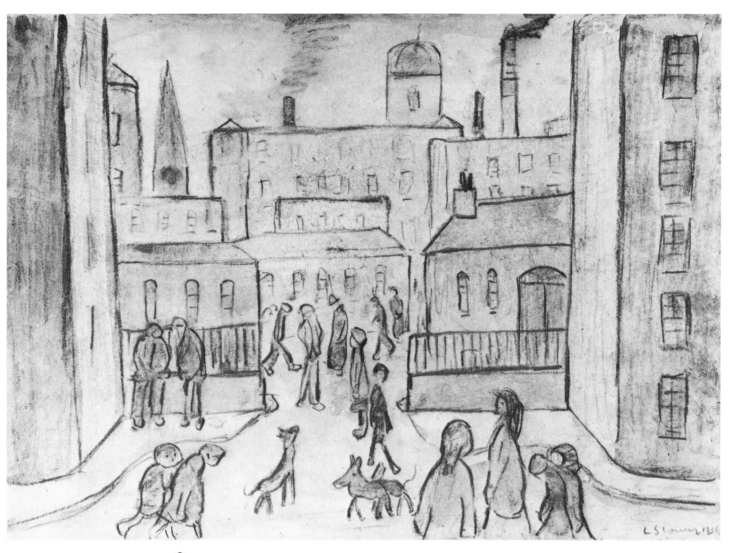

158

MILL SCENE

1956. Pencil 25.4 × 35.6 cm. Private collection.

Time and time again Lowry returns to the theme of the mill gates. The elements are always slightly varied. Here a cluster of dogs predominate, and a group of children hold the foreground. But it remains the artist's perennial stamping ground, the main source of his industrial inspiration. It is a scene of which he never tires. It is home.

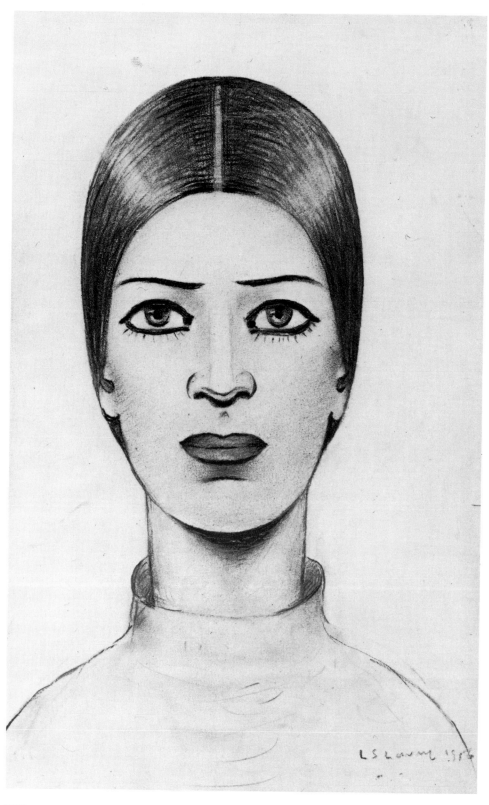

159

ANN

1956. Pencil 36.8 × 22.8 cm. Private collection.

Although the drawing is entitled *Ann*, this and similarly titled drawings of
the fifties are really 'composite' portraits: part Ann Hilder, his god-daughter;
part Anne, the girl he knew way back in the early 1900s and who died
young in 1913; and part his mother. 'Ann' is therefore all women to one
man. She is a dream.

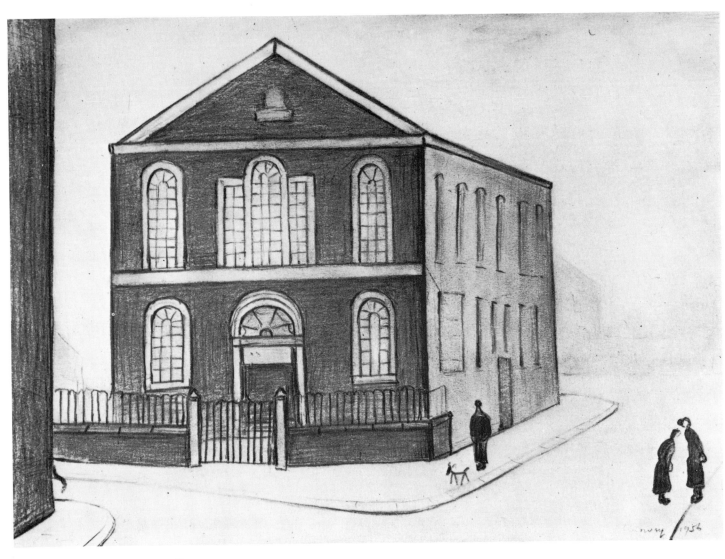

160

CHAPEL, ST STEPHEN'S STREET, SALFORD 3

1956. Pencil 25.5 × 35 cm. Collection: City Art Gallery, Salford.

Lowry was an oblique and mischievous thinker. He could devise 'attitudes' between buildings and human beings. Here the pomposity of the chapel is undermined by the figure disappearing around the corner of the building on the left, and the mischief-making of the gossips on the right.

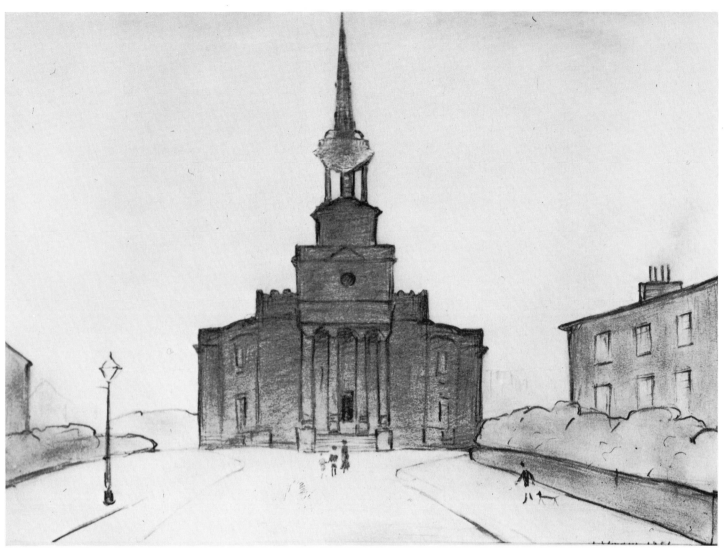

161

CHRIST CHURCH, SALFORD

1956. Pencil 25.5 × 34 cm. Collection: City Art Gallery, Salford.

This and the three drawings which follow are virtually studies in the personality of buildings.

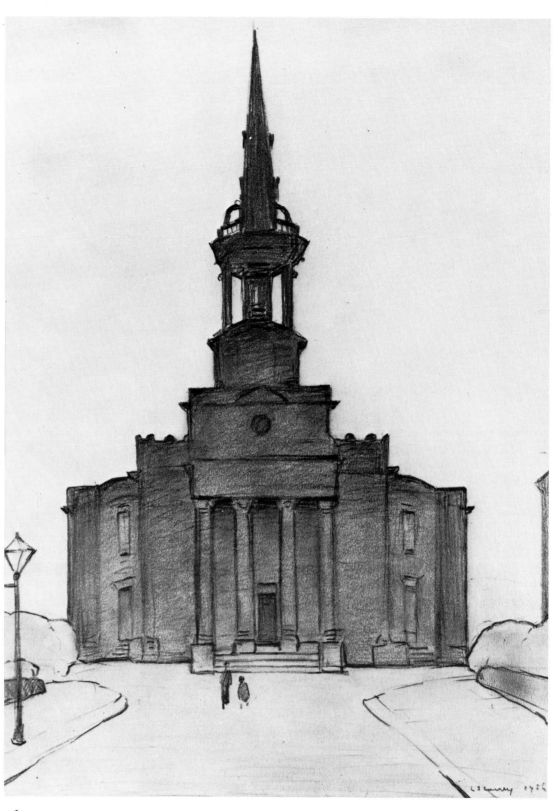

162

CHRIST CHURCH, SALFORD

1956. Pencil 34 × 25.5 cm. Collection: City Art Gallery, Salford.

The building as personality, dwarfing the littleness of man. A drawing of great dignity and presence.

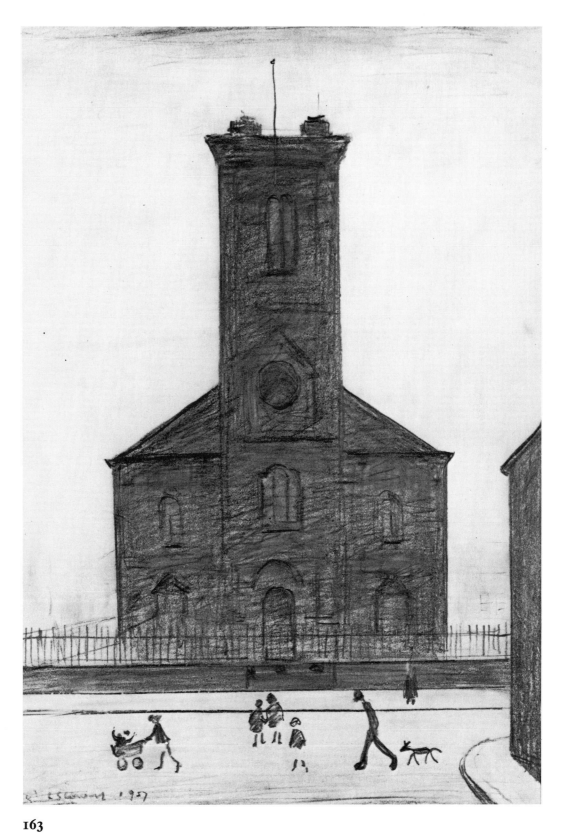

163

ST STEPHEN'S CHURCH, SALFORD

1956. *Pencil 35 × 25.5 cm. Collection: City Art Gallery, Salford.*

Another study in the personality of buildings.

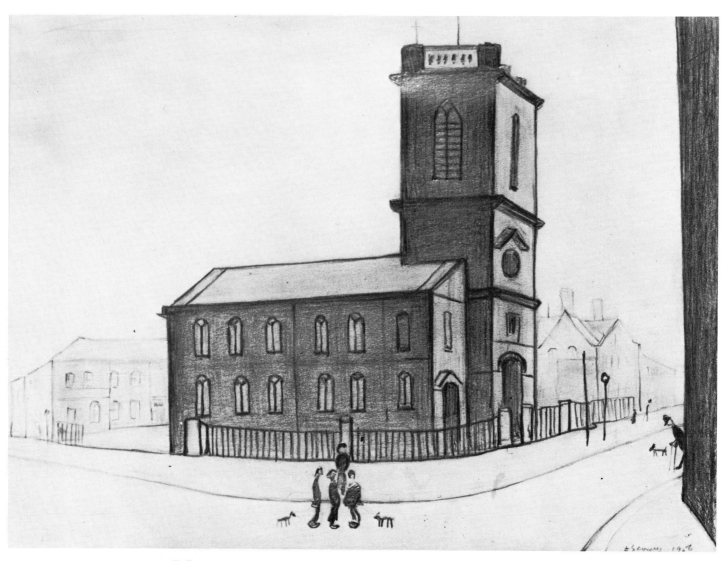

164

ST STEPHEN'S CHURCH, SALFORD

1956. Pencil 25 × 33.5 cm. Collection: City Art Gallery, Salford.

The artist explored every 'personality' aspect of this building in a series of drawings. There is great humour in the figures.

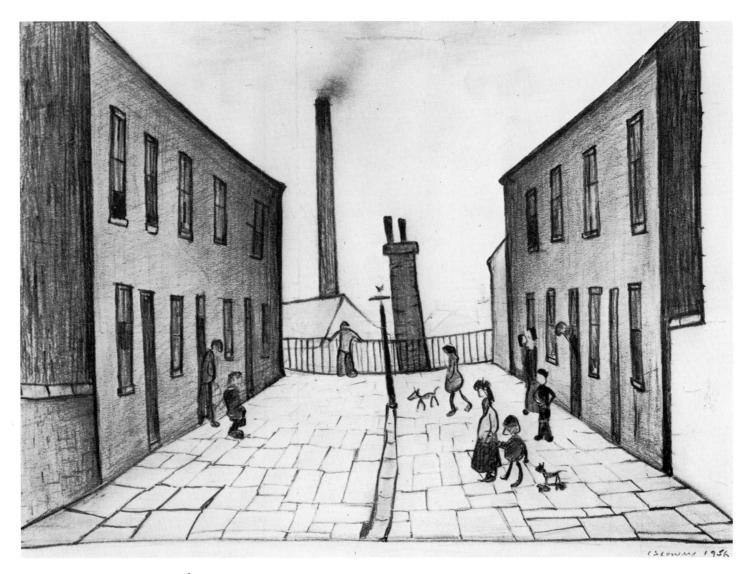

165

FRANCIS TERRACE, SALFORD 3

1956. Pencil 25.5 × 34 cm. Collection: City Art Gallery, Salford.

This and the following drawing show how skilfully the artist could hold the eye at the centre of his composition.

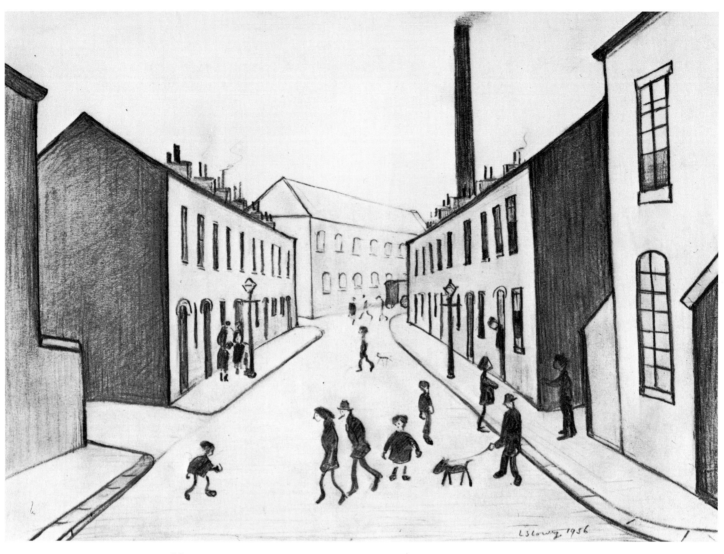

166

NORTH JAMES HENRY STREET, SALFORD 3

1956. Pencil 25.5 × 34 cm. Collection: City Art Gallery, Salford.

Here, as in the previous drawing, the figures seem to hold the scene; for once they have ousted the buildings. This conflict between the people and the buildings exists in many of Lowry's drawings. It is a battle of personality.

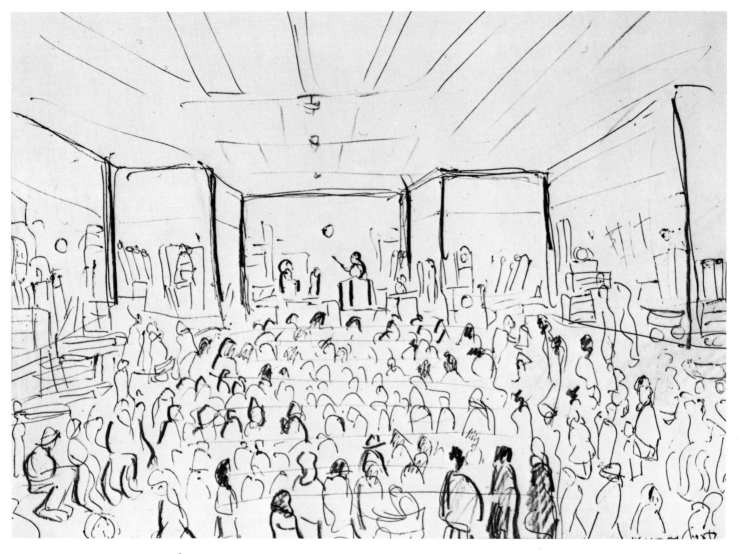

167

THE SALE ROOM

1956. Pencil 26.7 × 36.2 cm. Private collection.

Made at a Manchester auction attended by the artist, this has something of the satirical qualities of a Rowlandson. It reflects the sharp tenseness of the occasion.

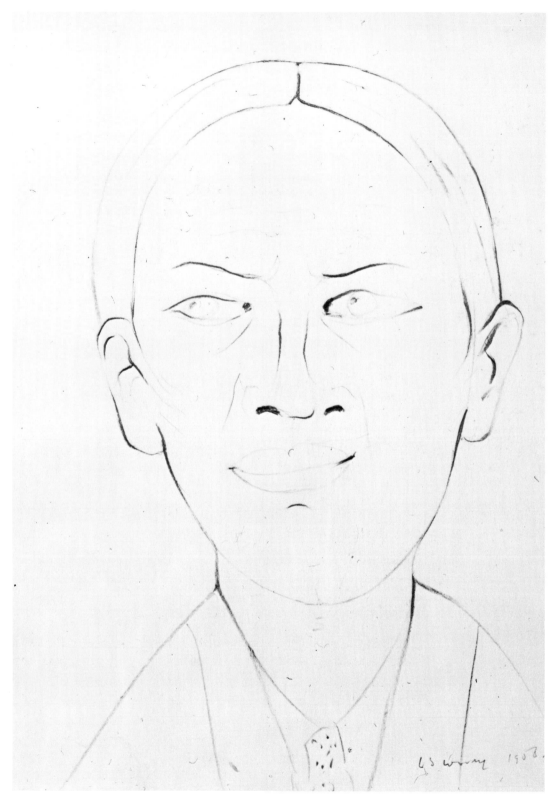

168

A YOUNG MAN

1956. Pencil 35.6 × 25.4 cm. Private collection.

A sly, imaginary portrait: perhaps autobiographical? The artist as voyeur?

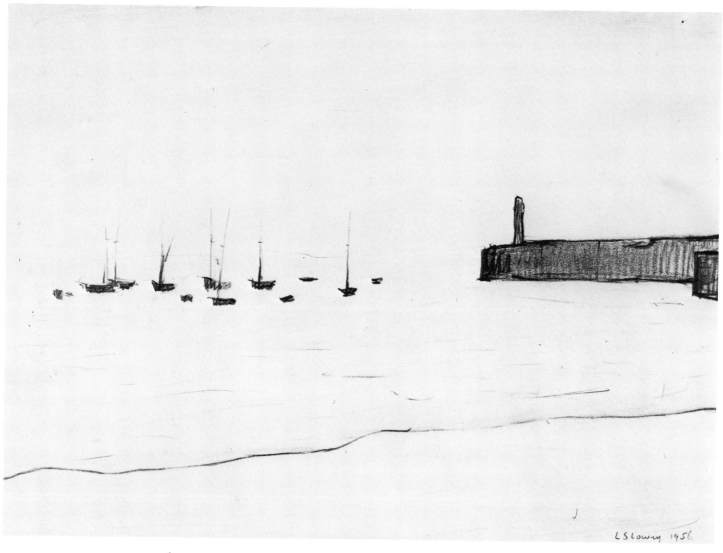

169

BOATS

1956. Pencil 30.5 × 35.5 cm. Collection: City Art Gallery, Salford.

Space created with a minimum of means. Consider the importance of the shore-line.

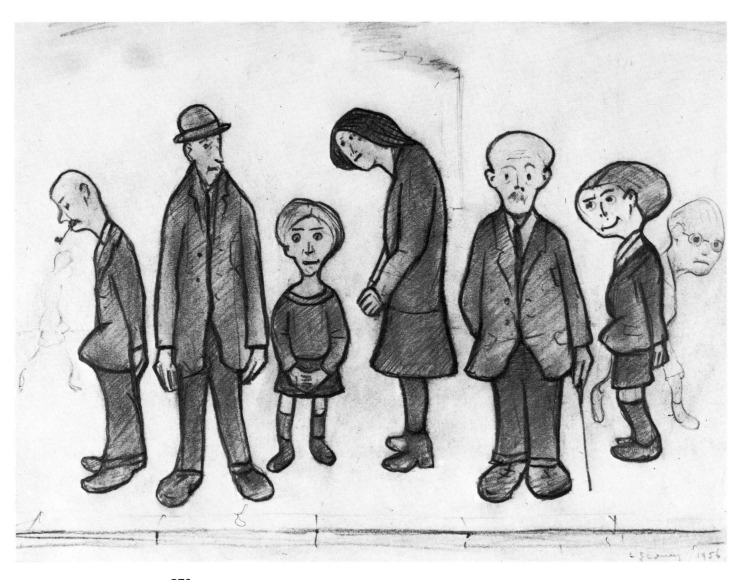

170

FAMILY GROUP

1956. Pencil 25 × 35.5 cm. Collection: City Art Gallery, Salford.

A superbly cruel study which reveals the artist in his most hostile mood. He was little concerned with the human situation – only with its appearance.

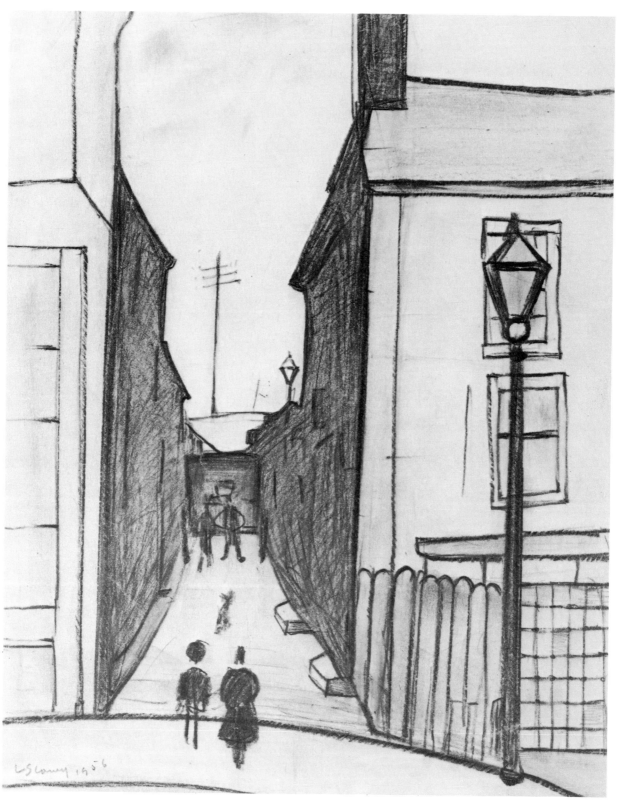

171

STREET IN MARYPORT

1956. Pencil 27.3 × 21.6 cm. Collection: Lefevre Gallery.

A dramatic conception in which the figures appear to be moving towards some kind of confrontation. The lamp-post on the right adds great strength to the composition. One should always think about the 'double meanings' in Lowry's art.

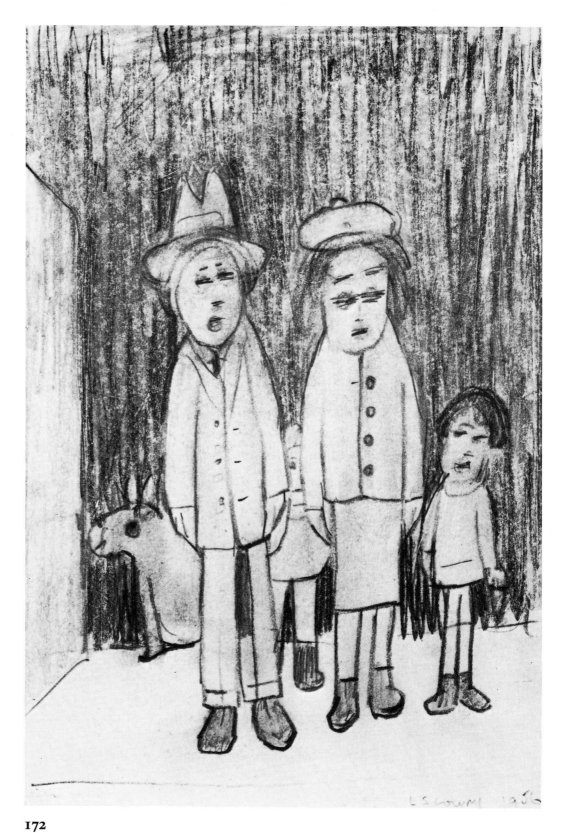

172

A FAMILY OF FOUR

1956. Pencil 25.4 × 17.8 cm. Collection: Lefevre Gallery.

A study in contempt.

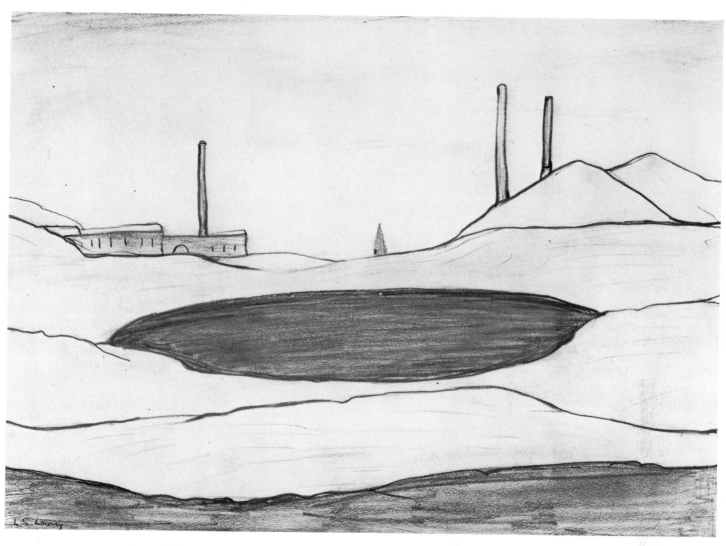

173

POND NEAR THE MILL

c. 1956. Pencil 25.4 × 34.3 cm. Collection: Lefevre Gallery.

A striking opposition of the vertical and the horizontal motif.

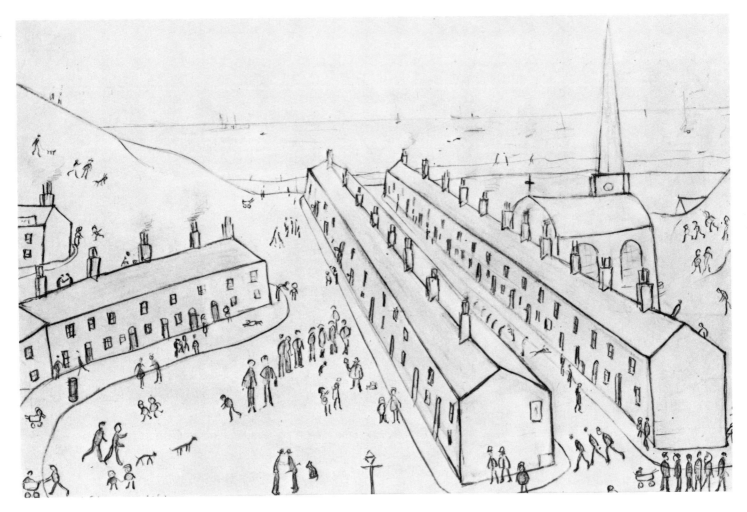

174

HOUSES BY THE SEA

c. 1956. Pencil 24.7 × 36.8 cm. Collection: Lefevre Gallery.

An expressionistic view of the endless boredom of seaside vistas.

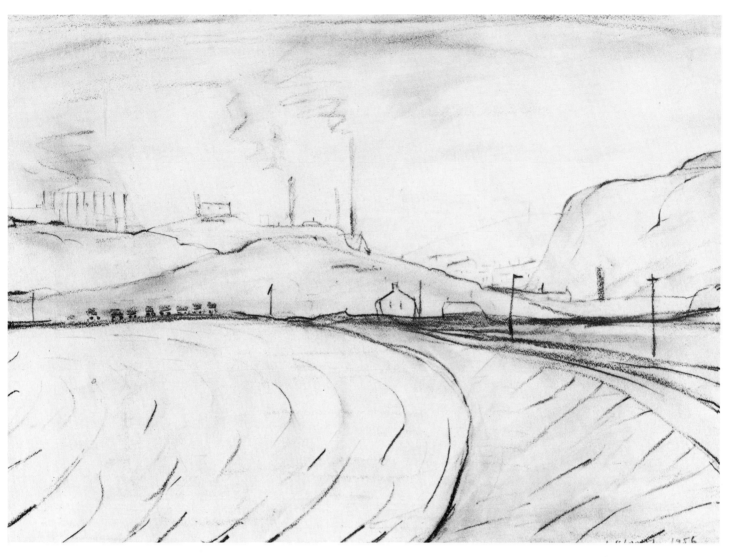

175

COLLIERIES NEAR THE SEA

1956. Pencil 27.9 × 38.1 cm. Collection: Lefevre Gallery.

This and the following drawing are primarily concerned with creating a feeling of space. To this end the size of buildings and figures is kept deliberately small.

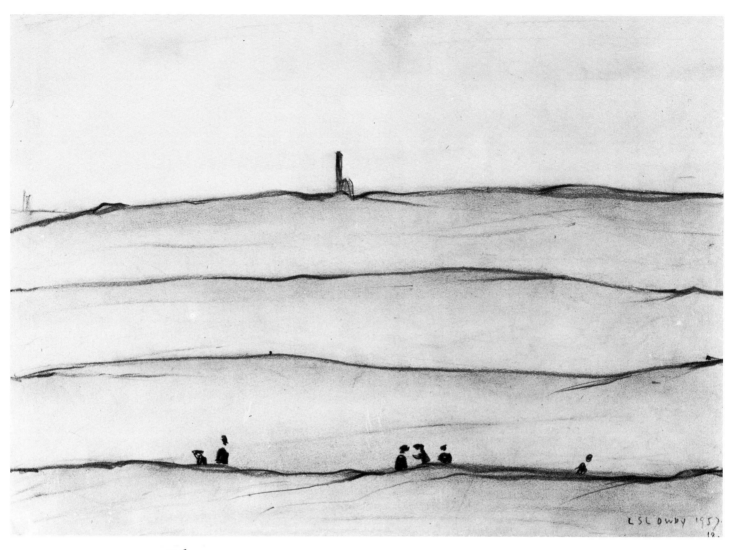

176

TIN MINE IN CORNWALL

1957. *Pencil 24.7 × 34.3 cm. Collection: Lefevre Gallery.*

See note for the previous plate.

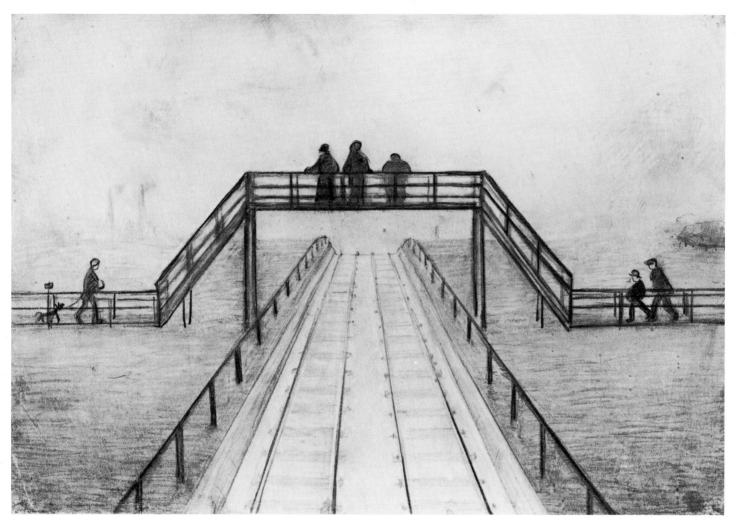

177

BRIDGE WITH FIGURES OVER COLLIERY RAILWAY

c. 1957. Pencil 57.5 × 74.5 cm. Collection: City Art Gallery, Salford.

A strangely symmetrical composition, unusual for Lowry. However, the symmetry only serves to emphasize the tedium of the scene.

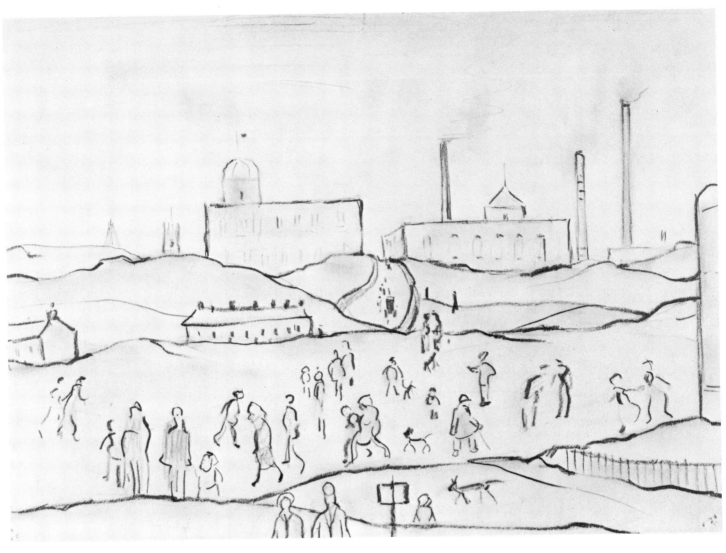

178

INDUSTRIAL SCENE

c. 1957. Pencil 25.4 × 36.2 cm. Collection: Lefevre Gallery.

A simple version of the classic Lowry scene. It is nowhere in particular, and everywhere. The drawing is constructed in a pattern of continuous rhythms, the line flowing easily from the soft pencil.

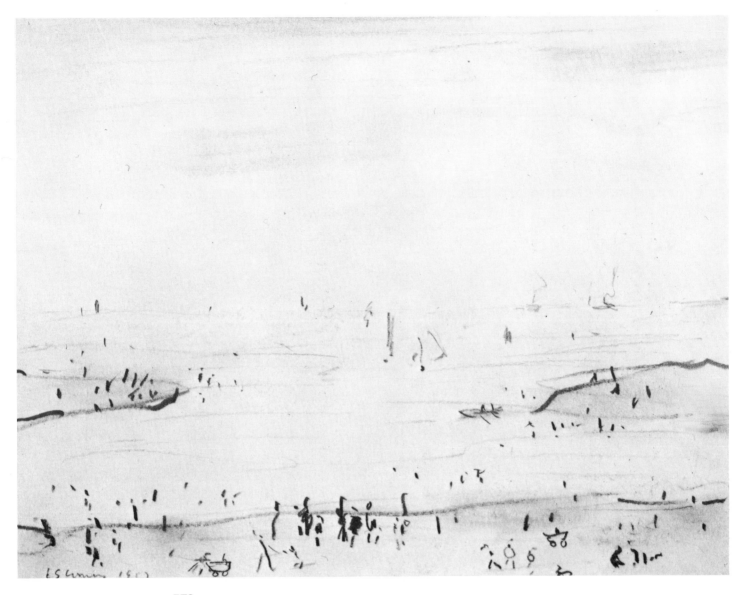

179

BEACH SCENE

1957. *Pencil 17.8 × 22.8 cm. Private collection.*

A brilliantly impressionistic rendering.

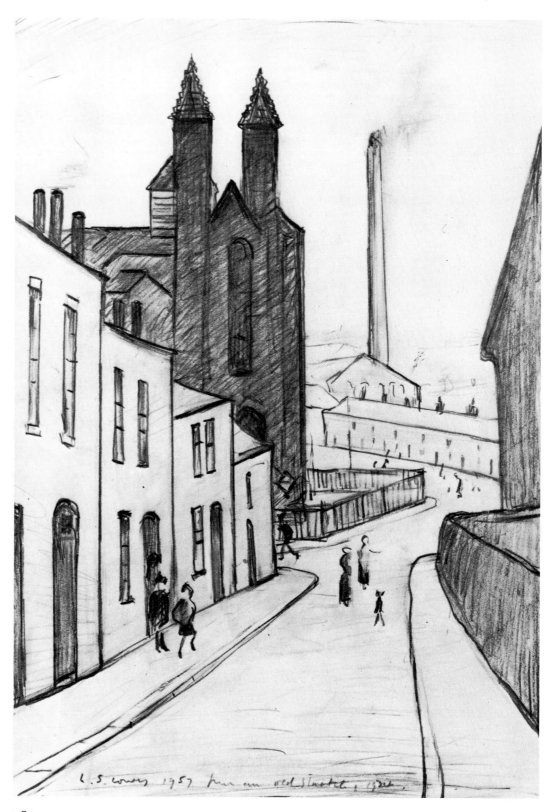

180

RICHMOND HILL

1957. Pencil 35.5 × 25.5 cm. Collection: City Art Gallery, Salford.

A composition which races subtly down-hill.

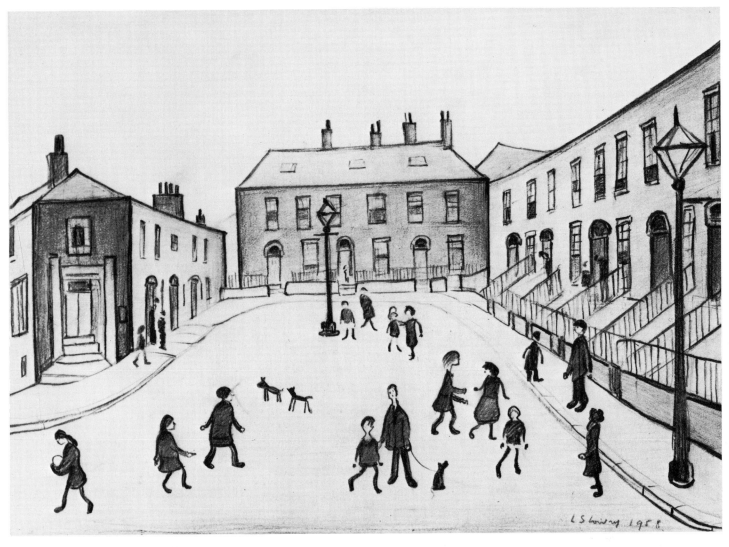

181

THE STREET

1958. Pencil 25.5 × 35.5 cm. Collection: Pendleton High School.

Lowry could always convey the exact nature of the plane in which his subjects had their existence. In the previous drawing the plane runs down-hill. Here it rises gently upwards.

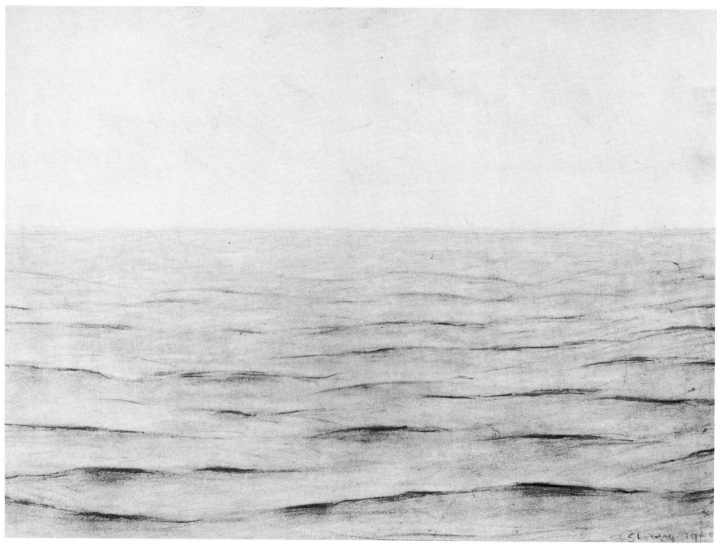

182

SEASCAPE

c. 1958. Pencil 24 × 34 cm. Private collection.

Lowry was to draw and paint many seascapes from this date onwards. Empty and desolate, they reflect the loneliness and isolation of the artist himself.

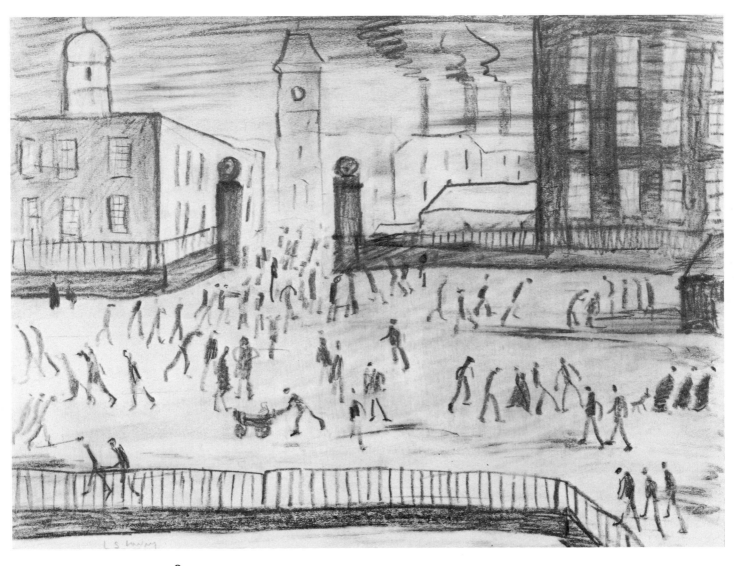

183

MILL SCENE

c. 1959. Pencil 24.7 × 34.9 cm. Collection: Lefevre Gallery.

A freely expressed 'vision' of the classic mill scene. The artist continually
returned to this subject, which haunted his imagination.

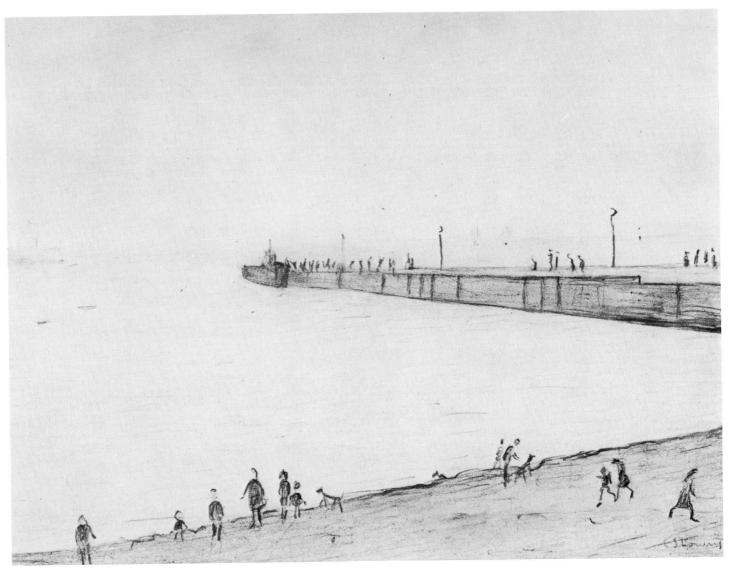

184

THE PIER

c. 1960. Pencil. Size unknown. Private collection.

No artist could create the feeling of dullness better than Lowry. He recognized that life is not always exciting, and could take the dreariest of subjects, as here, and render them with fascinating boredom.

185

OLD CEMETERY, CHARLTONVILLE

1960. *Pencil 24.7 × 34.3 cm. Collection: Lefevre Gallery.*

The loneliness of Necropolis. On the left is a lamp-post which might well symbolize the ever-watchful eye of the artist.

186

ON THE PROMENADE

1960. *Pencil 24.7 × 34.9 cm. Collection: Lefevre Gallery.*

The grimness of the English Holiday-maker, superbly conveyed.

Two Brothers L S Lowry 1960

187

BROTHERS

1960. *Pencil 33.3 × 24.7 cm. Collection: Lefevre Gallery.*

A study in the humiliation of being 'just ordinary'.

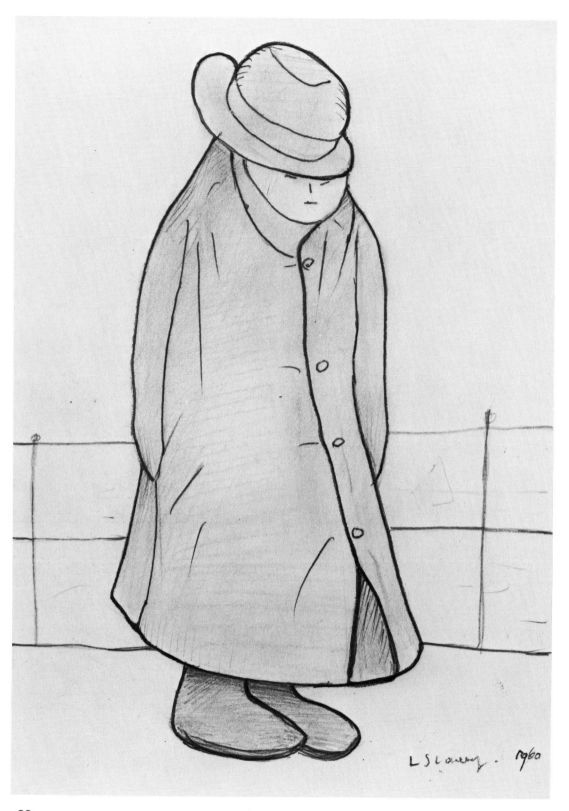

188

FISHERMAN RESTING ON MUMBLES PIER

1960. *Pencil 24.1 × 16.7 cm. Collection : Lefevre Gallery.*

In the 1960s Lowry visited the Rhondda Valley, and also the Mumbles out-
side Swansea. Here he made entertainingly expressionistic drawings of the
fishermen on the Pier.

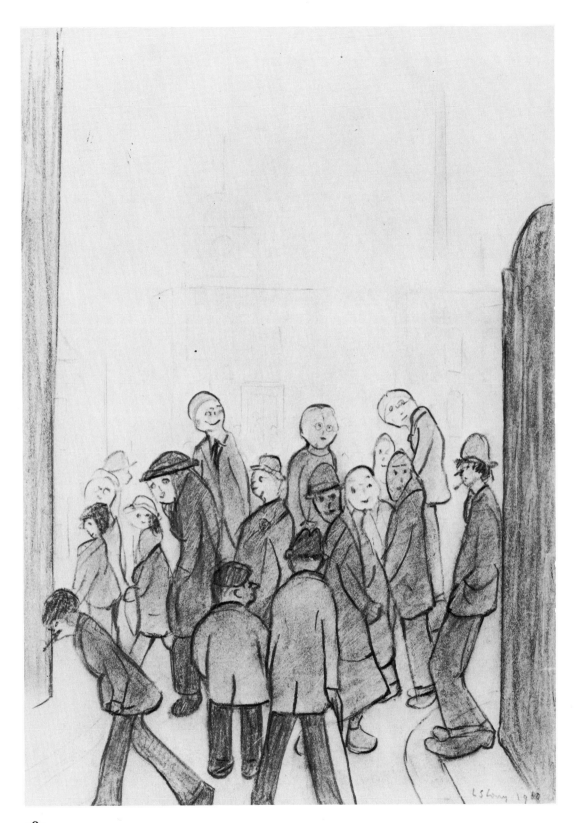

189

A STREET CORNER

1960. Pencil 35.6 × 25.4 cm. Collection: Lefevre Gallery.

A jumble of people seen as such and not, on this occasion, as an aesthetic unity.

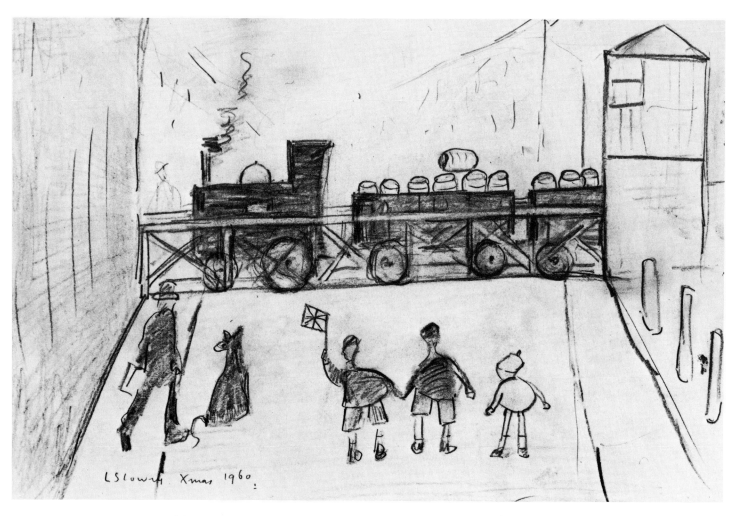

190

BREWERY TRAIN, HIGH STREET, BURTON

1960. *Pencil 24.7 × 37.5 cm. Collection: City Art Gallery, Salford.*

The theme of children at a level crossing often appears in Lowry's work. This is one of his more savagely expressionistic renderings of the subject.

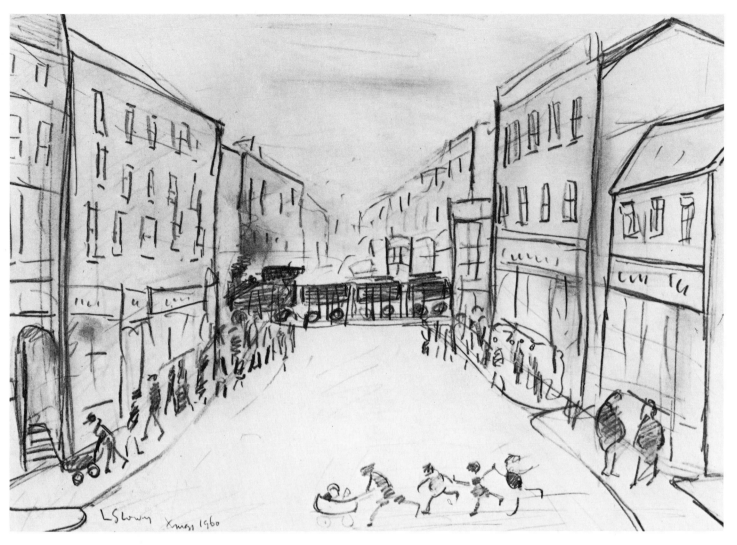

191

HIGH STREET, BURTON

1960. *Pencil 24.7 × 37.5 cm. Collection: City Art Gallery, Salford.*

The artist was now drawing with great freedom and panache. Consider the vitality in the stream of children crossing the road.

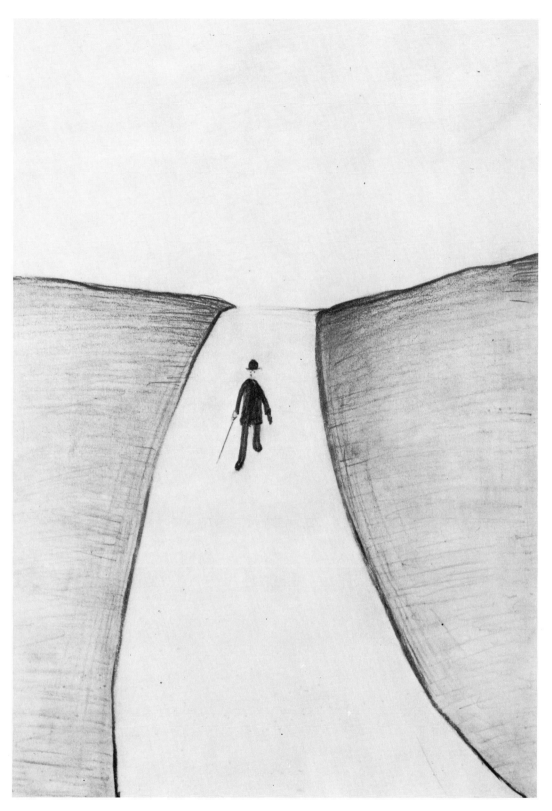

192

THE LONELY WALK

c. 1960. Pencil 30.5 × 19.1 cm. Private collection.

A late return to the Chaplinesque view.

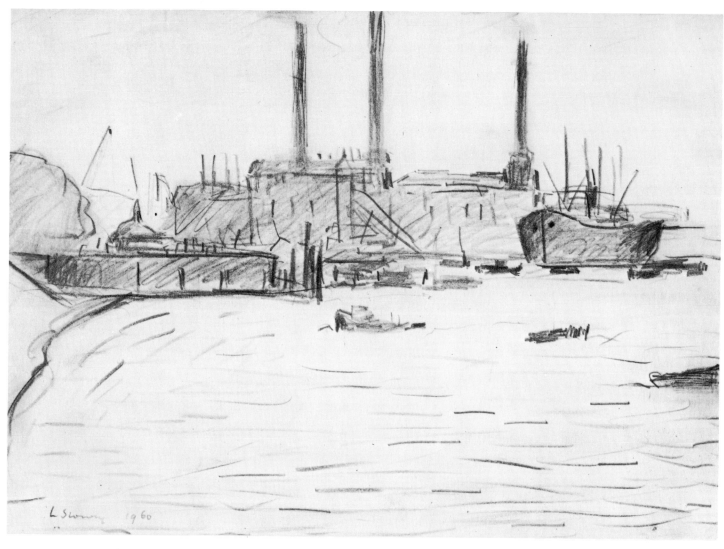

193

AT GREENWICH

1960. *Pencil 24.1 × 34.3 cm. Private collection.*

During his frequent visits to London, the artist made many drawings of the
Thames. This brisk, gusty view of Greenwich is typical.

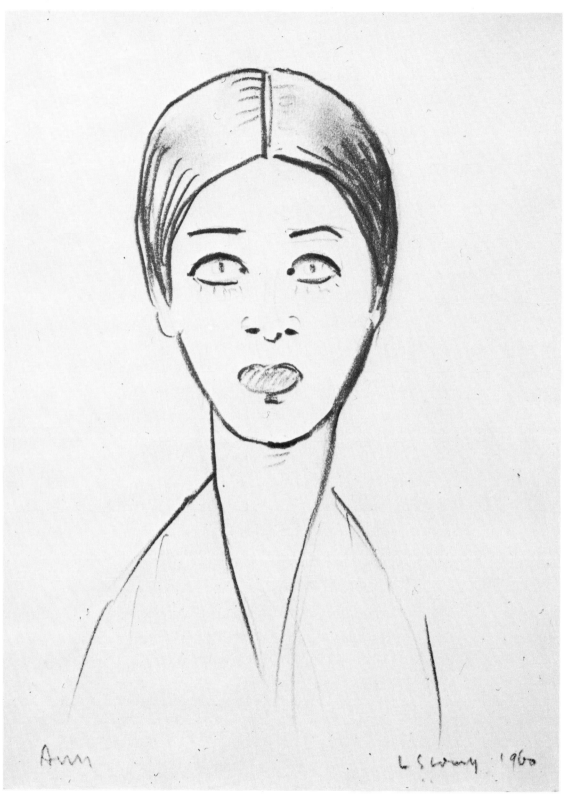

194

ANN

1960. *Pencil 17.8 × 13.3 cm. Private collection.*

One of the numerous 'composite' portraits of 'Ann' made by the artist at this time. (See note for Plate 159.)

195

ANN

1960. *Pencil 22.8 × 22.8 cm. Private collection.*

A variation on the theme of the portraits of 'Ann'. The conception is rare.

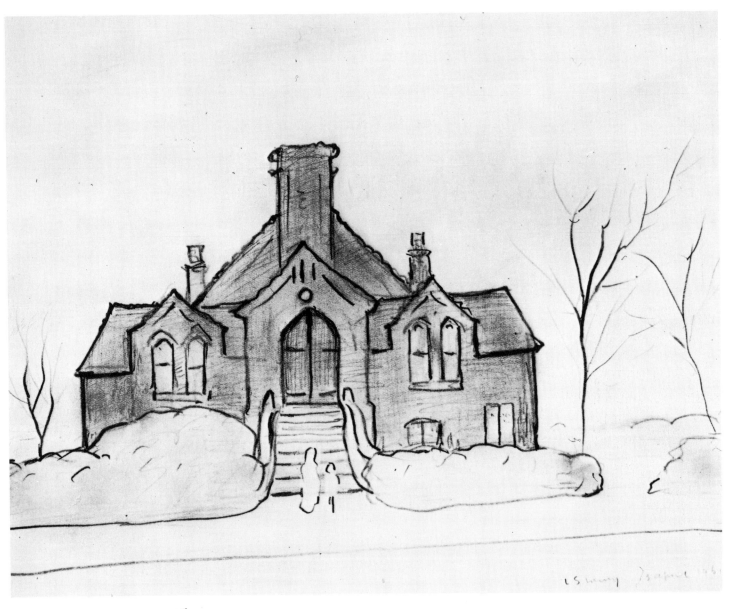

196

THE CHAPEL HALL, BURTON

1961. *Pencil 20.3 × 25.4 cm. Collection: City Art Gallery, Salford.*

Lowry had a great feeling for churches, chapels, church halls, and cemeteries.
The atmosphere of peace seemed to inspire him.

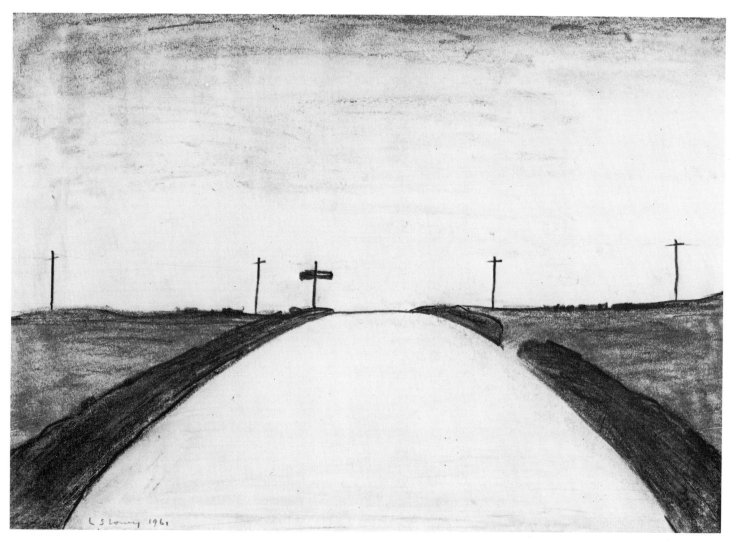

197

COUNTRY ROAD, CUMBERLAND

1961. *Chalk 24.7 × 34.3 cm. Collection: Lefevre Gallery.*

A subtly conceived sense of distance. The eye is sent hurrying along the road by the compelling thrust of the strong curves on either side.

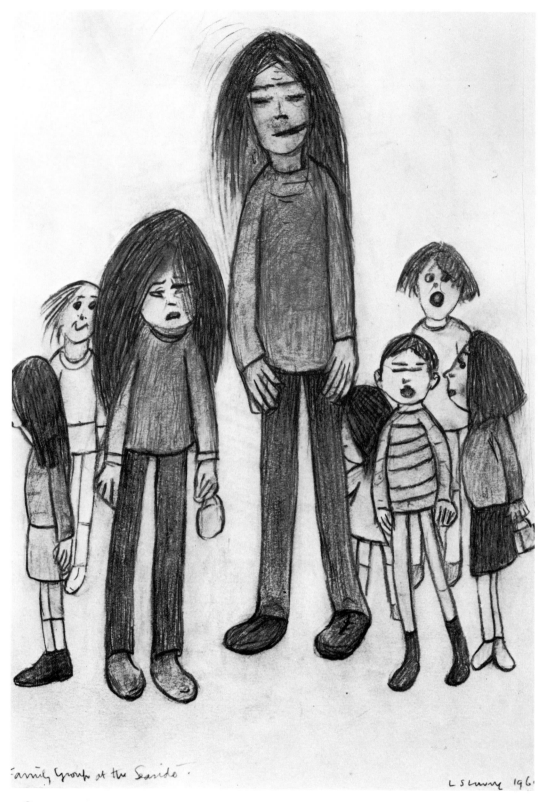

Family Group at the Seaside.

L S Lowry 1961

198

STREET SCENE

1961. *Pencil 41.9 × 29.2 cm. Collection: Lefevre Gallery.*

Inscribed 'Family Group at the Seaside', this is one of Lowry's rare studies of the modern teenager. Normally he paid little attention to such sartorial 'advances' as are seen here.

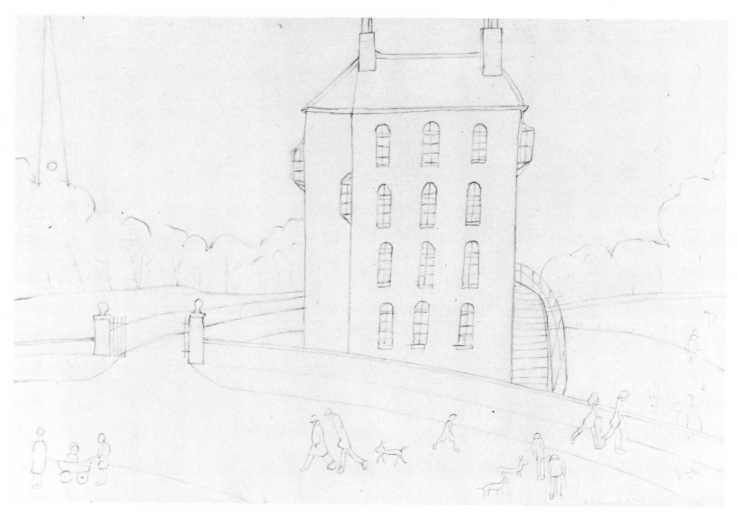

199

OLD HOUSE IN A PARK

1961. *Pencil 24.7 × 36.8 cm. Collection: Lefevre Gallery.*

An architectural study, which allows the imagination free rein.

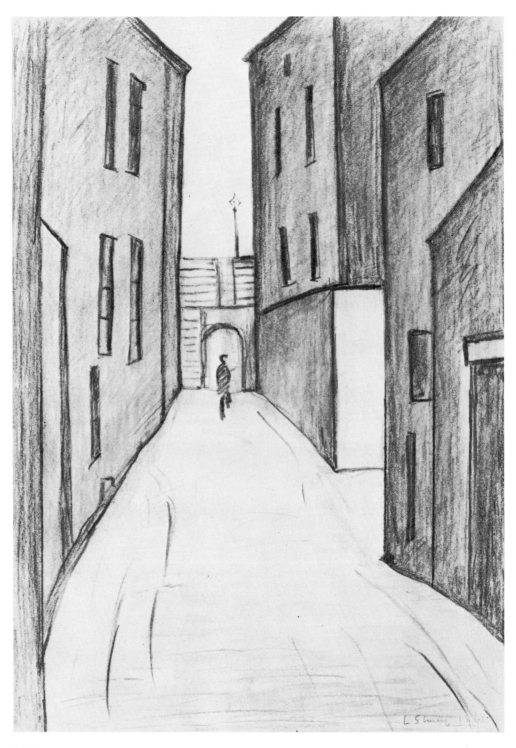

200

AT BERWICK ON TWEED

1961. *Pencil 34.3 × 24.7 cm. Collection: Lefevre Gallery.*

This and Plates 220 and 252 are studies in the art of composition. The eye is securely held in the picture by virtue of the lines of force which in each case lead to the central figures in the composition. Here it is a solitary figure. In Plate 220 the eye is led to the two figures at the top of the steps, and in Plate 252 the eye settles firmly upon the figure of the man with his hands on his hips.

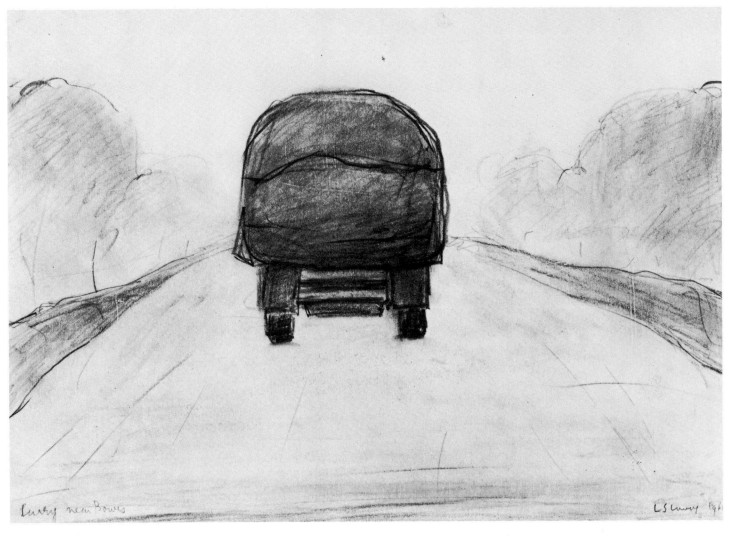

201

A LORRY

1961. Pencil 24.7 × 34.3 cm. Collection: Lefevre Gallery.

Lowry always expressed a hatred of all motor-vehicles. This drawing is a grudging concession to motorized transport. It is perhaps significant that the lorry is moving away from the spectator.

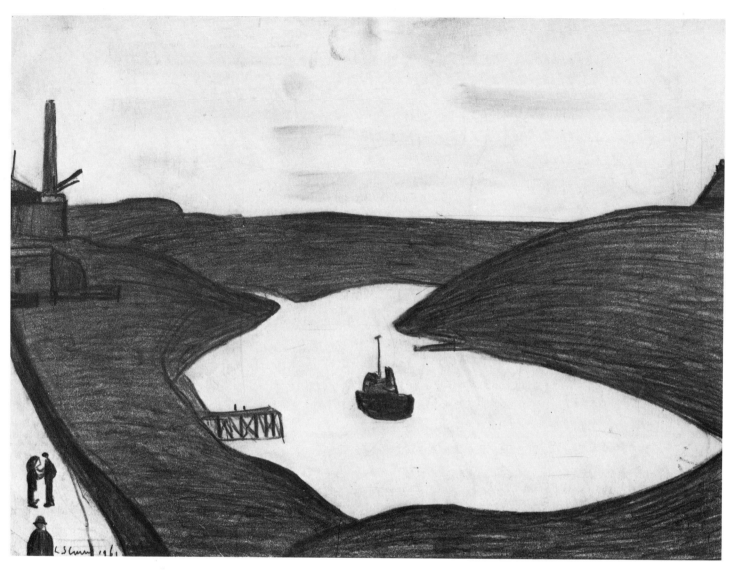

202

THE WEAR, SUNDERLAND

1961. Pencil 24.7 × 34.9 cm. Collection: Lefevre Gallery.

The artist possessed an extremely subtle vision. The drawing is really an excuse to make a comment upon the relationship of the two figures in the bottom left-hand corner of the picture. The watcher is Lowry himself.

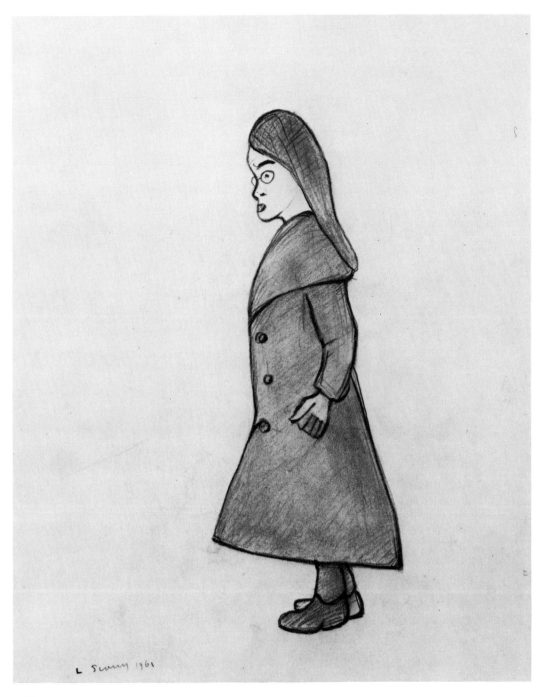

L Soury 1961

203

WOMAN WALKING

1961. *Pencil 34.3 × 24.7 cm. Collection: Lefevre Gallery.*

Throughout the sixties Lowry often dealt with the single figure. He concentrated upon types, or upon simple situations such as *A Man Taken Ill* (Plate 229). In most of these drawings the figure is totally isolated in an expanse of white paper – a method which serves to intensify the view, and to concentrate the attention of the spectator solely upon the subject, who is thus exposed as though studied through a telescope or even under a microscope. In this way the artist offers a voyeur's view of his subjects, who are themselves completely unaware that they are being scrutinized: a cruel and telling ploy.

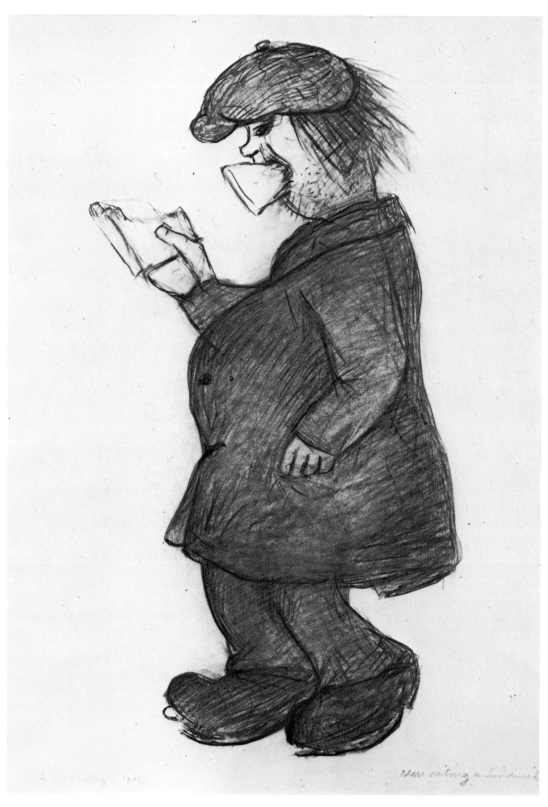

204

MAN EATING A SANDWICH

1961. *Pencil 41.2 × 29.2 cm. Private collection.*

Lowry actually saw this chap rummaging in a dustbin. He came up with a
sandwich which he promptly stuffed into his mouth.

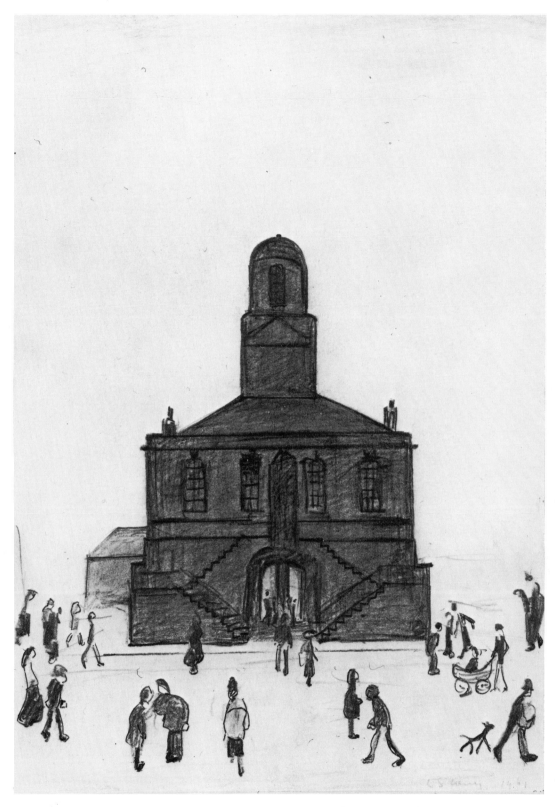

205

OLD TOWN HALL, SOUTH SHIELDS

1961. *Pencil 34.9 × 24.7 cm. Private collection.*

A charmingly decorative interpretation. The artist has made full use of the very interesting shape and design of the Town Hall. The figures are beautifully placed in relation to the building. This drawing shows Lowry's very considerable skill as a designer.

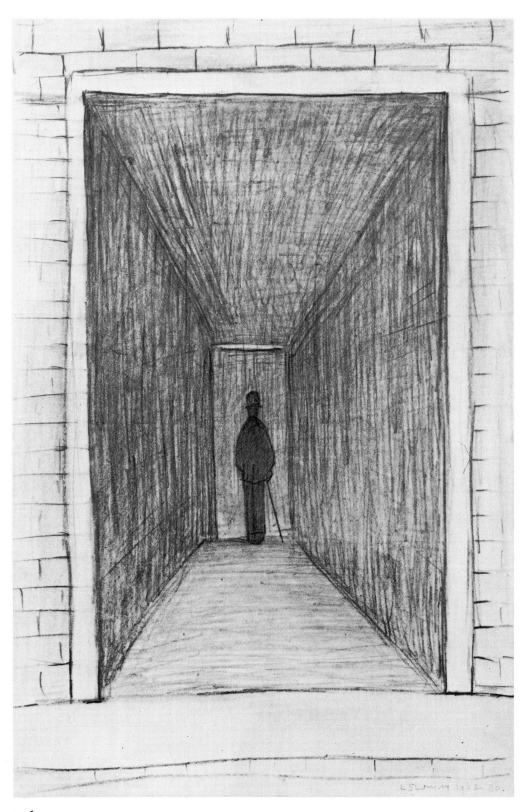

206

A VISIT TO BURTON-UPON-TRENT

1962. Pencil 36.8 × 24.7 cm. Collection: John Maxwell.

Lowry made this drawing after a visit to Burton-upon-Trent. As he explained to the writer, it is, in fact, a self-portrait. While he was in this town he found himself walking through a passage-way which led, he said, 'Nowhere!'

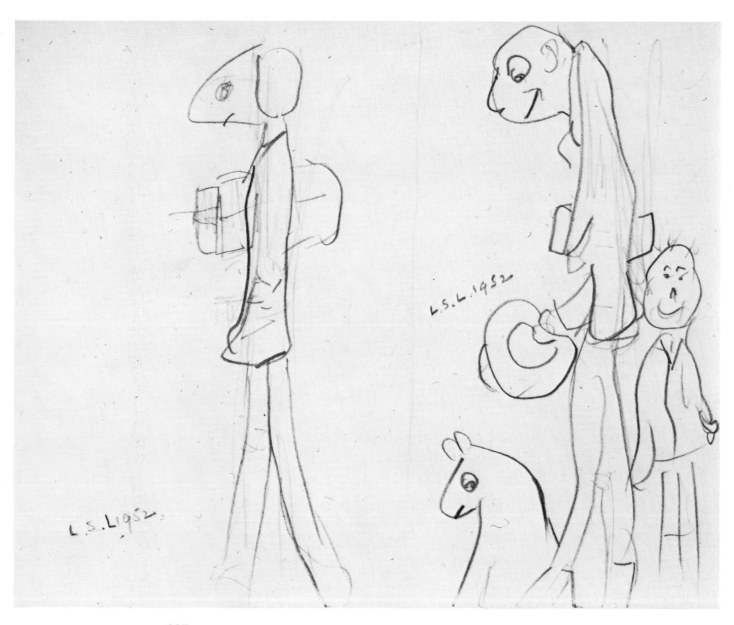

207

FIGURES

1962. *Pencil 15.8 × 20.3 cm. Private collection.*

A sheet of fantastic figures. About this time Lowry began to create grotesques:
part human, part animal. He is now clearly developing an actively hostile
attitude to his fellows. Children in particular are treated with considerable
savagery. (Dated later, inaccurately.)

208

ROAD WITH CARRIAGE

1963. *Pencil 15.8 × 20.3 cm. Private collection.*

Lowry's drawings of people were always off-set by a continual return to
nature. Very few people appear in the nature drawings. His style at this time
was bold and free.

209

ON THE MOORS

1963. *Pencil 15.8 × 20.3 cm. Private collection.*

Wide open spaces appealed greatly to Lowry in the sixties. They were a
source of spiritual refreshment to him after the heat and clutter of the
industrial scene.

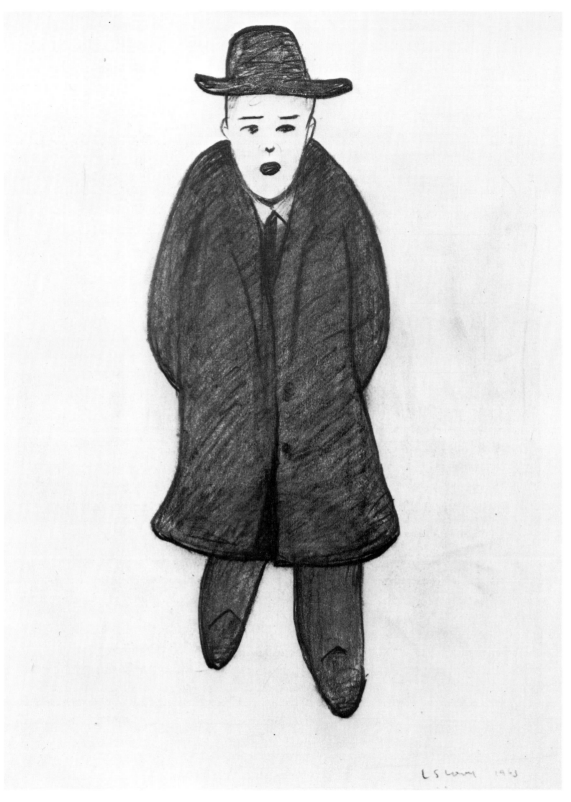

210

A MAN WALKING

1963. *Chalk 34.3 × 24.1 cm. Collection: Lefevre Gallery.*

See note for Plate 203.

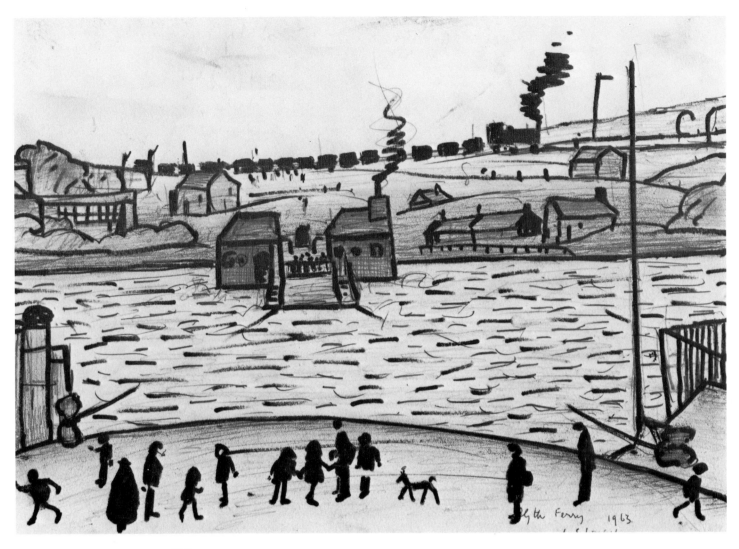

211

BLYTH FERRY

1963. Felt-tip pen 24.7 × 34.9 cm. Collection: Lefevre Gallery.

Lowry's vigorous response to his subject is here brilliantly complemented by the strong, stabbing strokes of the felt-tip pen, a medium which he used to great effect in his later years. Note again how much he can extract from a simple silhouette shape.

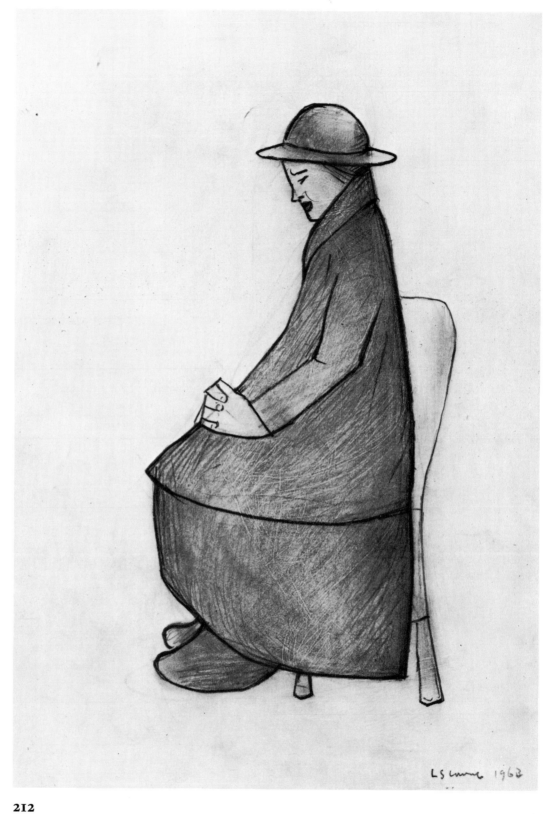

212

SEATED WOMAN

1963. Pencil 34.3 × 24.1 cm. Collection: Lefevre Gallery.

See note for Plate 203.

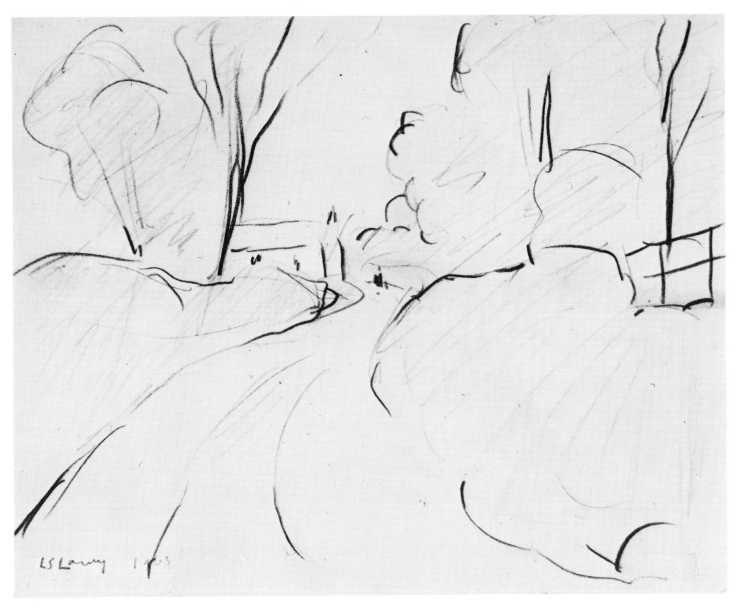

213

FARM AT ROCKCLIFFE

1963. *Pencil 15.8 × 20.3 cm. Private collection.*

The artist made a number of brisk sketches of this farm. He is here primarily concerned with exploring the rhythmic potential of the scene. The sweeping lines of force add greatly to the life and vitality of the subject.

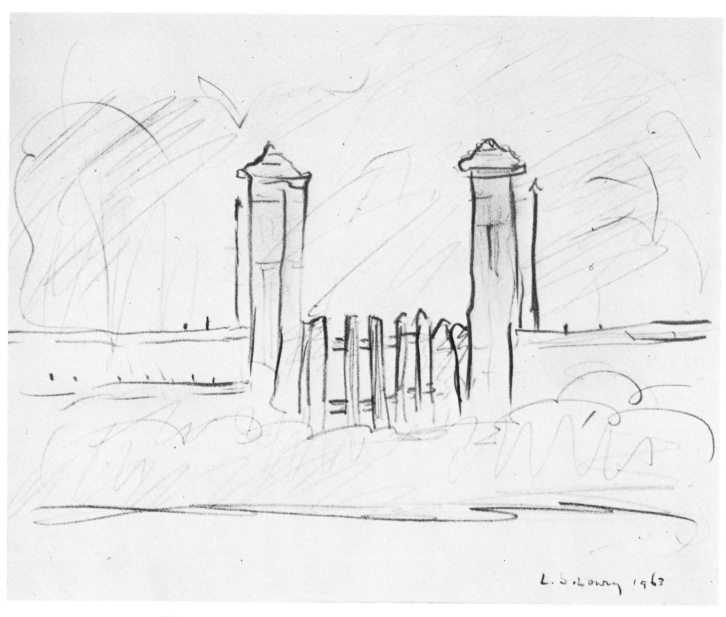

L. S. Lowry 1963

214

ORCHARD GATE, ROCKCLIFFE

1963. *Pencil 15.8 × 20.3 cm. Private collection.*

Another view of Rockcliffe Farm using the same vigorous technique.

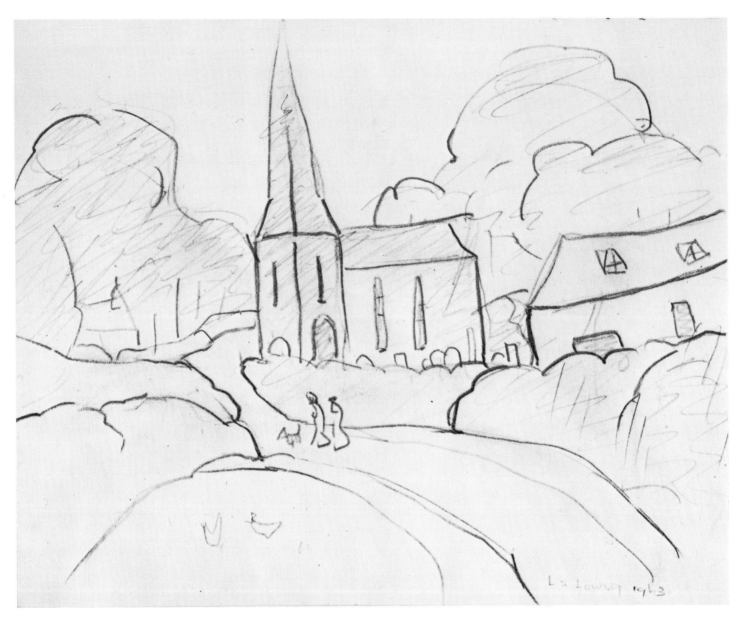

215

CHURCH AT ROCKCLIFFE

1963. Pencil 15.8 × 20.3 cm. Private collection.

This and the following drawing are further studies made at Rockcliffe in the fluent, expressionistic style that distinguishes the Rockcliffe group.

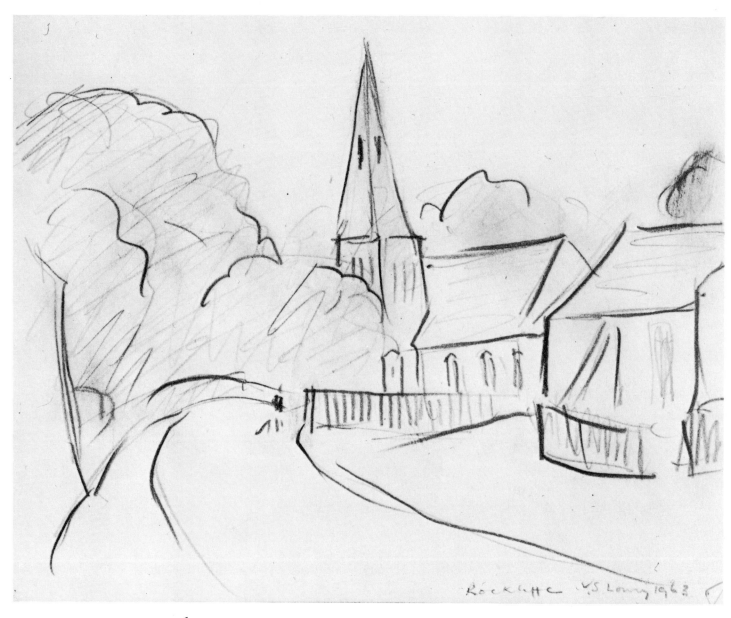

216

CHURCH AT ROCKCLIFFE

1963. *Pencil 15.8 × 20.3 cm. Private collection.*

See note for previous plate.

217

THE CARRIAGE

1963. *Pencil 20.3 × 15.8 cm. Private collection.*

This image first began to appear in Lowry's work in the late fifties. It was, he told the writer, originally inspired by a curious contraption he saw trundling through the streets of Manchester with a man perched at the front operating the vehicle by a kind of handle. He only saw the object once, and was never able to identify its type. For another view of this vehicle, see *The Contraption*, Plate 87 in *The Paintings of L. S. Lowry*.

218

CAERLAVEROCK CASTLE

1964. Felt-tip pen 12.7 × 20.3 cm. Private collection.

It is interesting to note how wide was the range of styles, techniques, and materials used by the artist. He varied these continually, and never permitted himself to fall into any ruts, unlike lesser artists. In later years he particularly liked to work with a felt-tip pen, the boldness and strength of which greatly appealed to him.

219

HOUSES ON THE MOORS

1964. Pencil 24.1 × 34.3 cm. Collection: Lefevre Gallery.

The mood of loneliness and isolation suggests the bleakness of the artist's own way of life. Though he had many friends, he always retained his remoteness. His life style was simple in the extreme: hard and stony – like this drawing.

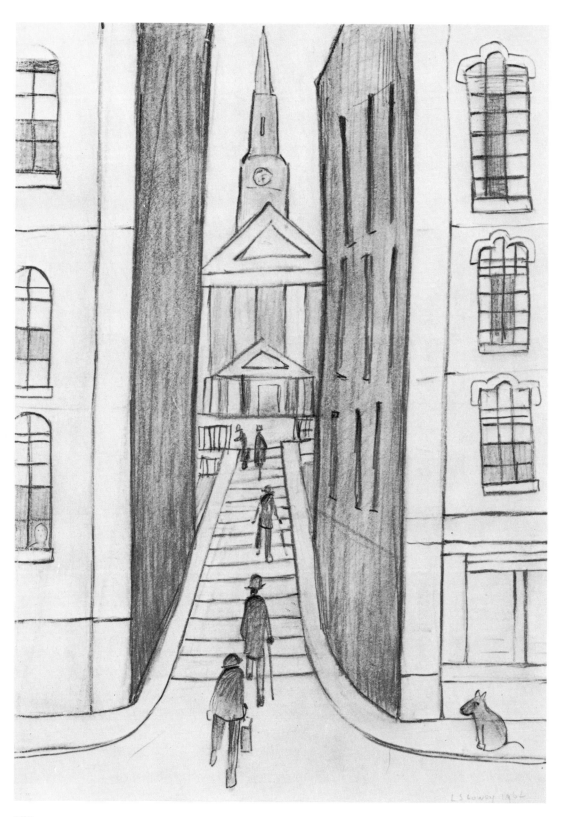

220

CHURCH IN NEWCASTLE

1964. Pencil 34.9 × 24.1 cm. Collection: Lefevre Gallery.

See note for Plate 200.

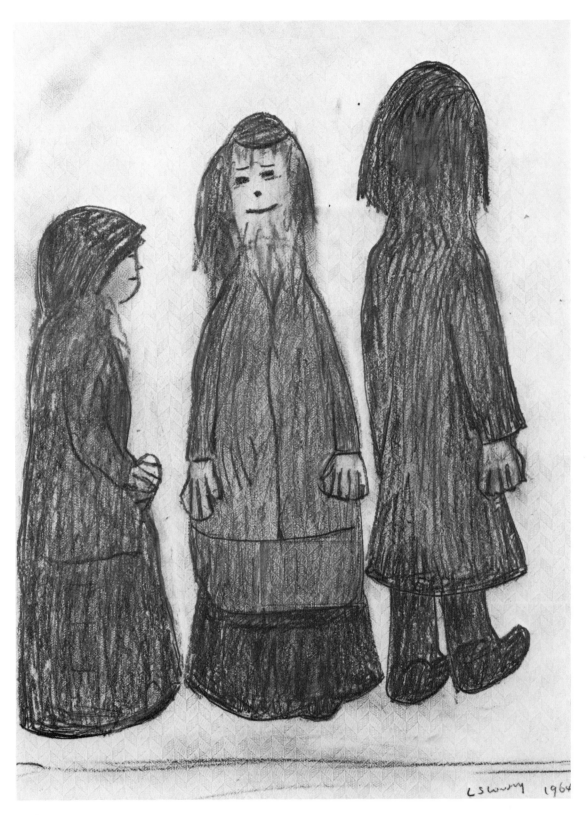

221

THREE PEOPLE

1964. Pencil 35.6 × 25.4 cm. Collection: Lefevre Gallery.

See notes for Plates 203 and 260.

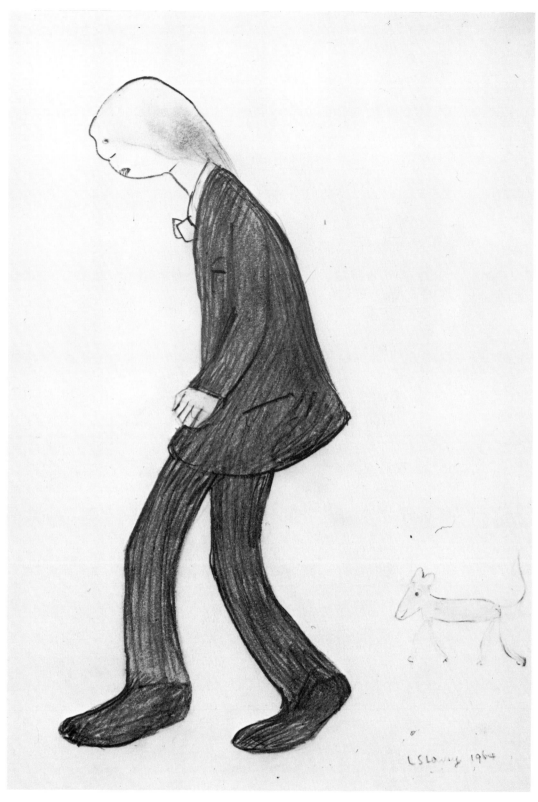

222

TEDDY BOY

1964. *Pencil 34.3 × 24.1 cm. Private collection.*

A delightfully satirical view of the fashion of the day. Lowry seldom paid much attention to sartorial advances, but he was interested in the Teddy Boy image and, curiously, in the Beatle and Pop cults. He also found the mini-skirt attractive (see Plate 280).

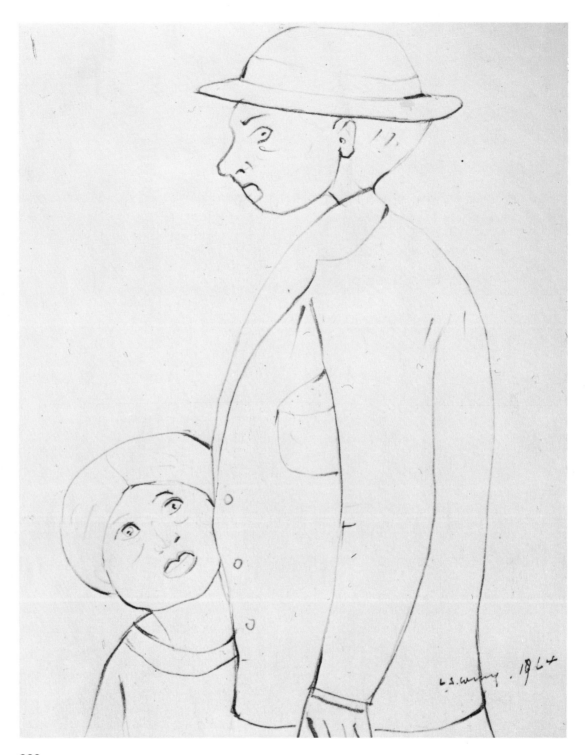

223

MAN AND CHILD

1964. Pencil 20.3 × 15.8 cm. Private collection.

The theme of adults and children intrigued the artist. Here there seems to be some conflict of interests. What does the child want? What is it that the man will not concede? Are the two figures related? Is the situation sinister? The title does not help. Lowry revelled in the ambiguous, in an element of mystery. This drawing leaves us wondering. We must make up our own minds as to the true story-line.

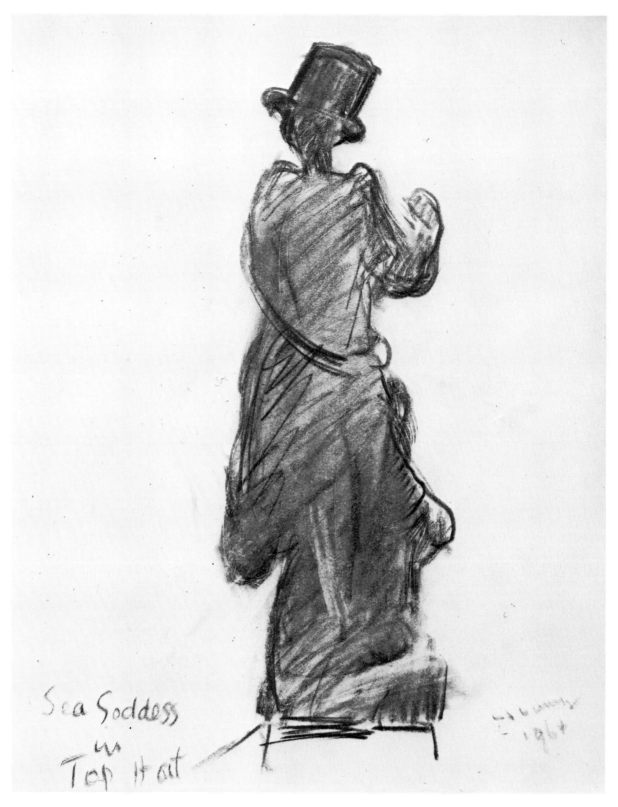

Sea Goddess in Top Hat

224

SEA GODDESS IN TOP HAT

1964. *Pencil 20.3 × 15.8 cm. Private collection.*

Simply a fantastical sketch the artist drew for his friend the Revd. G. S. Bennett on a visit to Carlisle.

225

BOAT ON THE TYNE

1964. *Pencil 15.8 × 20.3 cm. Private collection.*

A lot said with a little means.

L S Lowry To G S Dennett 1964

226

ON THE TYNE

1964. Pencil 15.8 × 20.3 cm. Private collection.

One of the many bold studies which the artist made of ships at South Shields.
The rendering is fresh and breezy, and captures perfectly the feel of the sea.

227

BOAT AT SOUTH SHIELDS

1964. *Pencil 15.8 × 20.3 cm. Private collection.*

This, like the previous drawing and the one which follows, is one of many drawings made at South Shields. The artist made his visits to the port from the Seaburn Hotel, Sunderland, where he often spent long periods.

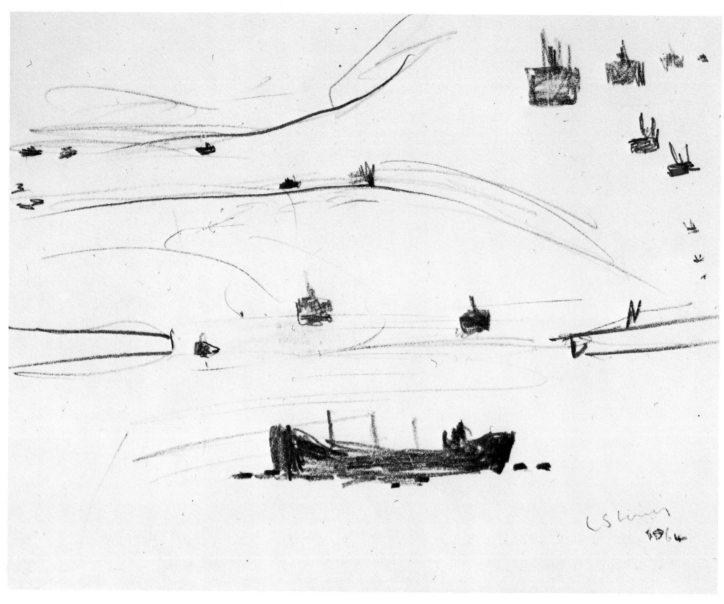

228

SEA SKETCHES

1964. Pencil 15.8 × 20.3 cm. Private collection.

See note for the previous plate.

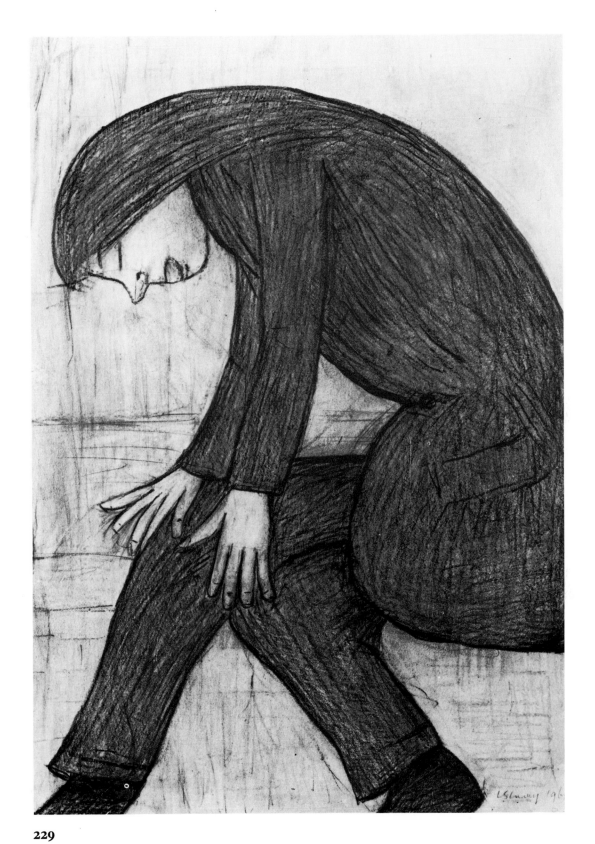

229

A MAN TAKEN ILL

c. 1965. Pencil 35.6 × 24.7 cm. Collection: Lefevre Gallery.

See note for Plate 203.

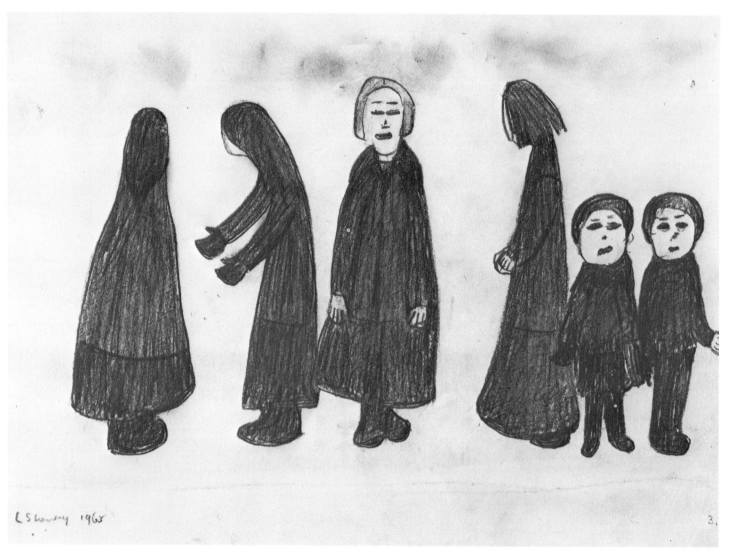

230

SIX PEOPLE

1965. Pencil 24.7 × 34.3 cm. Collection: Lefevre Gallery.

Apart from the single figures of the sixties, the artist also explored the relationship of groups of figures such as this. Once again they are not so much compositions in the strict sense of the word, as studies in the problem of communication. Lowry was haunted by this idea, and once told the writer that he did not believe that, in the end, any human being could really make contact with another. His own sense of isolation led him to show his characters' isolation even when they are apparently taking part in some joint activity. Frequently they are set in situations, and settings, which serve to emphasize this isolation. *In a Park* (Plate 239) is one such example, and the extraordinary study *Man Eating a Sandwich* (Plate 266).

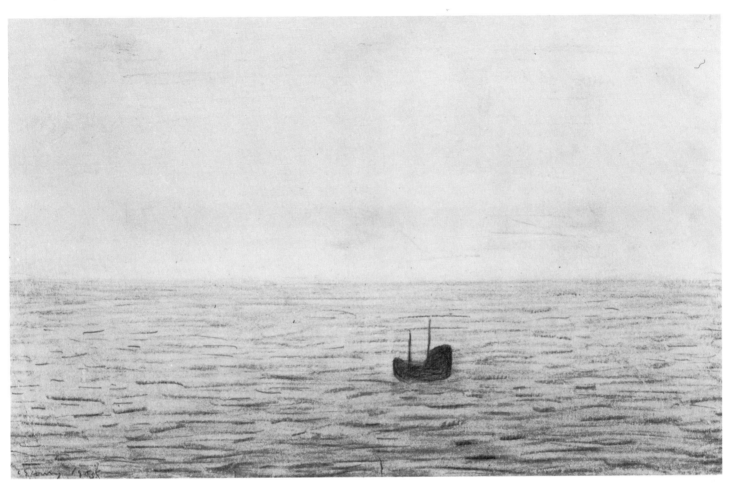

231

THE NORTH SEA

1965. Pencil 23.7 × 36.8 cm. Collection: Lefevre Gallery.

Perhaps the most interesting thing about this drawing is the placement of the ship in the expanse of ocean. The positioning is immaculate.

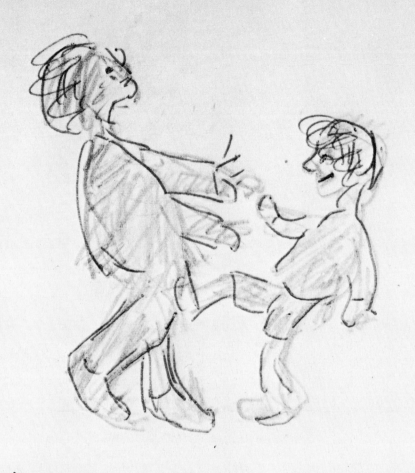

232

CHILDREN SQUABBLING

1965. Pencil. Size unknown. Private collection.

The subject of children squabbling and fighting intrigued Lowry. The essence of the situation is here brilliantly conveyed through the immense vigour and verve of the style of drawing.

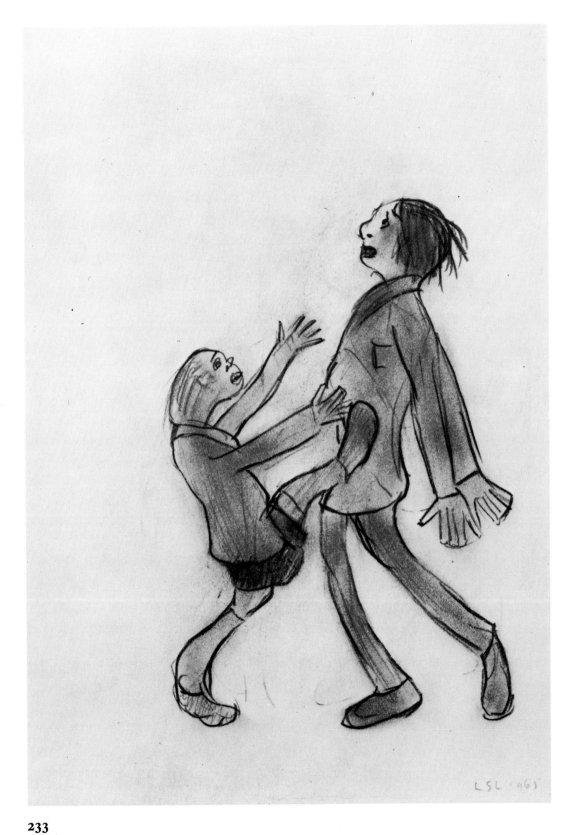

233

LITTLE BROTHER KICKING BIG BROTHER

1965. *Pencil 34.3 × 24.7 cm. Collection: Lefevre Gallery.*

See note for the previous plate.

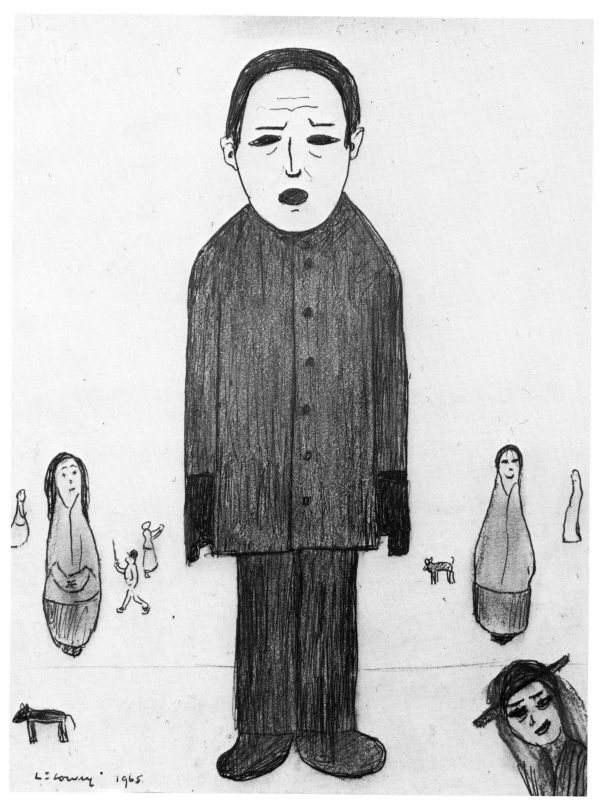

234

HE SHOULDN'T HAVE BEEN A NAUGHTY BOY

1965. Pencil 27.9 × 21.6 cm. Private collection.

Presumably a scrap of private symbolism? It would seem to suggest the ostracism of the individual in disgrace. But in disgrace for what? Is it an autobiographical statement? Let the reader conjecture.

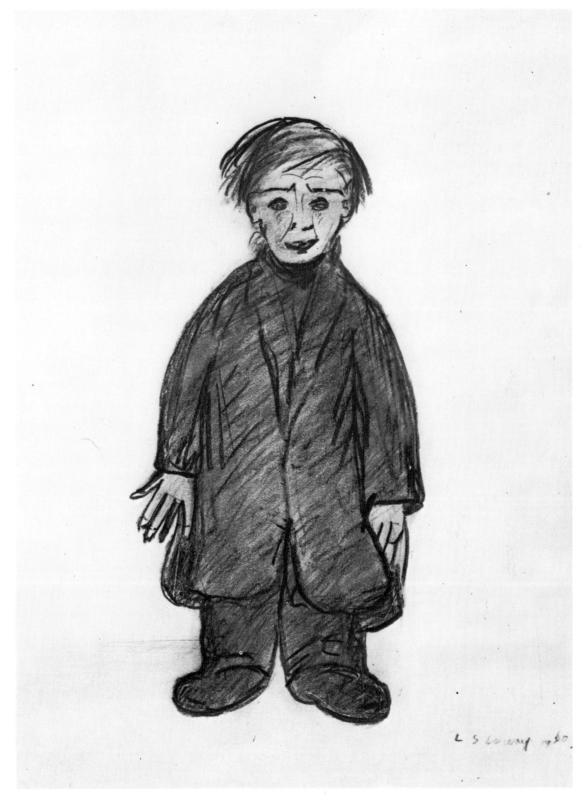

235

MAN IN OVERCOAT

c. 1965. Pencil 33 × 25.5 cm. Collection: City Art Gallery, Salford.

In the sixties the artist made many drawings of the odd, eccentric, and dere-lict characters he saw wandering around the streets of Manchester and Salford. He was particularly attracted to clumsy and ill-fitting clothes.

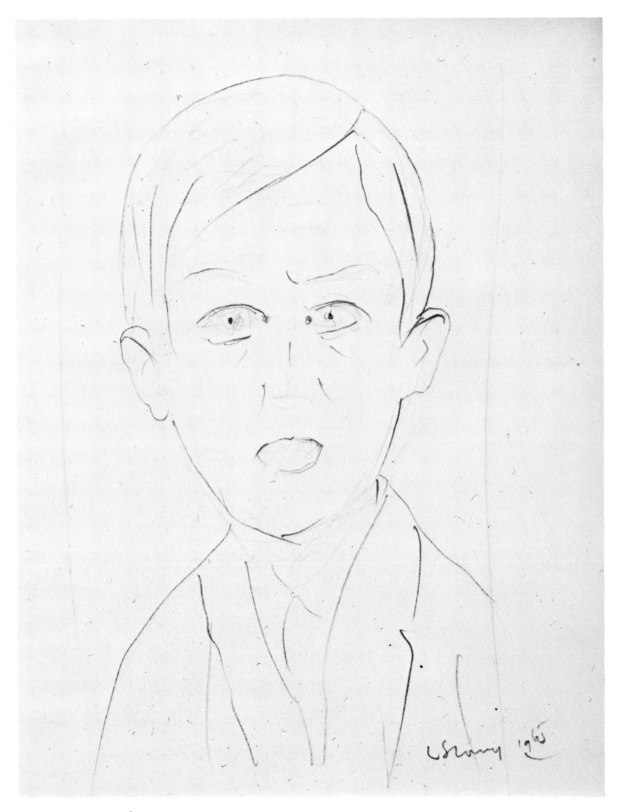

236

A YOUNG MAN

1965. Pencil 20.3 × 15.8 cm. Private collection.

A delicately drawn imaginary portrait. The sitter looks out upon the world with wondering eyes. Is it an evocation of the artist's vanished youth? I think so.

237

SEASCAPE WITH ROCKS

1966. *Pencil 40.6 × 29.2 cm. Collection: Lefevre Gallery.*

An original expression of a common Lowry theme: loneliness and isolation.

238

CHURCH SPIRE AND ROOFS OF HOUSES

1966. Pencil 29.2 × 41.2 cm. Collection: Lefevre Gallery.

A typical Lowryesque fantasy. Why are the figures – and the dog – crawling around the roof-tops? It is less a piece of Lowry symbolism than a study in sheer whimsy.

239

IN A PARK

1966. *Pencil 25.4 × 34.3 cm. Collection: Lefevre Gallery.*

See note for Plate 230.

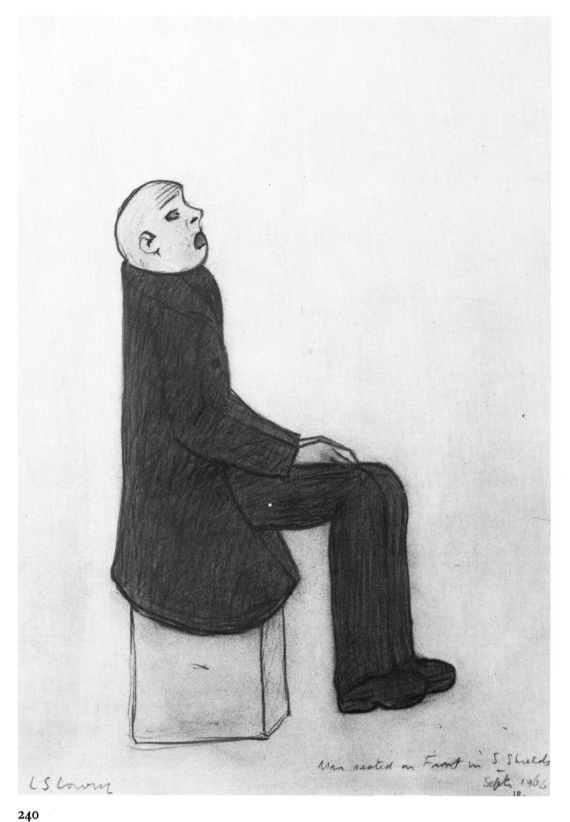

240

MAN IN SOUTH SHIELDS

1966. Pencil 34.3 × 25.4 cm. Collection: Lefevre Gallery.

See note for Plate 203.

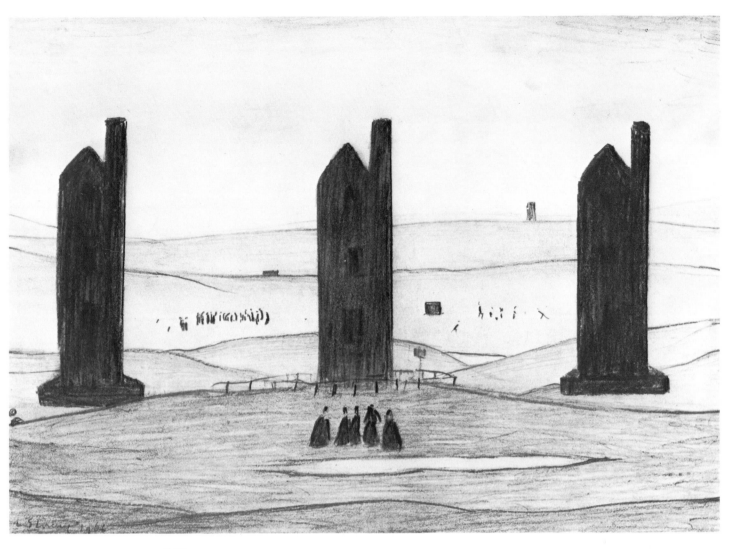

241

LANDSCAPE AND BUILDINGS

1966. Pencil 25.4 × 34.9 cm. Collection: Lefevre Gallery.

Lowry's late drawings are remarkable rather for their vision than for their qualities of drawing *per se*. In short, though he could always draw with great academic skill, Lowry is here, as in so many of his drawings of the sixties, concerned with the presentation of an *idea*: the smallness of man when seen against the size of buildings and the vastness of nature.

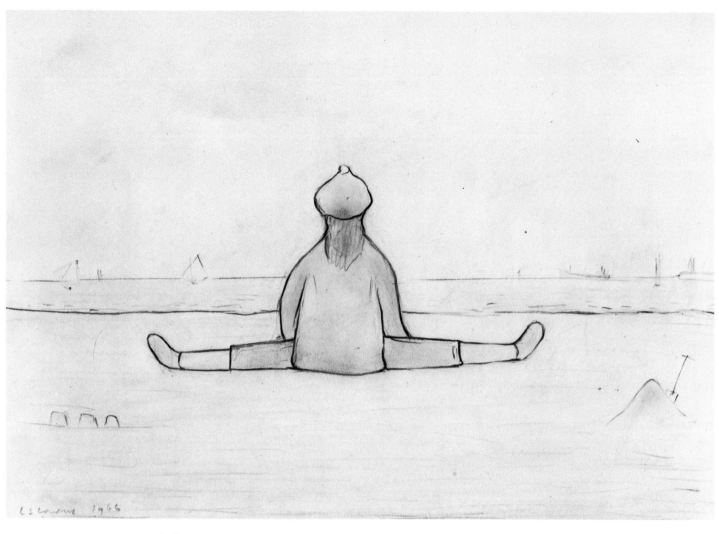

242

ON THE SANDS

1966. *Pencil 29.2 × 41.9 cm. Collection: Lefevre Gallery.*

See note for Plate 203.

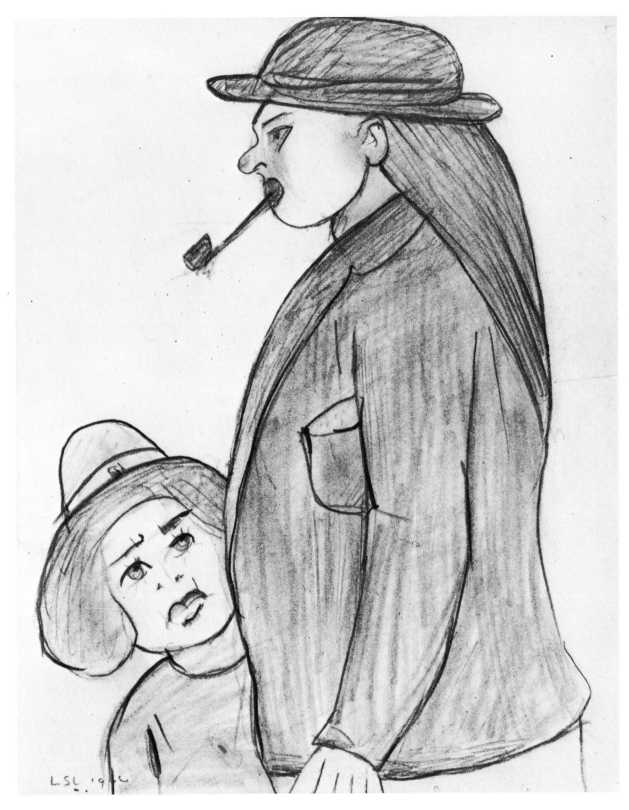

243

TWO FIGURES

1966. Pencil 20.3 × 15.8 cm. Private collection.

Perhaps a satirical comment on contemporary hair styles? Clearly the execution of the drawing is of less importance than the subject. A state of tension would appear to exist between the figures. An irate parent and an irritating child would seem the most likely interpretation. Family tensions were often explored by Lowry.

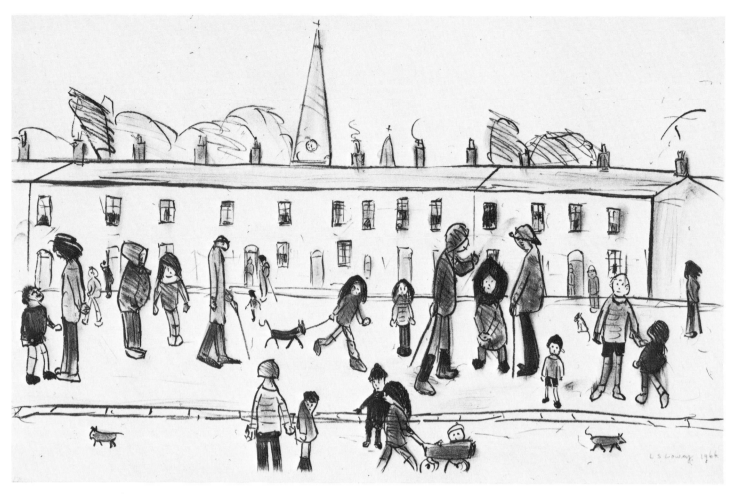

244

A STREET FULL OF PEOPLE

1966. *Pencil 62.9 × 98.4 cm. Collection: City Art Gallery, Salford.*

This is the drawing for a lithograph of the same title. It is executed with a characteristically brutal expressionism.

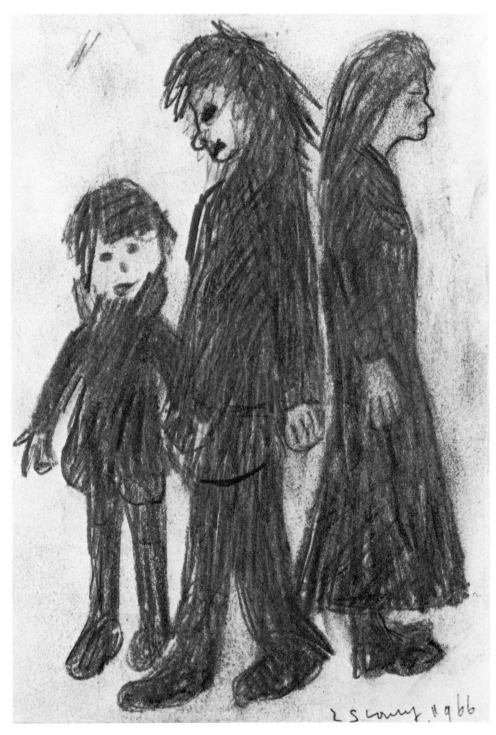

245

SMALL FAMILY

1966. *Pencil 18.4 × 12.7 cm. Private collection.*

The idea of the family unit is common in Lowry's art – the family communicating or unable to communicate. Many shades of the ambivalence of family life are examined by the artist in these studies. Here there appears to be some difficulty with mother. The style of drawing is powerful and rugged, and emphasizes the importance of the situation. Lowry was a great social psychologist. He understood the patterns of human behaviour; of conflict – and rapport.

246

A FIGURE OF A GIRL WITH THE LEAST EFFORT

1966. *Pencil 20.3 × 14 cm. Private collection.*

This brilliantly funny sketch was made for the Revd. G. S. Bennett, a close friend of the artist. The essence is in the title rather than the drawing! But the drawing is also brilliant – and reminiscent of Giacometti.

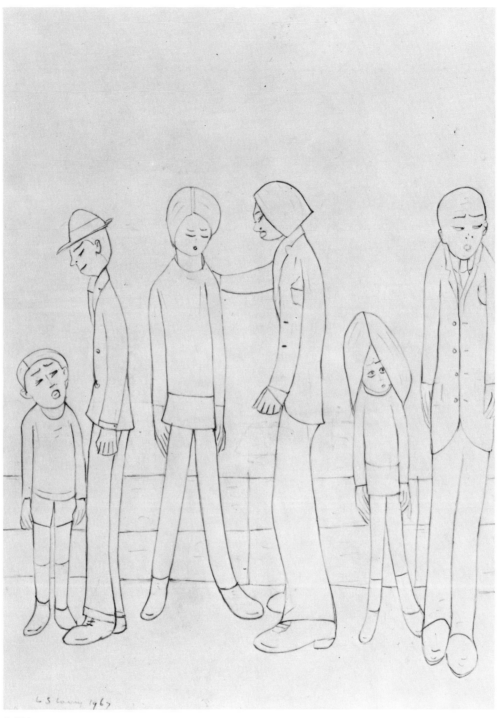

L S Lowry 1967

247

ON A PROMENADE

1967. Pencil 39.4 × 29.2 cm. Collection: Lefevre Gallery.

In the sixties the artist made a number of drawings in line, thus echoing, but in a much freer style, his line drawings of the twenties. Many of these compositions were made on the Promenade at Sunderland, and are delightfully satirical. They poke fun, but gently, at the fashions of the day as sported by the teenager. Hair styles in particular come in for a spot of sharp treatment. The style of drawing is frankly expressionistic, but very well controlled. In these late drawings the artist has lost none of his powers, though the mood is more relaxed, the tension of the early years absent. (See also Plate 268.)

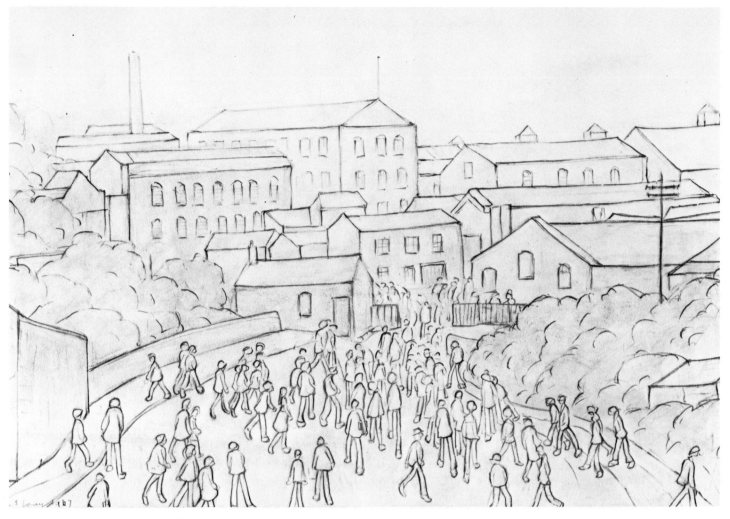

248

SIMPSON AND GODLEES MILL, ENTWISTLE, LANCS.

1967. *Pencil 29.2 × 41.9 cm. Collection: Lefevre Gallery.*

A memorable excursion into the topographic, deftly executed with fine contrasts.

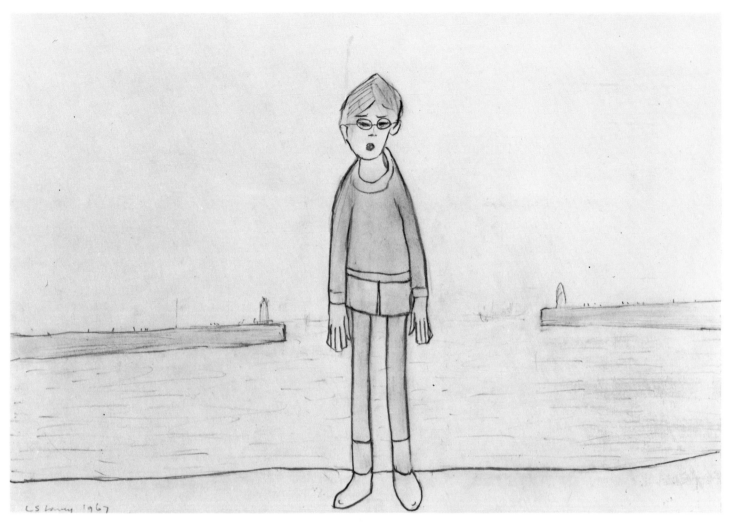

249

BOY AND HARBOUR

1967. *Pencil 29.2 × 41.2 cm. Collection: Lefevre Gallery.*

See note for Plate 203.

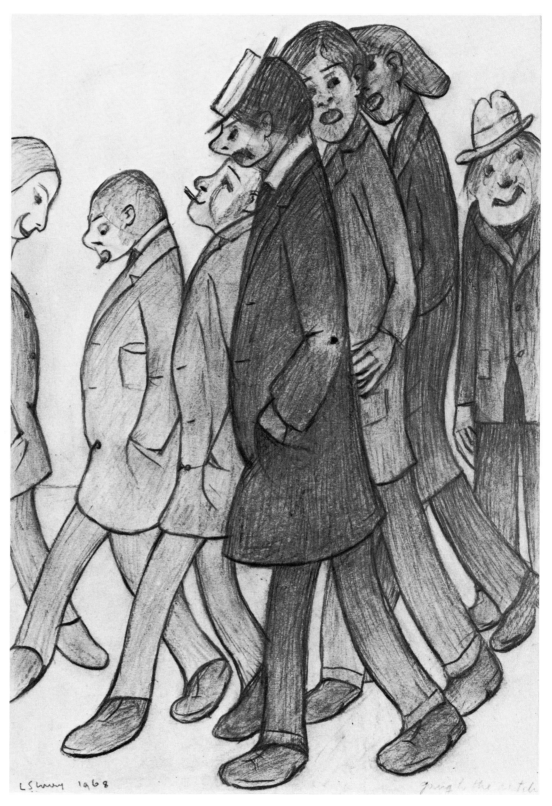

250

GOING TO THE MATCH

1968. *Pencil 41.9 × 29.8 cm. Private collection.*

The brutishness of the Football Fan.

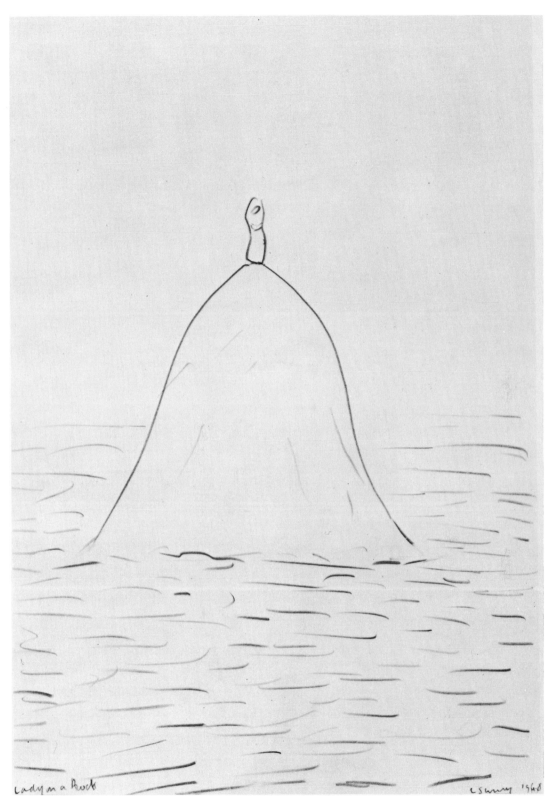

lady on a Rock L Scurry 1968

251

LADY ON A ROCK

1968. *Pencil 41.9 × 29.2 cm. Collection: Lefevre Gallery.*

An extension of Plate 237. Here the artist has introduced a note of tragi-comedy. The means of expression are superbly minimal.

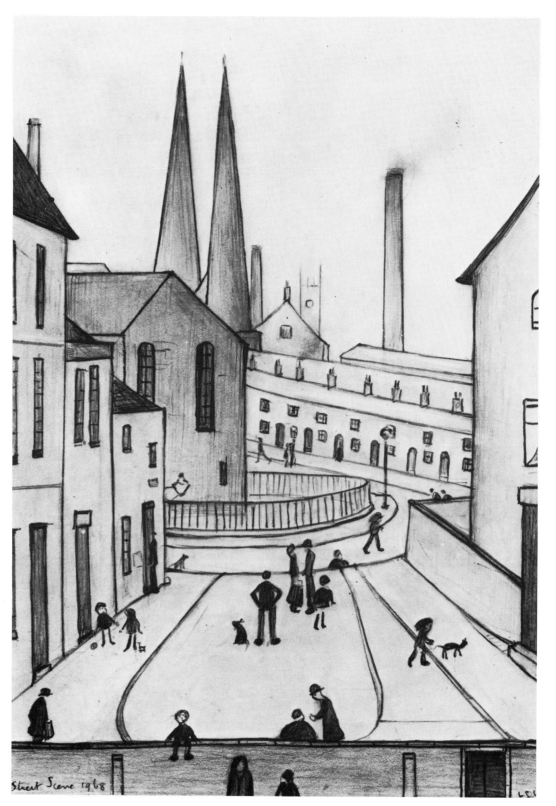

252

STREET SCENE

1968. *Pencil 41.9 × 29.2 cm. Collection: Lefevre Gallery.*

See note for Plate 200.

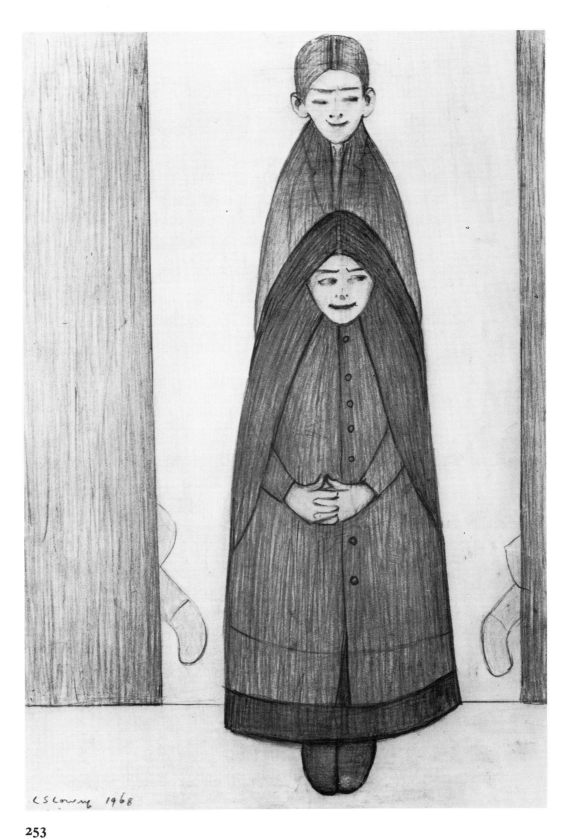

253

MOTHER AND SON

1968. *Pencil 41.9 × 29.2 cm. Collection: Lefevre Gallery.*

See note for Plate 230.

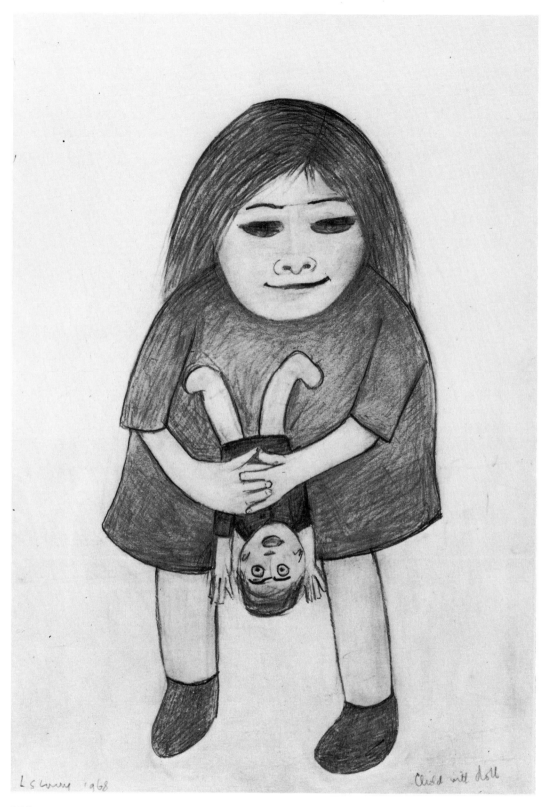

254

CHILD WITH DOLL

1968. *Pencil 41.9 × 29.2 cm. Collection: Lefevre Gallery.*

See note for Plate 203.

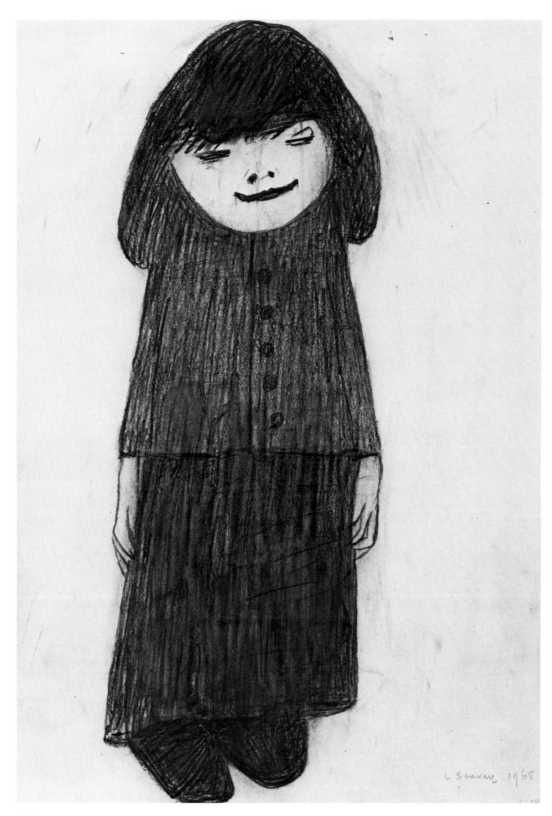

255

YOUNG WOMAN

1968. *Pencil 34.9 × 24.7 cm. Collection: Lefevre Gallery.*

See note for Plate 203.

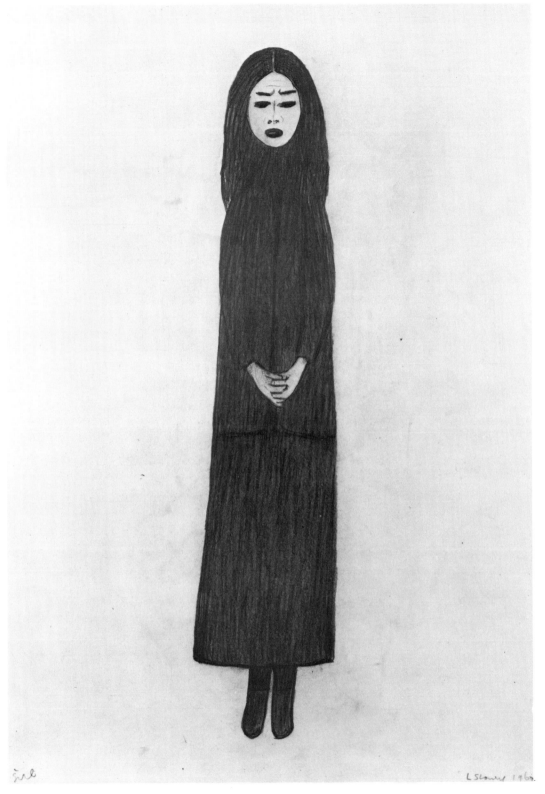

256

GIRL

1968. *Pencil 50.2 × 34.9 cm. Collection: Lefevre Gallery.*

See note for Plate 203.

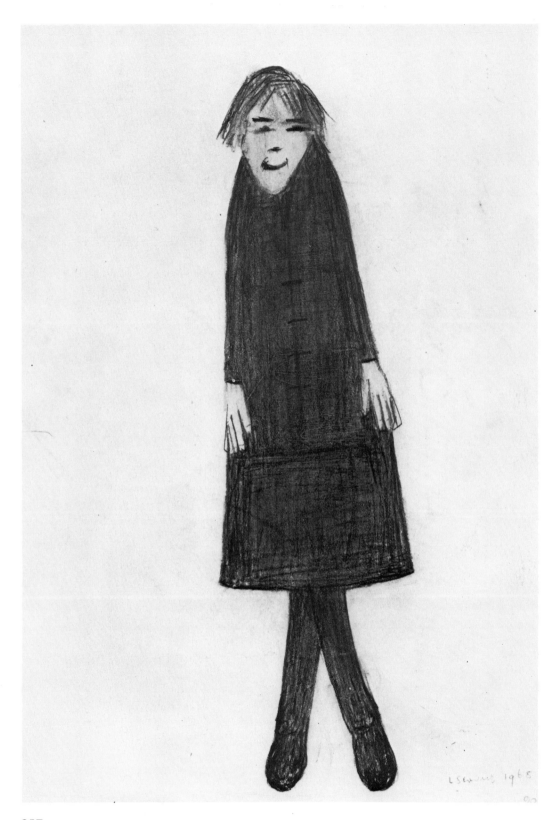

257

ELDERLY LADY

c. 1968. Pencil 34.3 × 24.7 cm. Collection: Lefevre Gallery.

See note for Plate 203.

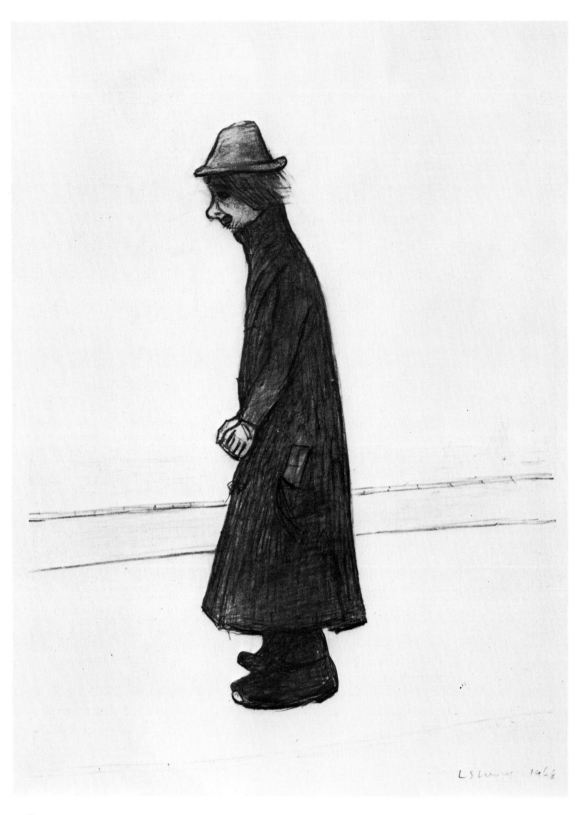

258

MAN ON A PROMENADE

1968. Pencil 41.2 × 29.2 cm. Collection: Lefevre Gallery.

A characteristic Lowry 'derelict' found on the Promenade at Sunderland.

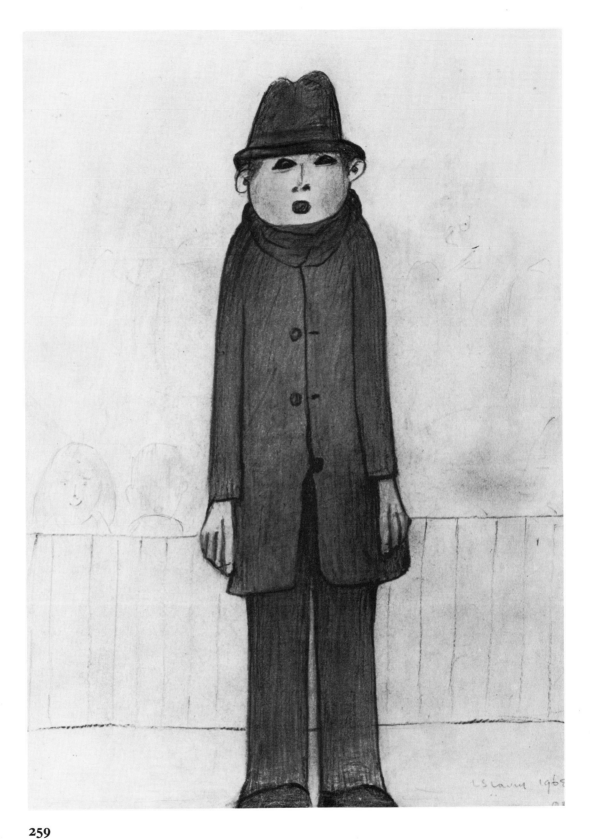

259

A MAN STANDING

1968. Pencil 35.6 × 25.4 cm. Collection: Lefevre Gallery.

See note for Plate 203.

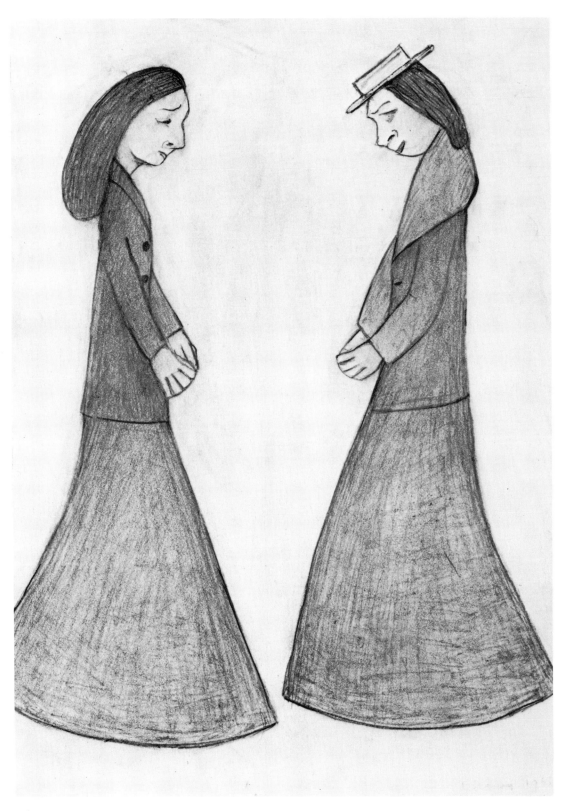

260

TWO LADIES

1968. Pencil 34.9 × 24.7 cm. Collection: Lefevre Gallery.

An extension of the theme of the single figure (see Plate 203). The confrontation deals with the problem of communication, always one of Lowry's favourite themes.

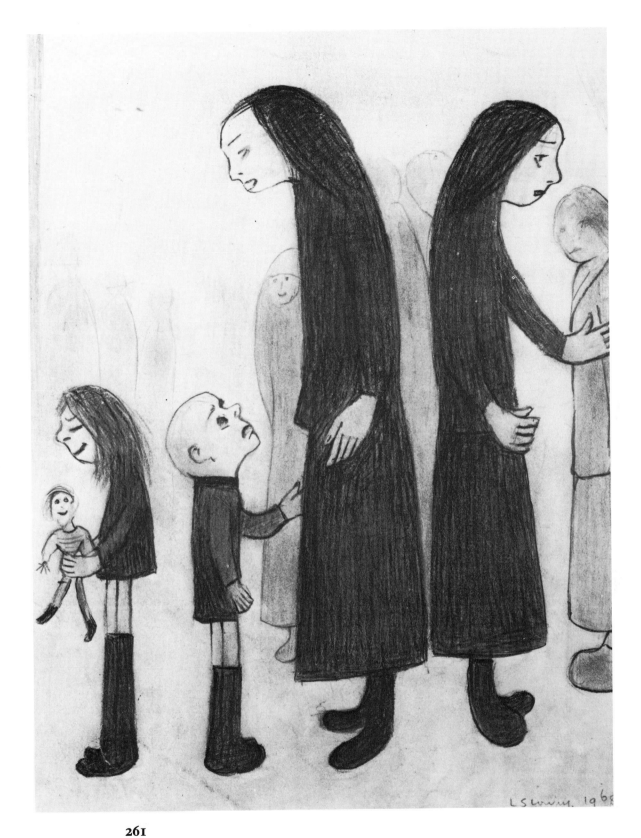

261

GROUP OF PEOPLE

1968. *Pencil 33 × 25.4 cm. Collection: Lefevre Gallery.*

See note for Plate 230.

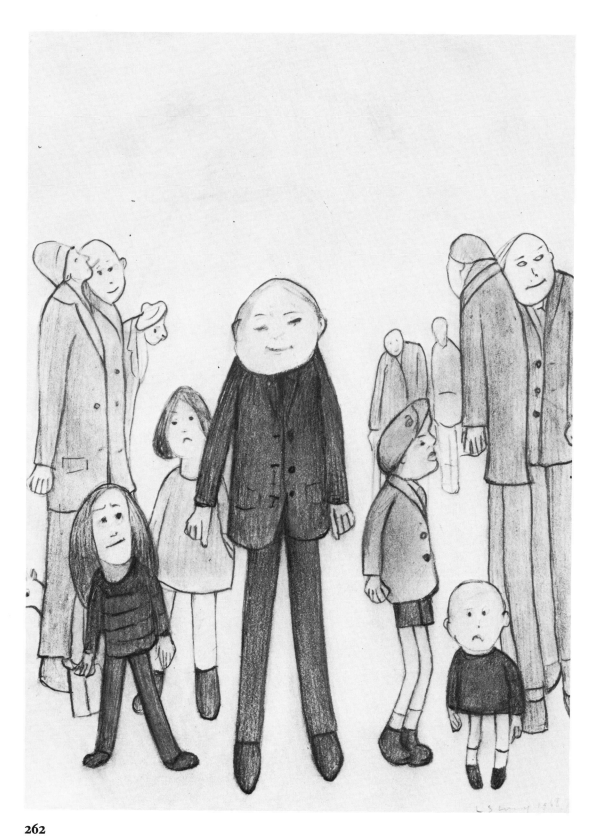

262

OLD GENTLEMAN AND CHILDREN

1968. *Pencil 33.9 × 25.4 cm. Collection: Lefevre Gallery.*

See note for Plate 230.

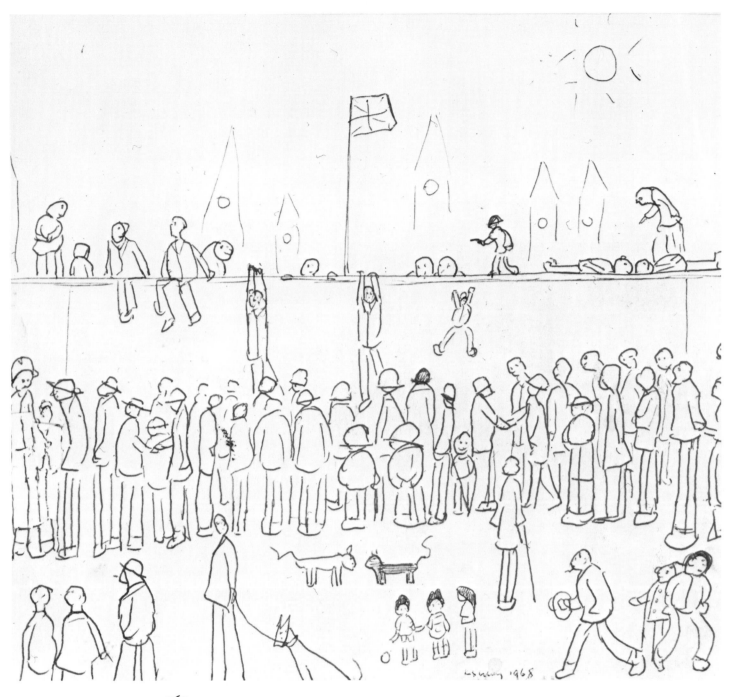

263

MAN WITH A GUN

1969. *Pencil 20.3 × 22.2 cm. Private collection.*

A neatly humorous piece of social satire inspired by the acceptance of violence as part and parcel of daily life. It is a conception which compares with the social satire of the German Expressionist Georg Grosz, working in Berlin during the twenties.

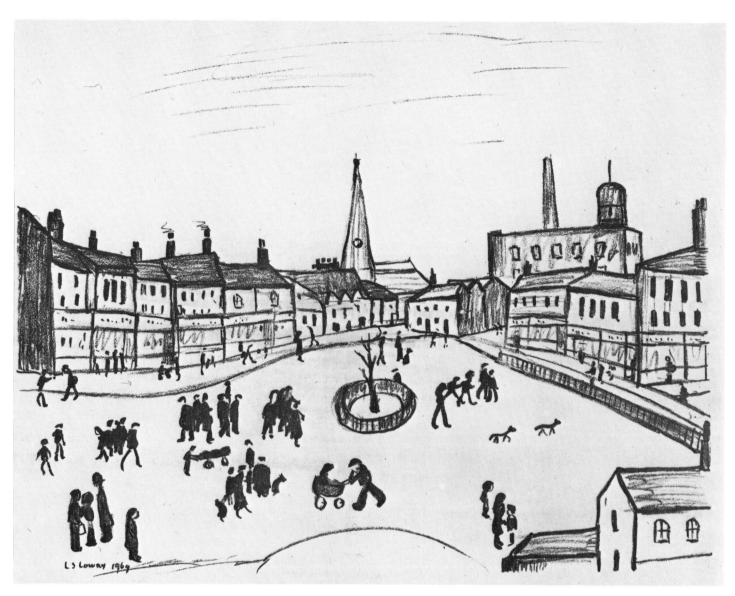

264

1969. *Pencil 30.5 × 38.1 cm. Private collection.*

During the late sixties Lowry reduced his figures in scenes such as this to bold, telling silhouettes. There is no detail in the black mass of the figures, yet the shapes themselves are brilliantly expressive. Age, youth, vigour, movement, stillness, are all conveyed through the very simplest of forms.

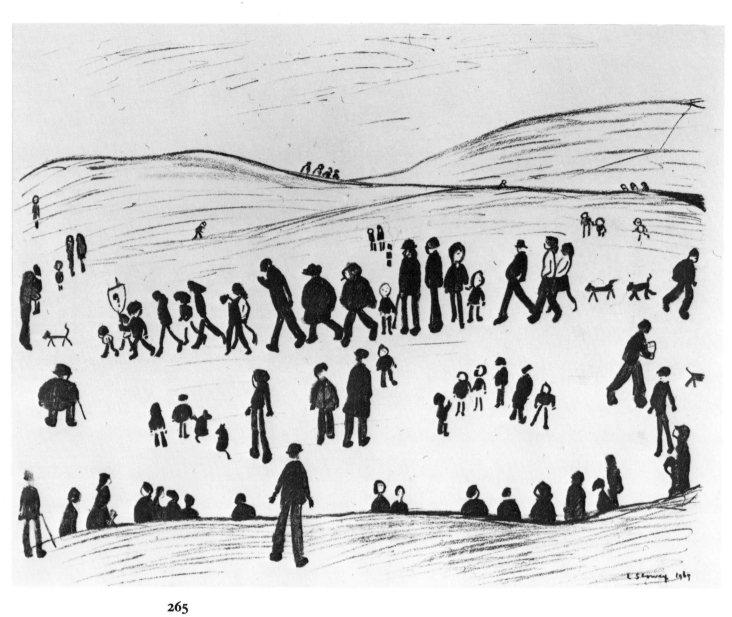

265

ON THE MOORS

1969. *Pencil 30.5 × 38.1 cm. Private collection.*

See note for the previous plate.

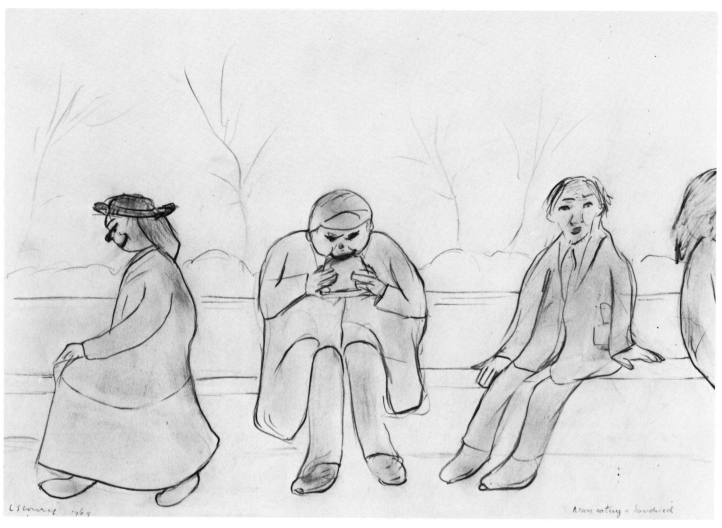

266

MAN EATING A SANDWICH

1969. Pencil 29.2 × 41.9 cm. Collection: Lefevre Gallery.

See note for Plate 230.

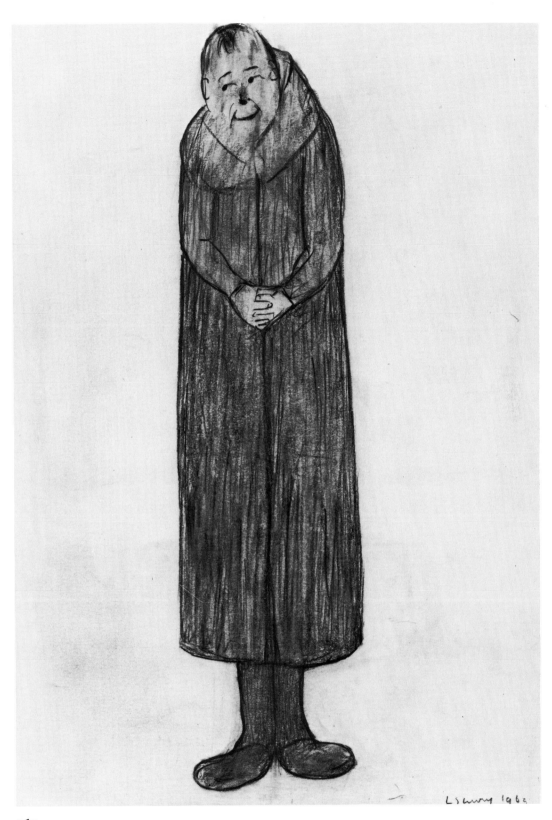

267

OLD LADY

1969. *Pencil 41.9 × 29.2 cm. Collection: Lefevre Gallery.*

See note for Plate 203.

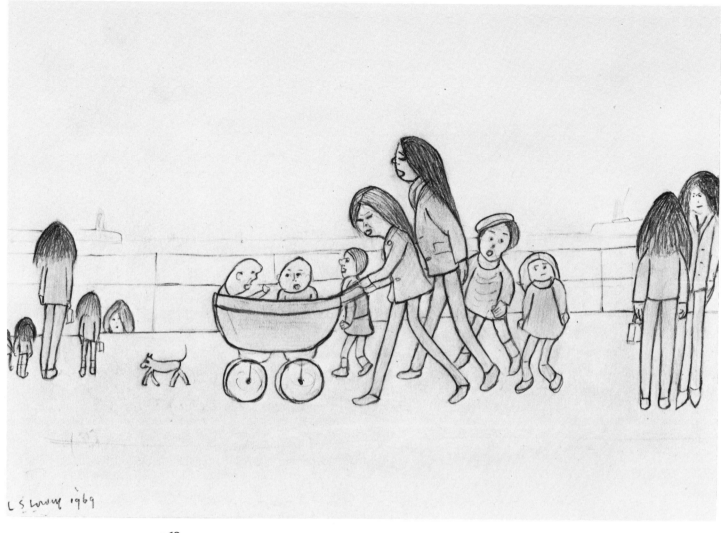

268

ON A PROMENADE

1969. *Pencil 29.2 × 41.9 cm. Collection: Lefevre Gallery.*

Another version of Plate 247.

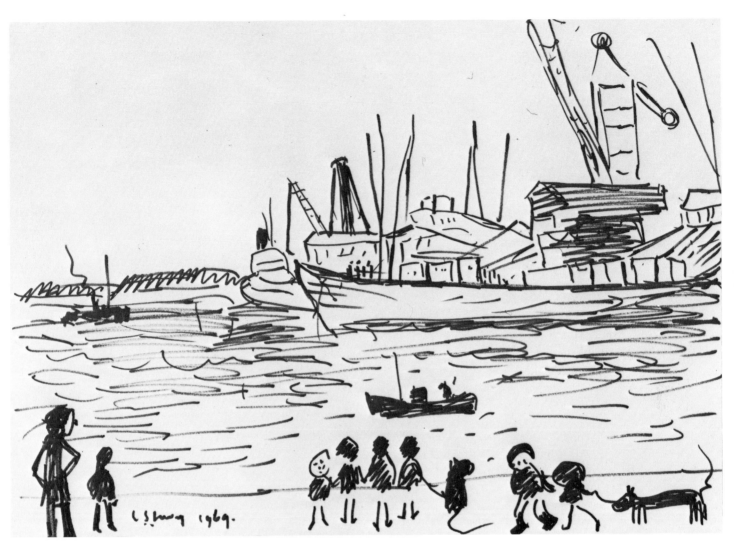

269

SCENE AT SOUTH SHIELDS

1969. Felt-tip pen 38.1 × 55.9 cm. Collection: Mrs Lore Leni-Cowan.

Another example of how Lowry made full use of the boldness of felt-tip pens and how much he could extract from the implement. The severe editing of the figures in the foreground only serves to intensify their significance. Once again the classic point is proven: it is not what an artist puts in but what he leaves out that matters.

270

MAN PROTESTING

1970. *Pencil 20.3 × 15.8 cm. Private collection.*

This and the following drawing were made within a few minutes of each other. They are little more than scraps, but they show how well Lowry could convey an idea with a minimum of means. It is always important, and revealing, to study the shavings of an artist's genius.

271

BIG HEAD

1970. Pencil 20.3 × 15.8 cm. Private collection.

See note for the previous plate.

272

MAN DROWNING

1970. *Pencil 20.3 × 15.8 cm. Private collection.*

Not to be taken too seriously – except as a humorous idea. This and the drawing which follows were made as 'fun' sketches for a friend of the artist.

273

ANOTHER MAN DROWNING

1970. *Pencil 15.8 × 20.3 cm. Private collection.*

The companion piece to the previous drawing.

274

THE SUN SHINES ON THE RIGHTEOUS

1970. *Pencil 34.9 × 24.7 cm. Private collection.*

A delightful study in the mechanics of self-satisfaction! Even the two impossible animals in the foreground are unbearably smug. The conception is expressionistic, distortion cunningly used to intensify the artist's message.

275

ON THE PROM

1971. *Felt-tip pen 38.1 × 55.9 cm. Private collection.*

A ferocious and marvellously annotated interpretation of bustling figures in vigorous action. The element of satire is savage. The suggestion of the sea in the background is infinite in its spaciousness. The energy of the central striding figure is almost unbearable. The conception is so powerful that it hurts!

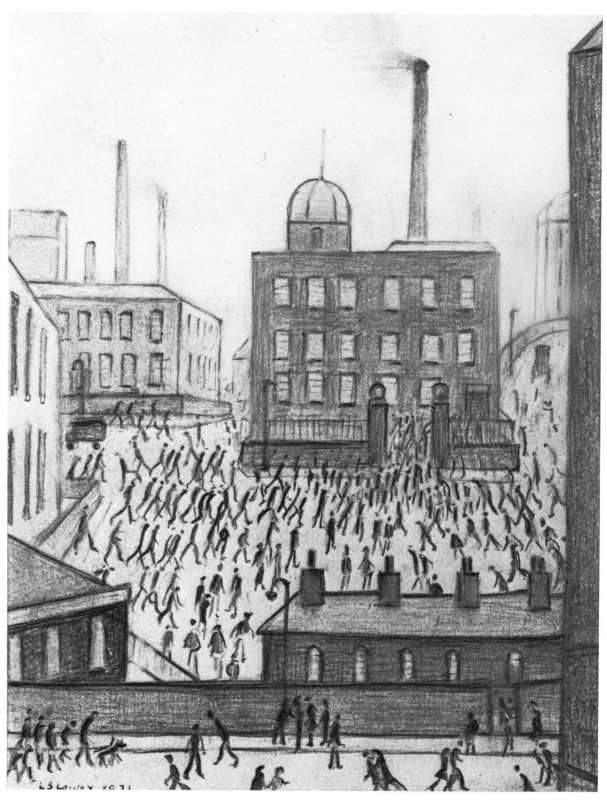

276

MILL SCENE

1973. Pencil 27.3 × 21.6 cm. Private collection.

Seldom in his later years did the artist produce a drawing as brilliantly elaborate and detailed as this. It shows how little his powers had waned. When the subject was sufficiently compelling he could express it with consummate grace, elegance, and finesse. This is a drawing which could have been done forty years earlier.

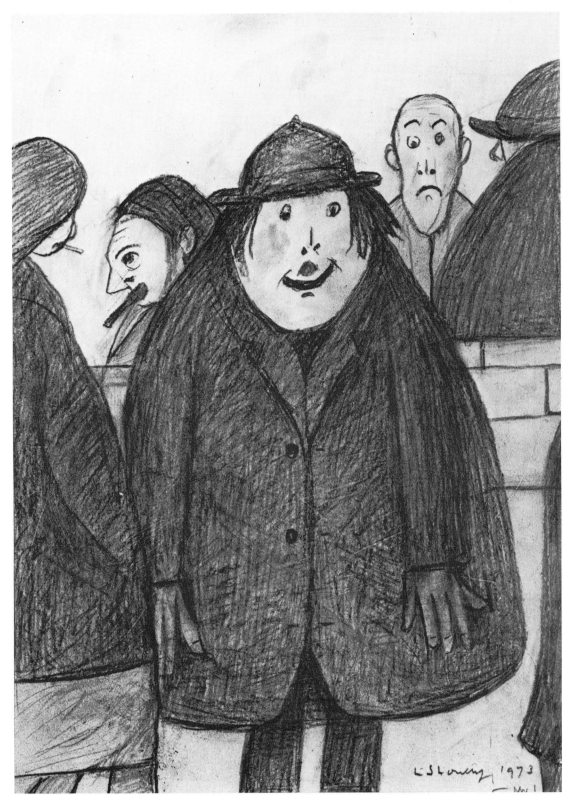

277

GROUP OF PEOPLE

1973. *Pencil 34.3 × 24.7 cm. Private collection.*

A superbly hostile view of man, exploring his worst features: cunning, ugliness, crudity, stupidity. The types are drawn from the lower echelons of Manchester gutter society.

Mottram

29 January 1964

Dear Ceri

a very belated
Christmas gift — I am
sorry it is so late

L S Lowry

278

POSTCARD

1964. Ballpoint. Reproduced actual size. Collection: Ceri Levy.

In 1964 the artist sent a belated Christmas present to the writer's son, Ceri, who was then three years old. The gift was a woolly owl. In 1975 the card was taken to the artist, who made a drawing on the reverse, which is reproduced as the next plate.

279

POSTCARD (REVERSE OF 278)

1975. *Felt-tip pen. Reproduced actual size. Collection: Ceri Levy.*

This drawing was made in the last few months of the artist's life. There is a serenity about the man, but a mystery about the curious, hybrid animal. Dog? Reptile? Pet? Or what? The ambiguity is characteristic.

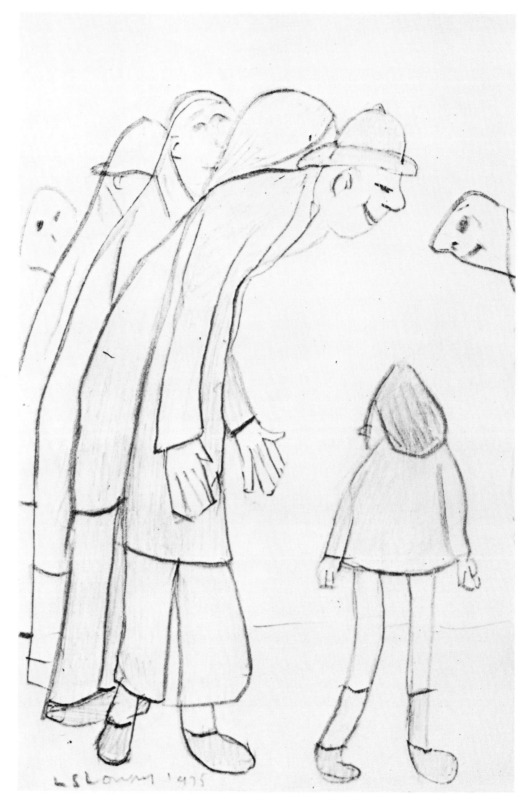

280

GENTLEMEN WITH LITTLE GIRL

1975. *Pencil 18.4 × 12.1 cm. Collection: Ceri Levy.*

A drawing made a few months before the artist's death. Why are these middle-aged gentlemen ogling the little girl in her mini-skirt? The drawing is fraught with sexual undertones.

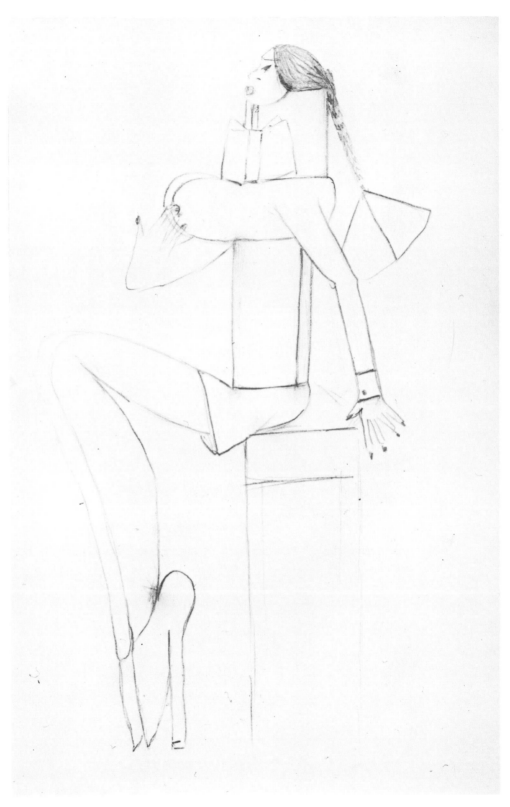

281

SEATED GIRL

1975. *Pencil 29.8 × 19.7 cm. Private collection.*

A study in erotica. During the last year of his life Lowry made a number of drawings in this vein. The Freudian implications are obvious. It is an image that would have delighted Fuseli – strongly fetishistic, cruel, and sado-masochistic. The libido lashes out. But the style of drawing is brilliantly controlled.

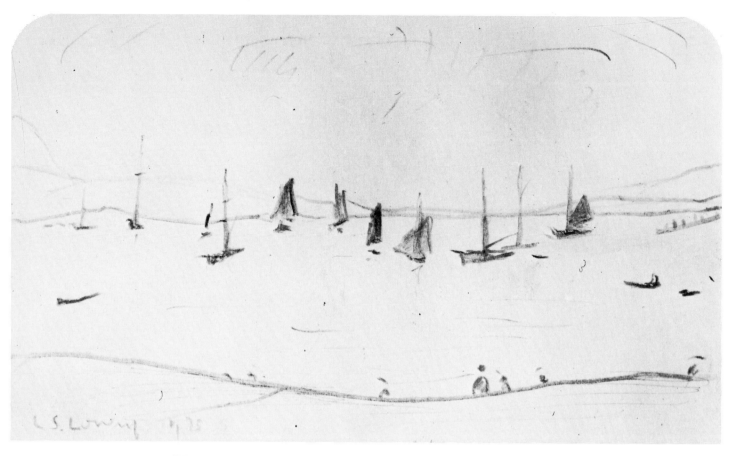

282

YACHTS AT LYTHAM ST ANNES

1975. *Pencil 12.1 × 18.4 cm. Collection: Ceri Levy.*

Seventy-three years separate this, the last drawing in the book, from the earliest. The subject is the same. In between lies the full range of the artist's genius. Only time has passed. Or has it? For this is time regained in the purest sense. Proust would have applauded.